THE CITIES WE NEED

THE CITIES WE NEED

ESSENTIAL STORIES OF EVERYDAY PLACES

GABRIELLE BENDINER-VIANI

THE MIT PRESS
CAMBRIDGE, MASSACHUSETTS
LONDON, ENGLAND

The MIT Press would like to thank the anonymous peer reviewers who provided comments on drafts of this book. The generous work of academic experts is essential for establishing the authority and quality of our publications. We acknowledge with gratitude the contributions of these otherwise uncredited readers.

This book was set in Arnhem Pro by the MIT Press. Printed and bound in the United States of America.

Library of Congress Cataloging-in-Publication Data

Names: Bendiner-Viani, Gabrielle, 1976– author.
Title: The cities we need : essential stories of everyday places / Gabrielle Bendiner-Viani.
Description: Cambridge, Massachusetts : The MIT Press, [2024] | Includes bibliographical references.
Identifiers: LCCN 2023054435 (print) | LCCN 2023054436 (ebook) | ISBN 9780262049030 (hardcover) | ISBN 9780262379366 (epub) | ISBN 9780262379373 (pdf)
Subjects: LCSH: Cities and towns—New York (State) | Cities and towns—California—Oakland.
Classification: LCC HT123.5.N7 B46 2024 (print) | LCC HT123.5.N7 (ebook) | DDC 974.7/23044—dc23/eng/20240309
LC record available at https://lccn.loc.gov/2023054435
LC ebook record available at https://lccn.loc.gov/2023054436

10 9 8 7 6 5 4 3 2 1

For Luca and Kaushik, with all my love.

And with love for my parents, Winnie and Paul, and my aunt Jessica,
no neighborhood stories compare to yours.

CONTENTS

INTRODUCTION:
A SOCIAL DISTANCE

THE WORK EVERYDAY PLACES DO

Stepping off the Q Train at the Seventh Avenue subway station in Brooklyn, walking onto the platform, up the stairs. People going to Park Slope go up on the left; those going to Prospect Heights split off to the stairs on the right, which deposit them in front of the Jamaican patty and muffin shop, on the brownstone block of Park Place and Carlton Avenue. The buildings are low for New York, three and four stories, handsome stoops, small front yards, low wrought iron fences where the stoops meet the cracked sidewalk. Where there was once an empty lot, a condo building is rising. At your back, there's the rush of Flatbush Avenue—a wide thoroughfare that crosses Brooklyn. Small shops are on the next avenue you come to: a pizza place, a supermarket, a roti shop, a bevy of nail and hair salons to choose from.

**

You get a good view of Mosswood, Oakland, from the BART train, or from the freeway if you're stuck in traffic. Running parallel to Telegraph Avenue, you pass the pediments and steeples of the AME and Baptist churches interspersed with the spires of signs for motels and Church's Chicken. On the avenue, the color pops: the red, black, and green of small Ethiopian and Eritrean stores; down the side streets, yellow, white, and peach single-family houses, stucco and wooden, sit low and close to each other. Just before the train pulls up to the elevated platform at MacArthur Station, you see West MacArthur Boulevard stretching out before you—light bouncing off the pink motels. The leafy green

of Mosswood Park is oddly lush against the concrete of a street so wide you can tell it was once a highway bringing travelers to those motels. In the distance on Broadway, the Kaiser hospital tower looms and the car dealerships glint in the sun.

**

When I asked Mike in Prospect Heights how he had prepared to take me on the tour of his neighborhood that I had requested, he explained, "I said to myself, we'll take a walk around the block and I'll tell you what I know, you know?"

Much of the work of being human happens in everyday places: we become ourselves, we become able to see each other, to be a community. Everyday places are personal but also global, intertwining history, emotion, and memory. They are experienced, talked about, negotiated, and woven into lives; we create places and, in turn, places shape us. It's not too much to say that these small public and semi-private spaces even have the potential to be spaces of liberation. It is in these spaces that we find the cities we need.

What are these remarkable everyday spaces? They're often thought of as banal: sidewalks, diners, bus stops, churches, meeting places, barber shops, bike shops, repair shops, donut shops, laundromats, schools, parks, playgrounds, libraries.[1] Not every one of these kinds of spaces does this important work; some are as banal as they seem, and others are merely places of consumption or simulation. Still others have been co-opted into places that surveil and enforce a social order, what architect Michael Sorkin has called *pseudopublic*.[2] Yet there *are* these special places—and more of them than we might think—that continue to do this work, usually because of the special people who run them. The work these places do helps us become ourselves and to become communities, laying the groundwork for a functional society; I call that work *placework*.

Places that do placework don't just emerge on their own. People create them, often in between making sandwiches, giving out change, taking inventory, paying the rent. Without these kinds of places, we are lost. The chat that takes place within them, that ranges from ordinary to transcendent and back again, and the everyday places that allow this chat to take place are not simply "nice to have."[3] They are, to use a word made ubiquitous through the coronavirus pandemic, *essential*. And yet both this work and these places are often at risk.

Through the voices of residents in two small neighborhoods in Brooklyn, New York, and Oakland, California, who gave me unique "tours" of their places, this

book tells essential stories of the placework that everyday public spaces have the capacity to do, the ways they do nothing less than help us become ourselves and help us be together. It is about how these hardworking physical spaces are created and protected and how they are threatened.

This book values the messy detail of everyday experience and everyday people as experts. At the beginning of this chapter, you got a snapshot in words from the early 2000s of each of our neighborhoods. Tangible things have changed since then; the Q train no longer goes to Seventh Avenue, the vista from the BART train is now blocked. And less tangible changes may be even more significant. Interspersed throughout the book, there are photographic tours of our neighborhoods—"portfolios" of images from Mosswood, Oakland, and Prospect Heights, Brooklyn. Immerse yourself in the images. Listen to the stories. Ask your own questions. What places of your own do they remind you of? Do you have new questions to ask? What stories would you tell?

Of course, Brooklyn and Oakland do not hold a monopoly on important ordinary places; people everywhere find public spaces that do the placework of supporting much-needed dialogue with others, and of helping them become more themselves, and everywhere these spaces are threatened. Everywhere, the individual process of making a life is in conversation with cultural, historical, and political constructions of physical public space. The stories people told me in Brooklyn and Oakland demand that we take seriously the work (and needs) of the often-banal spaces that support the meaning-making of society, and its members' ability to feel freedom and joy, when we plan for the future of our cities. We need to listen to these stories.

"GUIDED TOURS"

For twenty years, I have been researching everyday places, and I've spent hours and hours talking about them with residents in Mosswood, Oakland; in Prospect Heights, Brooklyn; on Manhattan's Lower East Side; in the East End of London; and in the informal settlements of Buenos Aires, Argentina.[4] In each neighborhood, I have been struck by how a sidewalk, a doorway, a diner, a supermarket, a parking space can have such a multitude of meanings for different people. And, even more, how these unassuming places turn out to play such a big role in our understandings of ourselves and our ability to be with others. How do these unremarked places do such vital placework?

I wish I could just ask people these questions directly, but everyday experience is elusive. It's hard to talk about what it's like to live our everyday lives because mostly, we just get on with it. Yet there are so many ordinary things to which people give little reflective attention but that support a deep connection to place.[5] The cyclical and improvisational rhythms of everyday of places are hard for people to talk about or even notice.[6]

This is why, to understand something not often verbalized, I began to ask people in Prospect Heights, Brooklyn, and Mosswood, Oakland, for what I called their "guided tours" of their neighborhoods, however each of them defined their neighborhood.[7] This book grows from the essential stories told to me on our tours by Mike, Tanya, David K., David W., Neville, Julia, and Ulysses in Prospect Heights, and Amanjot, Cynthia, Lois, Marty, and Tewolde in Mosswood. I asked the people I came to think of as my "tour guides" to walk me through their everyday spaces, to talk about them as we walked, and to later discuss them again with me over the photographs I'd made of these places.

The places mapped through these extraordinary peoples' lives have links and breaks, continuity and pause. There are as many other defining stories of these places as there are other people whose neighborhoods overlap with those of my tour guides. These tours are no boundary-drawing exercises. They are an attempt at writing how a city is lived—through the experiences of a few of those lives.

By physically putting myself in their places, I attuned myself, as geographers Tim Ingold and Jo Lee Vergunst would say, to my tour guides' experiences.[8] I attuned myself to the rules they set for themselves in their places, experienced their serendipitous meetings, and experienced the constraints and needs that came with walking—especially when other people and other responsibilities were involved. As Tanya in Brooklyn said when we walked, "There really is a difference between regular walking and walking with a stroller." I saw how walking itself could be a place of familiarity; as essayist Garnette Cadogan eloquently puts it in his memories of walking toward home as a child in Kingston, Jamaica: "The way home became home."[9] In how my tour guides made their ways and routes their own, I saw how they shaped, and were shaped by, neighborhood places.

Asking people to think about ordinary places enough to take someone else to them sets in motion an unusual process. When I've been riding in someone's car, seeing the world from their windshield and at the speed they drive, and they proclaim how the neighborhood is with a broad sweep of their arm across the dashboard, or when I've been walking with someone, falling in step with their pace, and

they see someone they know and engage in cheerful banter, I have to assume that this is both part of daily life and a little bit of performance for me, a *presentation of self*, as sociologist Erving Goffman would term it.[10] I have asked people to do something that is inherently a little of both everyday practice *and* performance: to be in the places they usually are, to do things they usually do, but also to show them to someone else.

I had begun this project of asking people for guided tours of their neighborhoods in earnest when I was working in the East End of London in 1998, but had earlier trial runs on the Lower East Side in my own city of New York and when I asked college friends for tours of the cities and small towns they came from, some of which I could not fathom ("Cows!" I shouted, shocked, on an early rural tour). In Brooklyn and Oakland, the tours would surprise and teach me even more.

Far from being a nostalgia trip to the "old neighborhood," this work is an inquiry into something hard-fought for in my own childhood. I grew up in a loft building in a neighborhood north of SoHo in New York City in the 1970s and 1980s, a third-generation New Yorker. My mother, an artist, had her studio in our loft. My father had built most of the walls and furniture, including his photography darkroom at the back. Until the late 1960s and 1970s, when the artists and musicians I would grow up with began to move in, each floor of the building had been occupied by clothing factories, sweatshops. In these spaces people had sewn silks, suits, and sweatshirts; had made wigs, trimmings, and hats.

When the landlord who rented these splintery raw spaces as illegal residences defaulted on his real estate taxes in 1976, our building fell into ownership by the city of New York through what's called *in rem foreclosure*. That year, when my mom was five months pregnant with me, my parents came home to find an eviction notice on the front door. Our building was like many other buildings across the city owned by delinquent landlords—a city in the throes of bankruptcy that President Gerald Ford had famously told to "drop dead." Through a New York City program called the Housing Development Fund Corporation, existing renters across the city, eventually including my parents and many people in the Brooklyn neighborhood I'd come to know later, were able to avoid threatened evictions by buying their buildings back from the city as co-ops for little or no money to be renovated through residents' sweat equity; though ours was somewhat uncooperative, it was secure housing.[11]

It was an odd neighborhood to grow up in. I was friends with the guys who worked at the nearby cardboard box company. It was a big event when the wholesale Christmas supply store across the street opened to regular customers for a few weeks in December. There was no local supermarket or diner where people might know me. My public school was nearby, and I had my network of places—but mostly these were disparate, spread ever further across the city as I grew up.

Later, as a teenager, I felt like I owned the city, and many of my formative experiences happened in the hours I spent walking New York. Walking was the place I would most often go. I knew exactly what Virginia Woolf meant when she wrote that walking allows us to be "no longer quite ourselves," how it lets us peek into other people's lives, to "put on briefly for a few minutes the bodies and minds of others." Yet I never felt completely invisible or truly part of Woolf's "vast republican army of anonymous trampers."[12]

Walks and routes—whether taken out of necessity or curiosity—can have many meanings, can involve radically different decisions based on your race or gender, and can change over time. I never really connected with the privileged views of many of the famous French walkers: inebriated white male situationists crisscrossing the city, drawn by randomness and their own desires, or the strolling, observing flaneurs so beloved by graduate students, protected by their gender, race, and class.[13] Walking isn't the same for everyone—the walks in Brooklyn and Oakland wouldn't have been the same for me walking alone, wouldn't have been the same for each of my tour guides, wouldn't have been the same for each of them without me. Walking is a curious intersection with power—sometimes toying with it, sometimes controlled by it.

When I walked as a young woman growing up in New York, I sometimes walked with friends—sometimes female, sometimes male, and the experience of each would be very different. In the first instance, we'd often be catcalled together, always as a way to exert power over us. In the second instance, I'd often be assumed to be the property of the guy I was walking with, even the subject of a remark made to him. I also walked alone, which I preferred, and this made me feel sharp, alive, but also vigilant—ready to cross the street, ready to duck into a shop if I felt someone near me was a threat, but also adamant in my right to walk, to own my city, to be an expert, to not be afraid.

Cadogan's essay "Walking While Black," even more than my experiences, sharply underscores this vital need to walk, to be in the flow of things—a need felt by so many people—while also deeply exploring what happens to that possibility

for joy when you fear that it is you who will be taken for a threat, and that this racist misperception will in fact existentially endanger *you*. It's a story many have told—and one that often has dire consequences, from feeling excluded from a place or a thing you love—I think of Christian Cooper in New York's Central Park, trying to watch birds—to losing your life—I think of Ahmaud Arbery, going for a jog in his South Georgia neighborhood. Cadogan writes that coming from a childhood of midnight wanderings and avoiding danger in Kingston, Jamaica, he'd had no fear of anything he might encounter on the street of an American city. But, he writes, "what no one told me was that I was the one who would be considered a threat." In New York City, he made his own rules of engagement, to try to protect himself, though they could never fully work—rules so stringent as to make being oneself almost impossible: "No running, especially at night; no sudden movements; no hoodies; no objects—especially shiny ones—in hand; no waiting for friends on street corners, lest I be mistaken for a drug dealer; no standing near a corner on the cell phone (same reason) . . . [I] learned that anything less than vigilance was carelessness."[14] These necessary self-protections, and the racist violence they hope to protect the walker from, mean that "walking while black restricts the experience of walking, renders inaccessible the classic Romantic experience of walking alone," writes Cadogan. Walking while Black—and in entirely different ways, walking as a woman—can mean never fully being oneself, never fully being able to be immersed, because of the vigilance required.

When I ask people to walk with me on these guided tours, I am navigating my own experiences of walking—maybe even my own experiences of walking the very same places that they will take me to. And I am always aware that I can never walk completely in their shoes, can never need those same rules that someone else might, can only rely on their capacity to tell me, as we try to bring our movements in tune with each other's, what it feels like to put their feet one in front of the other. Walks are, like everyday places, not things that are nice to have, but things to value, that hold power, that are unequally safe, and that are vital to understanding experience.

In Prospect Heights, Brooklyn, I began asking my neighbors for their tours in the summer of 2001. Although I was a native New Yorker, I was new to *this* neighborhood. I'd moved there only a year before but had already made my landmarks: the building where Kaushik and I lived and then got married, the diner where my

friend Emily and I regularly met for breakfast. A few months after I'd begun walking with my neighbors, I began graduate school across the street from the Empire State Building on September 11, 2001. That night, we walked back over the bridge and watched plumes of smoke and ash from the World Trade Center drift over our house and the rest of Brooklyn.

From that day on, my city reeled from those planes I'd first heard about from people breathlessly boarding our morning subway as it stopped in the station below the towers. On September 12, Emily, Kaushik, and I took a walk through Brooklyn on unnaturally quiet streets all the way to the Brooklyn Promenade, where we looked wonderingly at the smoking hole in the skyline across the river. Four days later, my grandfather died in his sleep in the Bronx. As we rushed down Saint Marks Avenue to find a cab to get to my family, I felt a kind of comfort from our neighborhood's front gardens and familiar places. In that emotional post-9/11 time, my work on the project I began calling "Guided Tours: Prospect Heights" built up steam, and I asked more and more of my neighbors to give me their personal tours of our community.

I would later return to make photographs of all the places to which they'd taken me, and later still return to my tour guides with the photographs, asking them to reflect on the images I'd made as similar to, or different from, their lived experience. As a photographer and an artist, I saw sharing these photographs as a way of sharing my understanding of these places with my tour guides; I made photographs knowing that images are always about choices, about storytelling, not about evidence.

Spending time with the photographs, spending time on the walks, gave us multiple moments and spaces for reflection, using artwork as one form of exchange and building knowledge together. I take seriously the idea of careful looking and phenomenologist David Seamon's suggestion that photographs can momentarily suspend the "taken-for-granted-ness" of the world.[15] A photograph, which sits outside the world in the image, can reveal how the unnoticed everyday things pictured are inherent and vital parts of the way we experience the world. This is part of how making photographs, and using them in my work, allows me to see in detail the small pieces that make up the everyday.

My guided tours in Brooklyn continued for five years with my many tour guides, even while "Atlantic Yards," a controversial plan for a basketball stadium and housing development using eminent domain to acquire land, was proposed for the edge of the neighborhood in 2004.[16] When Kaushik and I moved across the country to the neighborhood of Mosswood in Oakland, California—I began to ask the same kinds of questions in a neighborhood that looked quite different. I found that Mosswood

was shaped by similar histories and related pressures of development and gentrification as Prospect Heights, but also had different challenges including the redlined legacies of freeway construction and the real estate pressures brought on by the Bay Area's second tech boom.

My relationship to Oakland, too, was both similar to and different from my relationship with Brooklyn. In Oakland, we lived in a neighborhood that was new to me, but I did have family connections to the city. We settled there in part due to my sunny memories of having lived one summer with my aunt, uncle, and cousins in their home near Dimond Park. Yet there was no getting away from being a New Yorker in California. I moved to California as a person who didn't drive, and I left it much the same way. It meant that I walked often, and far. And took a lot of buses. Moving to California, I felt perpetually foreign, but also in awe. Even though the freeway loomed just behind our house, there was a lemon tree in the backyard, and an orange tree in the front yard of the house next door. In Oakland, the sun shone every day. Such abundance seemed impossible, and miraculous.

In Oakland, people took me on both walks and drives; the drives had much of the serendipity of the walks. This might be surprising, as driving can feel a solitary activity: novelist Joan Didion once described much of a Los Angeles day as "spent driving, alone, through streets devoid of meaning to the driver."[17] Indeed, in every photograph I made of Oakland, I can see car-surrounded houses; landscape historian J. B. Jackson argued that this is the new vernacular in a society about passing through and instant access.[18] The uneasiness of passing through is particularly important in a neighborhood like Mosswood where the houses abut the freeway, its pylons and roadways soaring above backyards. And yet there was an important human scale in the spaces between people's houses and their cars—in front of their houses where young Amanjot and her cousins would play, in the space between house and parking spot that was important to (and well-planted by) Cynthia. There was even a human scale between people on the street and people in their cars—made clear as Marty called out to a friend of his on a small street, and we slowly rolled up next to him, joking with him out the window. "Eh, Rodney! This is Gabrielle—she's interviewing me so I can give her the history of the neighborhood. I'm the right person, right?" To which, answering back in kind, Rodney chuckled, saying, "Exactly! You're the right person for any job!" We rolled slowly on, as Marty laughed hard, replying, "Shut up, fool!"

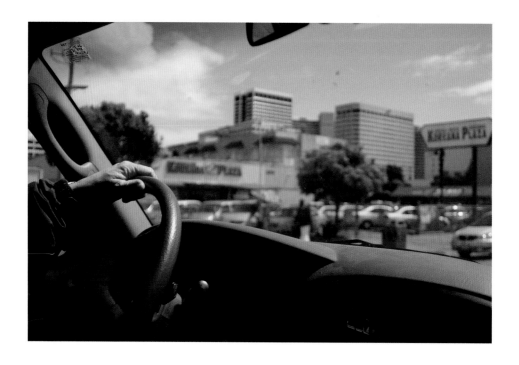

Driving with Cynthia.

The guided tours that people gave me in both places became my sacred texts to unravel the mysteries of the world—delivered by the wisest of people. Begun when I was in my twenties and continuing into my thirties, they, like the places my tour guides took me to, taught me nothing less than how to grow up, to be myself, to find ways of being together. People talked about how these places shaped their lives and how they held deep and (to me) unexpected meaning. As I've thought about their stories over decades, these tours have also shaped me, now in my forties, helping me learn about resilience, responsibility, parenting, politics, and the human heart.

STATE OF PLAY

Prospect Heights, Brooklyn, and Mosswood, Oakland, are similar and also quite distinct. Their histories, from their indigenous roots to their development as nineteenth-century cities in relation to more famous cities across the water—sometimes even with the same people designing them—to war industries, redlining, postwar pressures of urban renewal and urban disinvestment, and to their later gentrification, shaped them both. These histories are part of what created the everyday spaces on these tours, and also what has threatened many of these spaces and threatened people's abilities to make space for themselves. These histories are told throughout the book, through my tour guides' stories. But the time when the tours themselves happened, and what happened afterward, the crisis in which we find ourselves now, bears a short introduction before we embark.

For the last decade of the twentieth century and the first two of the twenty-first, housing or the lack thereof was central to both of these neighborhoods, which by the end of this era had become two of the most expensive housing markets in the United States. Geographer Neil Smith writes that "gentrification" is an economic creation that lies in the idea of the "urban frontier," visible at the local scale, but the result of global processes.[19] Too often the real power, and financial gain behind it, is not seen. As Brooklyn historian Craig Wilder says, in Kelly Anderson's film *My Brooklyn* about this time period in the borough, "gentrification in New York is not about people moving into a neighborhood and other people moving out of a neighborhood. The process of gentrification is about corporations sectioning off large chunks of those neighborhoods and then planning out their long-term development."[20] It is impossible to separate "neighborhood change" from displacement.

In 2006, sociologist Aviva Zeltzer-Zubida described Brooklyn at the time as having a racial and economic "segregated diversity," in which residents of lower-income

census tracts that bordered higher-income census tracts were at a higher risk for housing displacement, echoing similar research Oakland. In the early 2000s, this described both Mosswood and Prospect Heights very well: they were each a mix of incomes, and both abutted neighborhoods that were much more affluent, meaning that their most vulnerable residents were at significant displacement risk.[21]

In the early 2000s, people in Prospect Heights talked about gentrification as being on the horizon. Diner owner Mike explained that the neighborhood could still not support a seven-dollar sandwich; at the time, his sandwiches were four or five dollars, even though that seems impossible twenty years later. When I asked if fifteen-year-old David K. felt the neighborhood had changed, he described it obliquely: "A couple of years ago, it wouldn't be this quiet. It would be real loud. And a lot of people would be out here, on the street, doing stuff. . . . People would be talking, standing out here, in front of buildings. Loud music, cars. Now it's kind of dead. I guess all those people moved out of here." In 2006, I noticed a new bakery had opened up. The place looked plucked from a fancy Manhattan neighborhood, with prices to match. Investigating, I went in and had a coffee, watching the customers. Two middle-class thirty-something dads caught my eye. Each had a five-year-old daughter for whom they were buying an after-school snack, each showing their children the entire selection and asking them to choose: An éclair, a tart, a madeleine? Standing on line, the dads began to talk about the bakery: "You like this place?" asked one. "We've *needed* this place," the other vehemently confirmed.

In Mosswood in the early 2000s, the redlining of the neighborhood could still be clearly felt. The residential areas to the west of Telegraph Avenue remained primarily Black, and the residential areas to the east of Broadway remained primarily white, leaving the triangle of Mosswood in the middle to a working and middle-class mix of Black, Italian, Eritrean, Ethiopian, Indian, Korean, and new white residents. Mosswood was in flux between new immigration, recent gentrification, and recovering from the disinvestment of Oakland at large. While I photographed on Fortieth Street one afternoon, someone warned me, "You're going to have to have one of those infrared cameras. At night. That's when things happen." Yet Marty was hopeful that there were improvements happening for the people who had stuck it out: "I'm optimistic, for the first time since these freeways destroyed everything, and took out all the infrastructure." But at a Mosswood block association meeting in 2006, I heard about crime and garage sales, and one woman longed for Mosswood to emulate the upper-middle-class neighborhood to the north, asking the city council representative, "What do we have to do to make it more like Rockridge?" One

neighbor looked at a photograph I'd made of a recently opened café with a toddler play area and had a strong reaction to the neighborhood future it foretold: "In my opinion—it's the face of gentrification if ever there was. 'We're white, we're rich, and we're here to stay.'"

** **

In 2007, the city of Oakland proposed a high-density housing development on the sprawling parking lot of the MacArthur Bay Area Rapid Transit (BART) station: it would have 880 total units, of which 143 would have rents below market rate. Neighborhood residents celebrated the possibility of new housing but were concerned about the scale.[22] The following year, the subprime mortgage disaster precipitated an enormous housing crisis across the country and in both of these neighborhoods, but particularly in Oakland where more people owned and lost their homes. With the loss of housing came corporate entities that bought and flipped foreclosed homes. The second (and third) dot-com bubble sent rents and house prices skyrocketing, lining some people's pockets even as many others were losing their homes. By 2010, the eviction crisis in Oakland was so extreme that a mapping project was started to keep track of the fight.[23] Five years later, the think tank PolicyLink described the depth of Oakland's housing crisis, stating that "the majority of current Oakland residents could not afford to rent or purchase homes at the current prices in their neighborhoods . . . [so that] when Oakland families lose their existing housing to foreclosure, eviction, or other measures, they are unlikely to be able to afford to stay in their neighborhood or even in Oakland."[24] By 2016, Oakland's median monthly rent was $2,280 for a one-bedroom apartment; the average two bedroom was $2,600 a month.[25] Impossibly, Brooklyn's average rent was similar that year—$2,666—a truly radical departure for Oakland, which had never had rents anywhere close to New York's.[26] Rents in Oakland had increased 25 percent in just one year from 2015 to 2016.[27] Oakland was the fourth most expensive housing market in the country, with the fastest rising rents, with potentially the worst affordability crisis—as rents rose much faster than incomes.[28]

In 2019, the development on the BART parking lot opened, more than ten years after it was first proposed. The MacArthur Transit Village included one fully affordable building, the Mural, as well as two buildings (one a twenty-four-story, 260-foot tower three times taller than the other structures) of primarily market-rate—which by this point meant *luxury*—apartments, in which two-bedroom

apartments rented for between $3,500 to $5,500 a month.[29] The neighborhood had also struggled with a controversial twenty-five-story tower and parking structure expansion of the Kaiser hospital complex, which due to community activism ended up smaller than planned.[30]

In the same period, predatory lending, predatory purchasing, and evictions were taking a toll on Brooklyn too. My colleague Walis Johnson, in her work on walking and redlining, writes about the stunningly banal violence of a handwritten note she got under the door of her family's home in Bed-Stuy—not far from Prospect Heights—the day after her mother passed away. It read, "I am interested in buying your building I will pay cash now or in the future please give me a call if you ready to sell 646-400-9362 Todd."[31] Much the same thing was happening in Prospect Heights; a few years later, Mike would reflect, "The neighborhood was so small and everybody knew everybody. Now, new people are coming in and all the old people are being uprooted. One thing I couldn't stand was big companies coming in and offering old ladies I've known for twenty-three years, offering them a million dollars for a three-million-dollar property."

In the ten years from 2009 to 2019, the median rent for a two-bedroom apartment in Brooklyn increased by 23.7 percent. Within the already overheated Brooklyn housing market, Prospect Heights struggled with an accelerated gentrification. This was in part spurred by the huge Atlantic Yards development, which broke ground in 2010 after years of community protests; by the time of this book's completion in 2024, twenty years after the project was first proposed, only half of the planned 6,430 units of housing had been completed and its latest developer had defaulted on its loans.[32] The Barclays Center, for the Brooklyn (formerly New Jersey) Nets basketball team, was completed in 2012 and provided almost none of the economic boost to local businesses that its developers had promised—hardly a surprise since an enormous body of research shows that arenas and stadiums are almost never beneficial to local communities and are, if anything, actively detrimental.[33] As a bulwark against further large-scale development, in 2009 activists had tried, and succeeded in part, to landmark portions of the neighborhood.[34]

The planned luxury housing at the neighborhood's edge in what was now being called "Pacific Park" (no longer "Atlantic Yards") meant that landlords across Prospect Heights—beyond the development—began charging more for both residential and commercial rents, sometimes even preferring to keep storefronts vacant until the dreamed-of big spenders would arrive. In a country where there are few residential or small business rental protections, these are the domino effects of even the

suggestion of large-scale luxury development, even when they include a percentage of "affordable" units; these effects have been clearly seen across New York City, from Prospect Heights to the Lower East Side to the South Bronx.[35] By 2022, Oakland and Brooklyn were still on the top ten list of the most expensive places to rent in the country, with Brooklyn near the top of that list (the median one-bedroom in Prospect Heights itself was $4,295 a month) and Oakland at the other end.[36]

INTERSECTION | PROSPECT HEIGHTS

Having moved back from Oakland to a different New York City neighborhood in 2007, the guided tours stories and images had become my mental image of Prospect Heights, frozen in time. One day in 2014, my friend Emily and I reconvened in the beloved neighborhood we had both left and hadn't been back to for several years. When I got out of the train, walked up Park Place, and turned onto Vanderbilt Avenue, I felt like I'd been shoved. Hard. I stopped dead in the middle of the sidewalk. The neighborhood was dramatically changed. All the things we had feared had come true; gentrification and displacement were stark and unfettered. That giant development at the edge of the neighborhood, speculative development, and smaller-scale gentrification in a wild housing market had all wrought unbelievable change. Of course, I had heard the conversations about Brooklyn (and about the Lower East Side, where I had been working more recently) in regard to the many things that fall under the heading of *gentrification*. I had been frustrated, and then enraged, by the way the language used was vague, deterministic, and inaccurate—framing the losses that come with "neighborhood change" as regrettable but inevitable, even "natural," as though some people's lives just aren't as important as others.

My gut reaction wasn't wrong. There had been very significant demographic change to match the visible change to the streetscape. Within a population that had grown in size by fewer than one thousand people, the percentage of Black residents in the neighborhood had dropped by almost half, and the percentage of households making over $100,000 a year had more than tripled.[37] Clearly, though the population size was the same, the people who made up that population were not. In 2023, the *New York Times* would notice this trend and be shocked to realize that the city's total Black population had declined by two hundred thousand people over two decades, publishing an article titled "Why Black Families Are Leaving New York, and What It Means for the City."[38] And what was happening in Mosswood was similar: while in 2000 over half the residents were Black, by 2013 only a third of the neighborhood was.[39]

I continued down the street, and as I did, a plan began to form in my mind. I realized I had an archive of photographs and oral histories that could help people understand what had been lost—and what there still was to lose (or protect): physical places, but also experiences, and senses of connection and belonging. As a public artist, I could make a place for casual talk about big issues, a place like the many that this neighborhood had once provided for my tour guides and I, and which, as I walked along, I increasingly found to be missing.

But how to make a place? This was a moment when much was at stake, and a public version of the guided tours was needed. I began to think about how to take everything I'd learned in Brooklyn and Oakland about fostering dialogue and make something from it. I thought about the creative practices I'd always argued were valuable ways to learn about our world, and how those same approaches might support groups of people in learning about themselves and each other, in the context of neighborhood. I thought about how my creative practice could foster new places in which essential everyday conversations could happen.

The guided tours had changed my life in so many ways—starting with changing my experience of my own neighborhood. Even from my very first walks with Neville, Mike, and Tanya, the neighborhood of Prospect Heights had seemed to fill with an enriching cacophony of other people's histories, needs, desires, and hopes. My own landmarks were transformed: a trip to the supermarket was no longer the same, nor was the unassuming building in which we lived; that walk back to Prospect Heights on September 11, 2001, became intertwined with neighbors' memories of the view from Brooklyn. All the guided tours on both coasts had allowed me to realize how much I didn't know, how much other people were carrying, how much we were different, and in what surprising ways we might be the same. Taken together, these tours had changed my experience of *every* neighborhood, and I thought they might be able to do the same for other people too.

Along with the neighborhood, the reason to share my tour guides' stories had shifted. In the face of so much change, I realized that these stories could also help people get a hold on the kind of change that is both so quick and so long term that it is slippery. You notice the day a store closes or someone loses their apartment, but you haven't seen the patterns leading up to it. If you notice the changes today, you may have forgotten, or you never saw, the changes ten years ago. I wanted to use the not-too-distant past of ten to fifteen years earlier as a way to help people reflect on what they were living through, on what decisions had been made to make it so, who benefited, and how we all might want to behave for the future. Most important, I

wanted to make space for more specific, grounded, and nuanced conversations that called attention to real experiences of what is valued and what can be lost.

About half of my original tour guides were no longer in the neighborhood—displaced one way or another. Those who remained were largely people who owned their apartments. About half, or more, of the places they had taken me to were no longer there. It was dramatic to walk past a shiny high-end nail salon and remember the gatherings of a small group of West Indian men that had happened each week on that site. I wanted others to experience this disjunction that sparked important kinds of reflection in my own mind. I also remembered how powerful it had often been for my tour guides themselves to look at the photographs I had taken of their familiar places—how it helped them still time, hold on to moments, clarify, critique, and even talk about what really mattered. I wondered if these photographs could now do that for other people, in this moment when holding on, grappling with what was happening, saying things out loud was so important.

I wanted to hear the stories brought back to this place too. I'd listened to the interviews and looked at these photographs so often that I knew them inside out. These voices echoed in my head as I walked around, baffled by the neighborhood that no longer fit the narratives. I wanted to bring those voices back to the places for other people—I had originally heard these stories in place and I wanted to re-emplace them.

For years, I'd toyed with the idea of audio tours, digital tours, stories pushed to your mobile phone so you couldn't escape from them. Early on, my partner Kaushik and I had made an experimental DVD of stories and images from Prospect Heights, with a video menu to select a street to "walk down." But in the end, the project we'd make, *Intersection / Prospect Heights*, would be about exchange and connection, to facilitate community, not to encourage more atomized people to be plugged into their own devices. More than anything, I wanted this project to be approachable, to honor and care for the stories people had told me, stories I had been holding and cherishing for so long.

It was important to partner with people in the neighborhood already doing this work. I reconnected with local organizers in the Prospect Heights Neighborhood Development Council (PHNDC), a group I had worked with in the early days of their opposition to the Atlantic Yards project in 2004—when they had screened some of my images and audio recordings at the beginning of their very first community meeting.[40] We talked about what this project could do to forward the work of holding developers accountable, of helping people know what was happening in their

neighborhood, of making opportunities for both current and former residents to talk with each other. I also partnered with Brooklyn Public Library's main branch at Grand Army Plaza, which had been running a series of events about gentrification but had not yet done anything about the neighborhood immediately surrounding the main branch itself and had never done anything that brought the conversations out into the community and then back into the library. We all came to the work for different though related reasons, with different individual goals it would help us fulfill.

I set out to develop a space made from temporary connection, and thought about how the project could spark dialogue on three levels: First, within people's own minds, an intimate way they might even admit things they usually wouldn't to themselves. Second, a conversation with their neighbors. And third, a conversation with politicians, with the politics of the moment. To do this, I wanted to give people something to respond to, to be that instigator, that facilitator, to provide that straw man of stories that sometimes helps people share their own.

I created a series of guidebooks and creative walks to interrupt the anonymity and passivity surrounding conversations on gentrification by grounding them in individual stories from my Brooklyn tours. These funny, serious, surprising, human stories articulated the value of places that had been or could be lost. Six different "guidebooks" to Prospect Heights told six different people's stories of three places each—in different colors, so you could collect the set. I installed them in mini-exhibitions at businesses and organizations throughout the neighborhood: next to the beer at Met Food supermarket, on the counter at the dry cleaners, on the bar in a hip new restaurant, in the entryway of a long-time Dominican restaurant, in departments all over the huge main branch of Brooklyn Public Library. PHNDC's relationships with local businesses made it possible to have such a broad network of people who were enthusiastic about hosting the project and looking after it while it was in their space. Each of these sites hosted large-scale images of the neighborhood, copies of two or three of the guidebooks for people to take home, and cards, pencils, and a collection box for people to contribute their own stories.

Two months before we launched the project, Mike's diner, the Usual—formerly called George's after the two Greek men named George who had previously run the place—closed. The one place I had always imagined as the centerpiece of the project was no more, making the need to create spaces for conversation seem all the more pressing, and leaving a big hole in my heart about the whole thing.

The *Intersection | Prospect Heights* guides
installed in one of their most popular
locations, at Met Food, next to the beer.

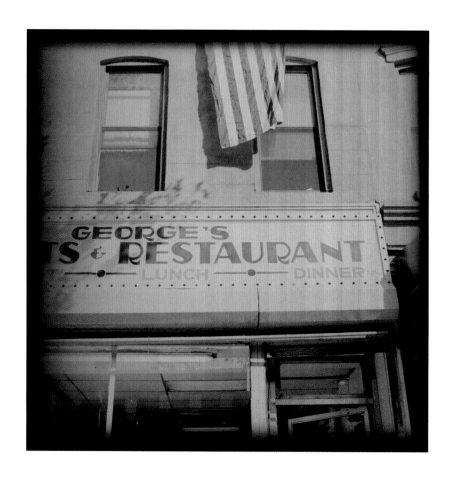

George's Donuts & Restaurant, 2000.

⁕⁕

These guidebooks and photographs, mysteriously popping up everywhere, were accompanied by a series of creative walking tours that I hosted for a year from 2015 to 2016. The routes of the walks echoed my tour guides' original tours, stopped at the places they'd taken me to, and involved tour participants reading out loud from my original tour guides' stories when we were in their places. In asking people to literally put themselves in other people's places, and to honor and repeat their stories, these tours built on the ways that walks have so often been part of both cultural reproduction and resistance. I thought a great deal about what allows walks to happen, thinking of anthropologist Emanuela Guano's description of how the essential Genoese *passegiata*, which itself does so much work to create culture, can only happen through spaces that support it.[41] Like the *passegiata*, other ritualized walks also create culture through practice. Anthropologist John Gray writes about how Scottish border hill shepherds keep their culture and identity through daily walks of their land. And Raja Shehadeh's beautiful *Palestininan Walks* has long been a touchstone in my thinking about walks within a changing geography. His chronicle of his own and others' ordinary and extraordinary walks over twenty-six years across the increasingly bounded, surveilled, and controlled lands of Palestine shows walks as practices of personal joy and of political action by insisting on the country's very existence, always with the tension of time and impending loss: "All my life I have lived in houses that overloook the Ramallah hills. I have related to them like my own private backyard, whether for walks, picnics or flower-picking expeditions. I have watched their changing colors during the day and over the seasons, as well as during an unending sequence of wars."[42]

In the structure I created for the *Intersection | Prospect Heights* walks, voice was important, and empathy was crucial. Each tour began at the Met Food supermarket, whose owners hosted us with exactly the kind of care and embrace that had made so many of my tour guides take me there in the first place. Each person on the walk received one guidebook, which really meant they held one person's stories, of which they were now the temporary guardian. As we walked to sites around the neighborhood, I would ask people to read the story they held about the place we had stopped in front of. Sometimes that place was still there, most often it was not, and they held up the photograph in their guidebook as a way for us to see what was now missing. Each person read out loud someone else's words, everyone genuinely giving care to what it means to read someone else's story—by turns laughing, crying, stunned,

fascinated. Many participants came to the tour with moderate interest, and left feeling moved in ways they hadn't expected. On many walks, one of my original tour guides would join us, sometimes reading aloud from their own guidebook, remembering the stories they had told and reflecting on them. One participant, Marci, wrote about the project later:

The walk I went on taught me about the history of a neighborhood that I didn't know, and from face-to-face encounters with articulate residents arranged by Gabrielle, alerted me to how people and places have interacted there to create community and civic life. I also witnessed how a relatively simple strategy employed by Gabrielle—having us read aloud from oral history excerpts while standing in front of the place being discussed—created a bond among those of us on the walk, and between us and the residents she had interviewed. Speaking their words rendered their testimonies more meaningful and memorable, and drove home the experiences of gentrification and displacement that underlay their comments.[43]

The tours were accompanied by public events at the library—story circles, oral history listening parties, events with the original tour guides, and discussions with activists and elected officials reflecting on the tours in the context of gentrification, large-scale development and rezoning, and housing and small business precarity around the city.[44] At the end of every tour and every event, participants could contribute their own stories to the project, through oral history recording sessions where neighbors interviewed neighbors, or through writing their stories on cards to become part of the project. All of these stories became part of a new oral history archive that lives in the *Intersection | Prospect Heights* collection at Brooklyn Public Library, and you will read some of these stories throughout this book.

People had so much to say, to each other on the tours, in our public events, in their oral histories. Most of the original Prospect Heights stories had been told to me before debate around, and the development of, Atlantic Yards and certainly before the large new development renamed Pacific Park actually started rising. They were told before wholesale purchase of property and violent evictions of residents in nearby Crown Heights and Bed-Stuy became commonplace. They were told before the majority of mayor Mike Bloomberg's incentives for large-scale development took effect and before the de Blasio mayoral administration's proposals for neighborhood rezonings across the city. Yet the project was about all of these, just as it was about creating opportunities to share similar or distinct experiences from other neighborhoods, and about imagining better futures for us all.

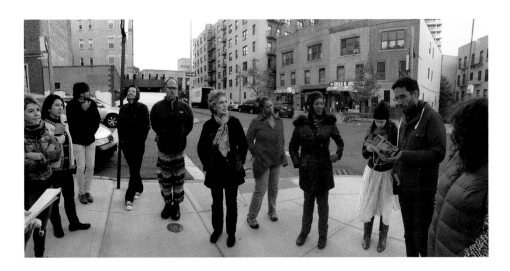

On an *Intersection | Prospect Heights* guided tour, one participant reads from the guidebook he carries, while everyone learns one of the meanings of this corner.

All six *Intersection | Prospect Heights* guidebooks.

Images overleaf: From Tanya's guidebook, from Neville's guidebook, and from David's guidebook. The 2016 guidebook collected old and new stories and photographs together.

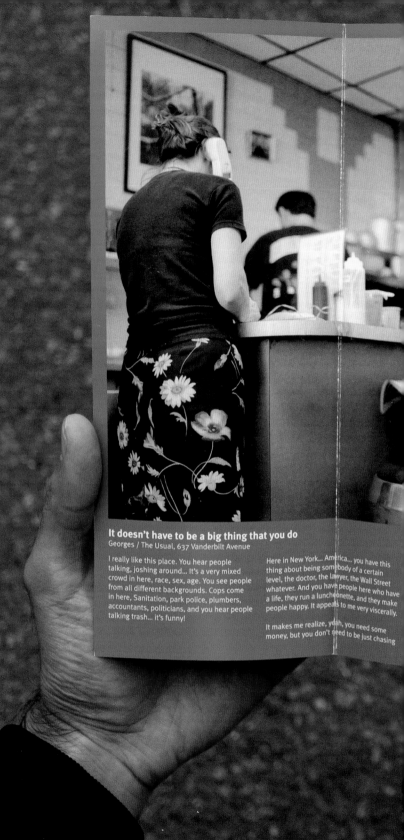

It doesn't have to be a big thing that you do
Georges / The Usual, 637 Vanderbilt Avenue

I really like this place. You hear people talking, joshing around... It's a very mixed crowd in here, race, sex, age. You see people from all different backgrounds. Cops come in here, Sanitation, park police, plumbers, accountants, politicians, and you hear people talking trash... it's funny!

Here in New York... America... you have this thing about being somebody of a certain level, the doctor, the lawyer, the Wall Street whatever. And you have people here who have a life, they run a luncheonette, and they make people happy. It appeals to me very viscerally.

It makes me realize, yeah, you need some money, but you don't need to be just chasing

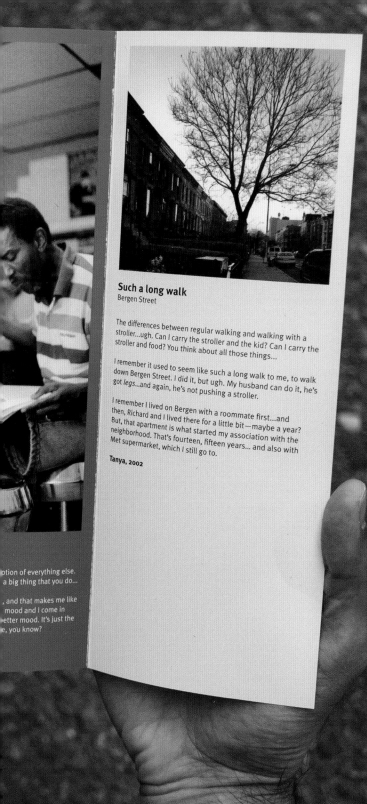

Such a long walk
Bergen Street

The differences between regular walking and walking with a stroller...ugh. Can I carry the stroller and the kid? Can I carry the stroller and food? You think about all those things...

I remember it used to seem like such a long walk to me, to walk down Bergen Street. I did it, but ugh. My husband can do it, he's got *legs*...and again, he's not pushing a stroller.

I remember I lived on Bergen with a roommate first...and then, Richard and I lived there for a little bit—maybe a year? But, that apartment is what started my association with the neighborhood. That's fourteen, fifteen years... and also with Met supermarket, which I still go to.

Tanya, 2002

ption of everything else.
a big thing that you do...

, and that makes me like
mood and I come in
etter mood. It's just the
e, you know?

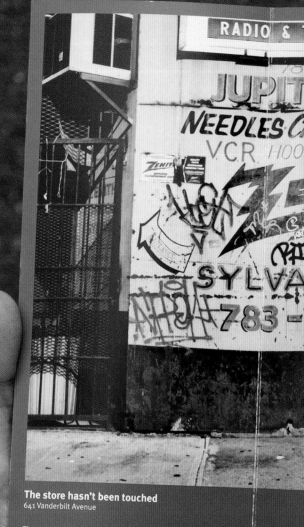

The store hasn't been touched
641 Vanderbilt Avenue

The man who owned this place was one of my best friends—he was in the electronics business like me—but he died a few years ago. Before he died, all his friends—he was a cricketer in the West Indies, and his friends were his old cricketers—we used to get together on Thursday afternoons in the back of the shop, and have a big party, food, drinking, eating. Even now, although the is boarded up, it's still the same inside, a the screws, nuts and bolts on the shelves untouched. Every Thursday, like today, w have the party.

He went to the hospital for a check-up and found something. When they operated, he c

't been touched.
ng, I'm short of anything,
ng it, I get it from him.

My building was abandoned
Vanderbilt Avenue

I went into Vanderbilt Avenue when most of the buildings were abandoned. And I was there until now. My building was abandoned. You couldn't walk up the front stairs. When I moved over I set up a darkroom and I started to do photography.

About twenty-four years I was there. I had the second floor and the store. I bought the building because of the store. I wanted to have a business of my own.

My trust in people is why I'm out of the building. I shipped merchandise down to the West Indies, but they didn't send the money back. I had the building all paid up, but I had a small commercial loan on the building.

I would still have it if I hadn't been introduced to a company that helped people in financial problems. They were a fraud. They said they'd do the work I needed and then hand the building over to me. They didn't do anything, and the bank foreclosed on them. That's why I'm out of Vanderbilt Avenue, and all my stock is in the dumpster.

It's a long story, and it makes me sick. My kids said look, let it go.

Now I'm in East New York. My wife just told me that the owner wants a rent increase already! Not even a year. I have to look for some place.

Nothing has really changed with this neighborhood.
But as time goes on, you know it will.

Neville, 2001

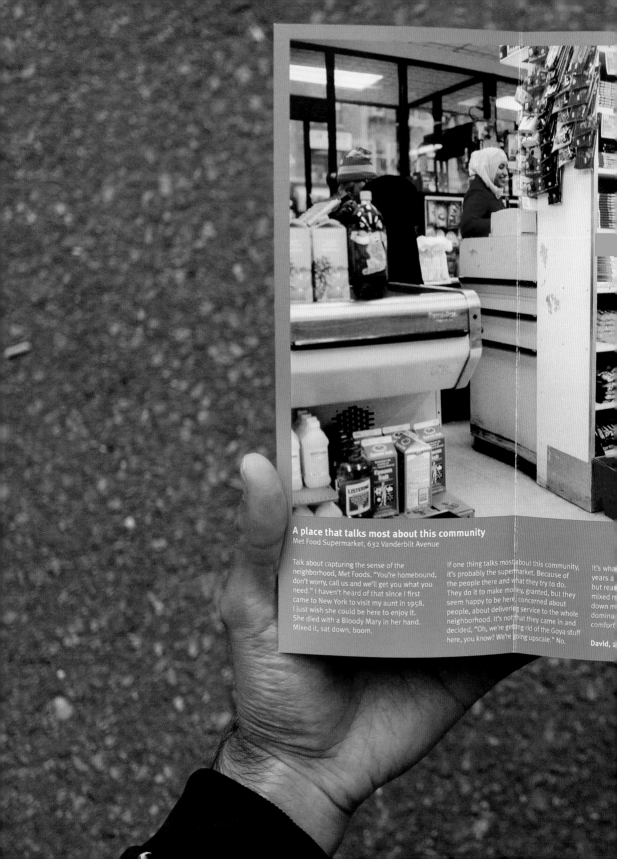

A place that talks most about this community
Met Food Supermarket, 632 Vanderbilt Avenue

Talk about capturing the sense of the neighborhood, Met Foods. "You're homebound, don't worry, call us and we'll get you what you need." I haven't heard of that since I first came to New York to visit my aunt in 1958. I just wish she could be here to enjoy it. She died with a Bloody Mary in her hand. Mixed it, sat down, boom.

If one thing talks most about this community, it's probably the supermarket. Because of the people there and what they try to do. They do it to make money, granted, but they seem happy to be here, concerned about people, about delivering service to the whole neighborhood. It's not that they came in and decided, "Oh, we're getting rid of the Goya stuff here, you know? We're going upscale." No.

It's wha
years a
but rea
mixed n
down m
domina
comfort

David,

This was heaven
Park Place

We went down to Underhill and turned down Park and that's where it all began to happen. We found a house. I became a father. It was just that quick.

There was this Volkswagen bug driving up the block with four women in it. They honked the horn and yelled out the window, "You looking for a house?" This was Laurie Guilford, who knew everyone on the block.

She dragged us down here and said this house is available. And true, it was available. It had been on the market for two years, two sales had fallen through. We came back the next day and went through it. It was as if the woman still lived there. Everything she had owned was where she had left it.

She died when she was eighty-nine, Pearl P. Jefferson. This was heaven to her. She had worked hard her whole life to get something together, and she got it here, thanks to an insurance policy from a son who didn't make it out of a knife fight on the streets of Newark. She bought this house and this was it. She lived here the last fifteen years of her life.

In this picture is a little piece of wood that's blocking the air vent under the stoop. I had the original ironwork in there, and it was rotting out. One day, my neighbor saw me looking at it and said, you really have to cover that up. And he didn't just say that. He went back to his house, cut a piece of wood, came back, and screwed the thing in. He had the tools and the inclination, and he just did it. It's nice to know people will turn out like that for you.

David, 2003

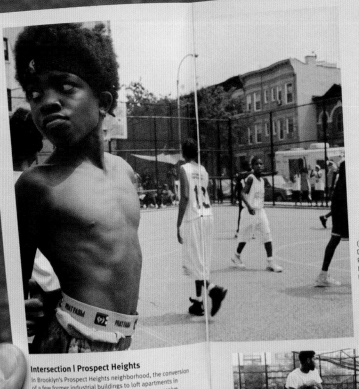

(left)
Dean Street
Park, Conrad
McRae Youth
League, 2001

(below)
Dean
Street Park,
Construction
workers on
break, 2016

Intersection | Prospect Heights

In Brooklyn's Prospect Heights neighborhood, the conversion of a few former industrial buildings to loft apartments in 1999 was followed by the announcement of the massive Atlantic Yards project in 2003, which in turn led to a dramatic increase in commercial and residential rents and an accelerated displacement of residents and businesses.

These forces are also faced by many other neighborhoods. Exposing change through individual stories, images, demographic data and public opinion research we hope the *Intersection | Prospect Heights* project provides insight into how rapid change driven by development has affected a diverse community and what hopes its members hold for its future. Can learning from Prospect Heights foster more nuanced and critical conversations on development, displacement and sustainability in the city?

Gabrielle Bendiner-Viani and Gib Veconi
May 2016

During the fifteen years of work in Brooklyn and Oakland that I began in 2001, I learned a great deal about place and its sustaining capacity. Through that time, I also saw the housing crisis worsening across the country and witnessed the threats to small businesses and other places that hold communities together. I saw these things everywhere, but I understood their impact most deeply in these two neighborhoods I'd looked at so closely and through the conversations that *Intersection | Prospect Heights* had allowed me to have. I always knew what my tour guides had talked about was important, that they'd told me incredibly valuable things about what places have the capacity to do—but I didn't know exactly what they meant until much later, when I couldn't go anywhere but the rooms of my own apartment.

I began shaping this book in earnest in 2020 in the midst of the coronavirus pandemic. One day in April that year, about a month into lockdown in New York City in my Washington Heights neighborhood, I realized that one strong feeling I had about the pandemic was grief—for lives lost, but also for the sustaining nature of our everyday lives and negotiations, those things enabled by these places I'd been so fascinated by for so long. I was taking one of the walks that sustained me in that time; as a parent of a young child, I was having rare time alone as well as rare time observing the few other people on the street. Avoiding each other nervously, not even daring to look at each other, it seemed as though we feared that even eye contact could transmit disease.

As I walked up a street I had walked thousands of times, I thought about how different this experience was from other parts of my work. I had spent ten years studying displacement, demolition, and urban renewal on the Lower East Side, grappling with the psychological impact of a neighborhood's becoming unrecognizably altered so that people cannot return to the physical spaces that once sheltered their lives. That work had seen trauma, and what psychologist Mindy Fullilove has called *root shock*, but it had also seen resilience through activism spurred by the goal of making concrete change. As I looked around on my walk, I saw that this was different. Our familiar sidewalks and buildings were all still there; they hadn't been demolished, it was just that the things that we did inside all of these spaces—and the people we did them with—were not there.

The events of 9/11 had spurred me almost twenty years earlier to talk with my neighbors to try to understand who we were. When I heard poet and performer Sekou Sundiata explain why he began his extraordinary collaborative theater work

The America Project in that post-9/11 period as well, it helped me understand my own impulses. Sundiata had said, "Those events triggered a running commentary, an unsettling conversation with myself to understand what it means to be an American. I knew right away that the world had changed in ways that would challenge much of how I understood my life and work up to that point."[45]

Almost twenty years later, the pandemic was like a laser, bringing me back to the heart of my guided tours project, teaching me what was at stake in our everyday places, in what had been made visible by those tours people had taken me on. It was crystal clear that the work places did for us was existential, was about creating our very senses of self, as well as our capacity to be with, to talk with, each other—even when we hardly knew each other's names. In lockdown, sustaining ourselves in our apartments and houses felt wrong; these guided tours from years earlier reminded me exactly *why* it felt so wrong. These small interactions are the things I've always seen as valuable. In the midst of the pandemic, I didn't know if we'd lost them. I didn't know if people even realized what was missing. What everyone who'd ever given me a guided tour had said about place mattered so very much.

**

The day after those realizations in 2020, I got sick with COVID-19. By the time my family and I were better a month later, in a city reeling from the disproportionate toll the disease had taken on Black and brown communities, reeling from the disease's death toll in America in less than three months—the highest of any country at that point—and wondering what life might look like in the future, police in Minneapolis murdered a Black man named George Floyd. In New York City, on that same May day, a white woman named Amy Cooper was asked by a Black birdwatcher, Christian Cooper, to follow Central Park rules and leash her dog. She responded by saying she'd call the cops and tell them "an African American man" was threatening her life—which, performing deadly whiteness, she did. Both of these events were filmed and led to long-lasting protests—when I began writing this introduction, nineteen days of protest, and when I edited it the first time, more than one hundred—on behalf of Black lives. These protests came not just in response to George Floyd's murder but in the wake of that year's March 13 murder by police of Breonna Taylor in Louisville, Kentucky, as she slept in her home, mistaken for someone else, and the murder of Ahmaud Arbery just a few weeks earlier in February, shot and killed in Georgia by neighbors as he was jogging.

I spent one week in June writing a first draft of this introduction, and the brutality in that short time was staggering. On June 9, two Black trans women were murdered—Dominique Rem'mie Fells in Philadelphia, Pennsylvania, and Riah Milton in Ohio. Three days later, Rayshard Brooks was murdered by police in a Wendy's parking lot in Atlanta, Georgia. On August 23, Jacob Blake was shot seven times in the back by police in front of his three children in his home in Kenosha, Wisconsin, paralyzing him from the waist down. On August 25, a white teenager, Kyle Rittenhouse, who had traveled across state lines with an automatic weapon, killed two people, and wounded another at a protest for racial justice sparked by the shooting of Jacob Blake. In November 2021, he would be acquitted of all charges. The list of people is now so much longer, and will be longer still by the time you read this. This violence is happening in public and in private, in places where people should be safe, in places where people should be able to negotiate, to talk, in places where people should be able to see each other as neighbors. Rooted in violent spatial histories, this violence is now part of our everyday places in ways that signal a real crisis in society.

I began this introduction in 2020, before 2021's January 6 insurrection at the US Capitol and the subsequent year of ever-deepening divisions in America, and internationally—over masks, then vaccine mandates, racial justice, and just about everything else. As 2021, 2022, 2023, and 2024 roll on, we appear genuinely not to be able to talk with each other at all. COVID exposed the cracks, deep injustices, and failures of our society that have been there all along. But it also has something to teach us about being in a society at all. Writing for *Slate* in mid-June of 2020, social justice journalist Steven Thrasher put it succinctly: "Viruses can be very dangerous. But they are good at exposing the myth that we live as discrete individuals."[46]

We are at the beginning of a new chapter of American reckoning with the country's founding on the tenets of racism, a reckoning that needs to be sustained. This reckoning is going to be long-term work, far beyond the incredible work of protests. It's going to require negotiation, real coming to terms with the existence and impact of white supremacy. If we are to move forward, it's going to require that we all build and exercise a capacity to talk about race and history, so that we can all get free.

And we need big spaces and small in which those conversations can happen.

The need for making our worlds together, building a shared consciousness, navigating being strangers through a banter that sometimes rises to the level of dialogue, and even collective action, is what I began learning twenty years ago from my tour guides. It is only now that I have come to understand how much was at stake in their teaching.

1

PLACEWORK

Early on in my work in Oakland and Brooklyn, someone challenged what might be the purpose of knowing about everydayness, asking, To what *use* could this project be put? Thinking of the then-recent losses in New Orleans in the wake of 2005's Hurricane Katrina, I answered that if you understood everyday life and you understood how a place functioned, how it *worked*, then if some sort of natural disaster occurred, you would know how to rebuild, you would know what was missing in the wake of that disaster. In the subsequent years, I mulled over this question of the "use" or "purpose" of this work—sometimes rejecting it outright, sometimes allowing it to spark new questions.

When I returned to Prospect Heights in 2014 and was inspired to create the *Intersection | Prospect Heights* public art and dialogue project from these guided tours, it was because I realized that a natural disaster hadn't happened, but a man-made one had. I saw the damage wrought by the gentrification accelerated by Atlantic Yards and the Barclays Center arena, that large-scale development at the edge of the neighborhood. New expensive infill development and higher residential and commercial rents had arrived, with people who could pay and in preparation for even wealthier people landlords imagined would arrive once the development was finished. Many of the small businesses my tour guides had taken me to were vulnerable and priced out as their rents were raised. Sometimes those storefronts were then kept empty, waiting for luxury businesses who would pay top dollar. Many things that were special to people about the neighborhood were at risk.

In 2020, I realized that the next in these waves of crises, these natural and man-made disasters, was the pandemic that held us six feet apart for over a year. Recovering from this crisis would necessitate remembering and supporting the places in which the crucial and easily overlooked everyday interactions that help us be together happen. To do so, it is necessary to be able to name what they do: *placework*.

EVERYDAY PLACEWORK: BECOMING ONESELF, BECOMING COMMUNITY

The everyday is tricky to write about because it can feel both incredibly boring and unbearably illuminating. While it can seem like nothing happens, in fact, everyday places and their people change all the time; as geographer Allan Pred has eloquently written, they are "ever-becoming."[1] Placework is a way to understand the many ways we are all in flux, becoming in and with places over time.

Placework is the dynamic, reciprocal work that everyday places do for and with individuals and communities, enabling us to grow into being ourselves, and enabling us to be together. By doing these two things—helping us become ourselves, helping us become communities—these places do nothing short of creating the conditions for a functional society. Without places that do this kind of work, our lives are at best hollow and two-dimensional; at worst, they are filled with violence.

This is a book about the work places do to support our becoming: our becoming ourselves, and our becoming communities—or if not communities, at least becoming able to be together. Becoming themselves was what David told me about at the supermarket, Tanya at the diner, Cynthia in front of her house, and Marty on neighborhood streets. It is intensely personal work that happens in public; places can help our bodies feel free and can also shape the way we feel we belong.

Becoming community—being together with strangers—was what I heard from Tewolde in the donut shop, Neville in the electronics store, Julia at the fence. I could see how their places fostered two crucial kinds of talk: the casual but humanity-acknowledging qualities of everyday banter, and the enduring talk that grows over weeks, over years, that builds on trust, and might eventually change everything.

In this book, my tour guides in Brooklyn and Oakland take us on walks through places that do each of these kinds of work. They notice what is usually taken for granted, talking about the placework in their two somewhat unremarkable—though beloved—neighborhoods, but of course it happens in many cities and towns—probably some you know well.

In both Mosswood and Prospect Heights, there were massive forces and histories at work, pushing and pulling the everyday spaces of the neighborhoods, as they have pushed and pulled places in your own city or town. As we walked, my tour guides expressed what it was like for them to live in their neighborhoods, how they built a sense of themselves as residents, and what memories were evoked by the places we passed by, making clear how space is never fixed and is always socially produced. As structural theorists from Henri Lefebvre to Manuel Castells have written, individuals are shaped by culture, as, in turn, culture and its spaces are shaped by individuals.[2] Researchers and artists have explored how people connect to many kinds of places in their everyday lives: from homes to disparate spaces such as laundromats, barbershops, and schools to plazas and piazzas, markets, and public parks; from sites of local history, and entire neighborhoods, extant and destroyed, to national monuments and many more.[3] These places' meanings are relational—and help us figure out how we relate to worlds far beyond our everyday. "Oh, I see!" Cynthia in Mosswood exclaimed as we talked about why I was asking for her tour of the neighborhood. Echoing what sociologist Doreen Massey called "the global sense of the local," Cynthia proceeded to find the most eloquent way of describing this project: "It's how people fit the big world into their small worlds."[4]

<p style="text-align:center">**</p>

At the same time that I was doing these tours—and learning the important work that everyday neighborhood places did—I was also doing work with residents of unique affordable housing developments in New York City, doing tours with people inside their own apartments to understand where and how people were able to really inhabit their homes, how their homes helped them be themselves, what it felt like to *dwell* not just to have a roof over their heads. I was making photographs of their important places within their apartments, focusing on a chair where a resident said the sunlight fell just so first thing in the morning, or the nook another resident had set up for her son to read in, or the innovative way someone else had made space for a table large enough to seat their extended family.[5] My collaborator on this project, environmental psychologist Susan Saegert, defines *dwelling* as "an active making of a place for ourselves in time and space . . . the most intimate of relationships with the environment."[6] And I found that intimacy in both home spaces and neighborhood spaces. There was both vulnerability and action when my tour guides

in Brooklyn, Oakland, and in apartments across New York City talked about making home, and this word, *dwelling*, and the idea of *inhabiting* kept coming to mind: a cyclical relationship of place and well-being as deeply intertwined and made together.[7] I was grounded by the idea of a give-and-take between people and place, epitomized by Wright Morris's evocative photo-novel *The Inhabitants*, which helped me think about telling these stories with pictures and words.

Noticing the similarities between what was happening in people's apartments and in the ordinary neighborhood spaces that filled people's tours—it seemed important to think more about how these could all be places of dwelling. I could intensely feel the reality of Fullilove's assertion that "buildings and neighborhoods and nations are insinuated into us by life; we are not, as we like to think, independent of them."[8] Philosopher Martin Heidegger's suggestion that architecture fosters dwelling when it creates and joins meaningful spaces—or *locales*—which "shelter or house men's lives" stuck in my mind; that a place could "shelter" a person's life took root in the way I thought about all spaces. [9] Yet I remained circumspect, as too often this word dwelling gets connected with a rustic authenticity, suggesting that modern life makes dwelling impossible—or that modern people have forgotten *how* to dwell.[10] But modern people *do* dwell, in both cities and rural places, as many other writers have since explored.[11] We can see it in all these places my tour guides took me to—in places that are not obviously connected to the land, but certainly build connection between meaningful places. We make our worlds by inhabiting our places, by dwelling in them. And places do a powerful work, when they let us dwell.

NICE WORK IF YOU CAN GET IT

With all this talk about places and the work they do, we also need to think about the intense work that people do to create and protect places—the housing activists, the community gardeners, the small business owners, the neighbors. This work to create and protect places can look like lots of things: physical labor, the labor of building community, the labor of caring enough to argue, to talk, to listen, to show up regularly. The labor of making something new from what you have. The labor of taking care of others. The amount of work people do to create the places we inhabit every day is extraordinary.

We live most of our lives within what planning historian Margaret Crawford calls *everyday urbanism*, which is where people enact radical, necessary, creative,

and everyday actions that shape place.[12] When people reshape their places through their own cultural practices and everyday needs, in their own images, it is a way to insist on one's place in the world even when marginalized by large-scale or "official" planning. Roberto Bedoya, cultural activist, policymaker, and current cultural affairs manager of Oakland, has called this process *rasquachification*, drawing on Chicano scholar Tomás Ybarra-Frausto's theory of *rasquachismo*. This potent work to make place uses the leftover stuff you have to make what you need, with an "attitude rooted in resourcefulness and adaptability yet mindful of stance and style," resulting in survival and resistance.[13] What it takes to change a place, or protect a place, what it takes to imagine differently and resist—often over years, often facing intense opposition—is what inspired me through my years learning from housing activists on the Lower East Side and in writing *Contested City*.[14] And when people do all that work to make places, there's also a cycle *between* people and the places they work to make and protect; there's a work that those places, in turn, do for us, allowing us to become ourselves, enabling us to be together: placework.

But why call it *work*? What is work? Work implies a seriousness, a routine, a regularity, a difficulty, but also a rhythm, a practice. In some spaces, work is tedious—a grind of clocking in and out, working nine to five, as both Dolly Parton and oral historian of work Studs Terkel would tell you.[15] Work is constraint.

Yet in some spaces that *do work*, constraint can be what allows play or experimentation that wouldn't be possible otherwise. I think of art *work* and artist Anni Albers's explanation that the essence of weaving, of which she was a master, is in the play between structure and material, "supporting, impeding, or modifying each other's characteristics." In working at the intersection of two kinds of constraints, she was able to make something new.[16] It seems to me that supporting, impeding, and modifying each other's characteristics is what we all do everyday in the rhythms of our neighborhoods. This is not something that happens once, but rather many times, over and over, eventually making something new together. Understanding this power of repeated pattern, in Prospect Heights Mike took down the sign reading "George's" from the front of his much-beloved diner; the new sign he put up read, "The Usual."

Work is also used in challenge, in encouragement, in celebration of someone's incredible skill. "You better work," "Work it!," and, of course, "Werk!" are phrases that are now pervasive in popular culture but which come from the house ballroom scene of the Black and Latinx LGBTQ+ community. While this kind of work is clearly about the effort you need to put in to really show off your talent, I love the

way dance writer Jonathan David Jackson sees this kind of work on an even more elemental level—as being about the need to be truly "possessed in the spirit of the battle."[17]

And what about when something works *for you*? Placework, like emotional work and completely different than employment, does not produce financial capital, nor is it *for* the production of financial capital.[18] To paraphrase Mike's description of Prospect Heights when he lived and worked there, placework is not *about* money. Placework and the relationships between people that it fosters produce *social* capital, which housing philanthropist Xavier de Souza Briggs explains as a series of relationships between members of a community—relationships that take two forms: *social leverage* and *social support*. The first helps one "get ahead," and the second helps one "get by."[19] This isn't a nice-to-have—it's essential; in the face of challenges and adversity, the mutual benefits of social capital allow people and communities to construct new, and even radical, futures through everyday interactions experienced at a visceral individual level.[20] Physical spaces are worth money, yet the placework they do has value far beyond it—as seen in all of my tour guides' stories.

YOU DON'T MISS YOUR WATER TILL YOUR WELL RUNS DRY, OR LOCKDOWN BLUES

The casual aspect of everyday places that do important placework is not incidental. This casualness lets people join as they can, when they can, and as they will, knowing they can always come back, knowing they can always rejoin. This became even more clear in the time of the coronavirus pandemic, when we couldn't be in most of our everyday places, though even then networks persisted and were created: mutual aid networks; connections by Zoom; and certainly the outrage, release, and power of the daily Black Lives Matter protests. But very often these connections needed to be formalized, planned, organized (though not always) in a way that everyday connections do not. And in formalizing them, you also lose something, some of their inclusiveness. If you were texting with people during lockdown, trying to support people, it meant that you had their phone numbers. It meant that you knew how to reach them. By contrast, in most public interactions, you don't have people's phone numbers, but you know that they'll be in a certain public space at the same time every day or every week. And that gives you—and them—stability.

In those interactions, do we ever say anything important? Rarely. But we validate the fact that we're all human, that time passes, that we all feel things, that we feel pain, that we feel happiness, that we're experiencing the world together,

not individually. The banter. The exchange. The ways in which public spaces build people's capacity to share even small amounts of their lives with people they genuinely don't know. Lacking all of that makes your life less good.

Many things threaten our hardworking places—through demolitions of the places themselves and displacement of the people who make them what they are, who facilitate their important work. For example, in the pandemic, and before and after, small businesses in New York City and the Bay Area (and beyond) are, and have been, at risk. They suffer from little rental protection and from rising costs due to supply chain crises and small profit margins, making them some of the most vulnerable parts of cities.[21] Small businesses as a category are often discussed as economic drivers, but they are rarely addressed as unique and crucial places that have the potential to shelter people's lives.[22] They are rarely recognized as doing this vital kind of work.

Systemic racism, neighborhood displacement, COVID-19, and climate change all intersect and hit people hardest who are already at the edge. All of these threats increase our need for hardworking local places, the kinds of places that support dialogue and make space for negotiation, that support the interactions that build community, that create more than financial capital; these places are one part of dismantling white supremacy. Yet the threats that make hardworking places so necessary are the very things that endanger those places.

These valuable places sustain us and are where we build the networks that help us get along. Placework is all the more vital now because in this late pandemic moment, in climate crisis, in racially segregated neighborhoods, in a corporate, distracted culture, we need all the support possible to honestly become ourselves, and to become that messy valuable thing that is community.

PORTFOLIO ONE: MOSSWOOD

On BART, West Oakland, 2006.

Mosswood Park, 2005.

Autobody shop, Fortieth Street, 2006.

Neighborhood ballet studio, 2007.

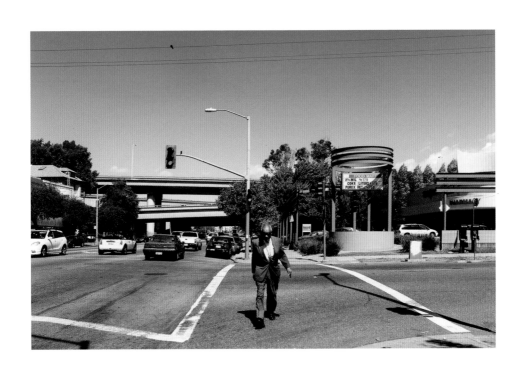

Walking to the bus stop,
Telegraph Avenue and Thirty-Fourth Street, 2007.

There were people here.
Telegraph Avenue and Thirty-Fourth Street

This neighborhood was pretty solidly Black. Lois and I grew up two blocks farther down. But we were up here all the time, we used to hit the plum trees up there. The hospitals were there, but they were much smaller. If you look at this neighborhood, it was a lot more prosperous commercially because there were houses in here under the freeway.

There were people here. . . . I would babysit for all the kids here, just as they would babysit for me. . . . Lois has her dad's complexion and looks, and her dad was a redcap—you know, the redcaps were the porters. I can never forget, Jack would be coming home from work with that uniform on, and I'd say I always wanted to [be like him]—and he'd say, "No, no, boy, you don't want to do this kind of work! This is the same kind of work your great uncle did." My great uncle Frank was a Pullman porter, too, but he worked out of Chicago and LA for the SP [Southern Pacific]. Uncle Frank got a master's degree from the University of Chicago in 1921. Where the hell was he going to work? No one was going to hire him. But this was why you had this degree of progressivism among these Pullman porters, because so many of them were so much better educated than the people that were actually on the train.

What we saw on this block was not the kind of blight that you see now . . . but people going to work every day. Black men going to work every day.

—Marty, 2006

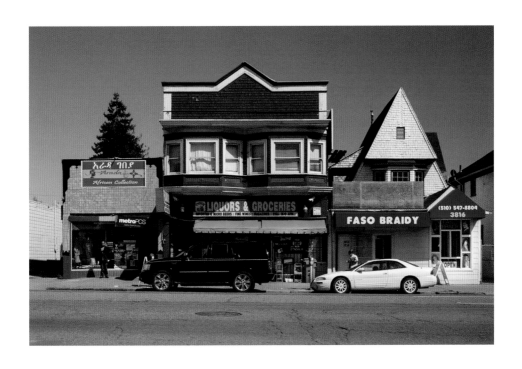

Triangles, Telegraph Avenue, 2005.

Telegraph and Fortieth Street, 2006.

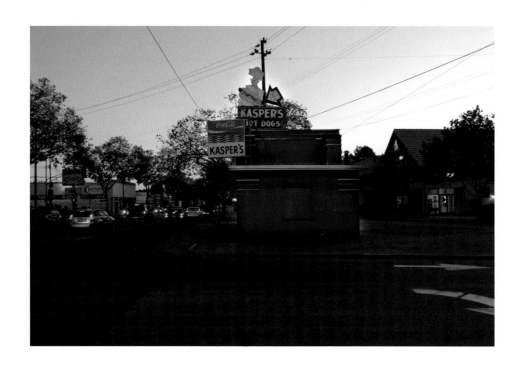

Hot dogs at magic hour,
Telegraph Avenue, 2005.

BECOMING YOURSELF

2

FEELING FREE AND BEING VALUED

One afternoon in the fall of 2015, I gathered the cards on which people had added their own neighborhood stories from the *Intersection | Prospect Heights* box in El Castillo de Jagua, a restaurant on Flatbush Avenue. On one card, I read María's story. "I had never been to Prospect Heights. A friend and I came to a Dominican restaurant for the first time," she wrote. "It's pouring cats and dogs outside, so we got inside and had hot soup. Being from Venezuela, the hot food and the Spanish music made us feel a bit like home. So yes, our first impression of Prospect Heights is heavy rain, puddles and "'home.'"[1]

María's story brought me back to a familiar theme about what it means to find *home*, to feel you belong, about what that does to a person's sense of themselves. And I realized that the way home shapes our sense of self, the way individuals are always becoming, hadn't been central to my thoughts until I began a graduate program in environmental psychology. Until then, what I had cared about were places, stories, culture, connection. I thought about how people shaped places and why they were important, but never really about what places did to shape each of us individually.

To my mind, psychology was about experiments in labs, divorced from lived reality. Clearly I was wrong. When I began reading about psychology that had an environmental perspective, an ecological perspective, psychology that considered how individuals navigated places, how places impacted not just how those people were part of something larger, but how they saw themselves, I felt like a piece of the puzzle slipped into place. This "ecological" way of thinking about people as never

separate from their contexts, places, and histories is powerful. How people's selves develop, are fed, and are nurtured by places changes the ways they are able to go out into the world.

When I think about what it means to *become* oneself, I think about time and context, about our physical bodies not just disembodied minds, and about what it means to situate all this in a cyclical way of making and being made by place. Knowing oneself, becoming oneself, always happens in place—we are never in a vacuum—so it is also important to understand how we know *place*, how we perceive it: place and self together. Psychologist Kurt Lewin's concept of the *life space* as "the person and the psychological environment as it exists for [them]" is particularly important. Who you are and what is defined as your life space is a shifting identity; you are always experiencing the world as yourself in a given temporally specific situation.[2] The parallel theory of *place identity*, which comes from a more cultural and ecological perspective, was first theorized by environmental psychologist Harold Proshansky as "those dimensions of self that define the individual's personal identity . . . [through] conscious and unconscious ideas, feelings, values . . . and behavioral tendencies relevant to a specific environment."[3]

As people, we're thinking, feeling bodies moving through the world, and each of our bodies experiences things from a specific perspective. What psychologist James J. Gibson called *ecological optics* made sense when I thought about how my eyes in my head that see from the height of a 5′3″ person and how my body that likes to walk shape my understanding of the world—and how other people's bodies are quite different. Maybe it was because I'd always thought about photography that way—changing the height at which I held my camera to get a different perspective—that it was satisfying to think that this photographic way of thinking might have some bearing on understanding ourselves as individuals.

Gibson's ecological approach to visual perception—which admittedly misses the many other important kinds of sensory perception—stresses the embodied aspect of how we know the world (which changes for different people, and over the course of one person's life).[4] Perceiving our environment is not simply about its shapes, its colors, how the light bounces off it, but about the use we each can put those things to—in a pinch, how any given place or object helps us survive, what each part of our world affords us. When I teach about this idea, which Gibson calls *affordances*, I stand behind the classroom desk to talk about how it's solid and grey, how it can hold many books, how culturally it's a site of authority, and so on, but—and here I jump up on the desk—were a tiger to enter the room, it

might afford me help in a very different way. Yet it's not a full theory to me without psychologist William Ittelson's parallel theory: that not only do we perceive things for their physical qualities that (could) enable our survival, but we also perceive them for the emotional connections to places and the way those might be just as essential for a different kind of survival.[5] These theories of environmental perception matter because they help us see what it is to be a person in the world—not only a member of a group, but an individual as well. The physical everyday world of homes, streets, neighborhoods, stop signs, cars, freeways, and bus fare affords us ways to get places, to stay dry, to get food—but maybe they afford us something even more sustaining; sometimes they tell us stories, teach us who we are, help us become more ourselves.

As my tour guides took me on walks, I saw how they understood their neighborhoods, and how their understandings of places were part of their ongoing process of becoming themselves. First, I saw how some places conveyed to my tour guides a sense of freedom, not through knowledge or words, but through how their bodies felt. And that sense of embodied freedom—of feeling viscerally, powerfully free—was clearly central to their capacity to feel like themselves.

Second, I saw that there were places that helped people build their belonging in the world—through the reinforcement of, or education in, a set of values while also making themselves *feel* valued. Of course, I saw this sense of belonging get built in home spaces—people often talked about "feeling at home"—but it was not only in residential spaces; very often *home* was not about where someone slept but, just as for María at El Castillo de Jagua, it was where they worked, shopped, met people they knew, or recognized something of themselves out in public.

The following chapters explore these two kinds of placework that help people become themselves: one chapter about that embodied freedom—in the words of Ulysses, "I be all over"; the next about home spaces that foster a sense of belonging through shared values and being valued—in the words of Julia, "landing someplace safe"; and finally, a third chapter about some more surprising spaces where values and being valued intersect—in David's words, "probably the supermarket."

PORTFOLIO TWO: PROSPECT HEIGHTS

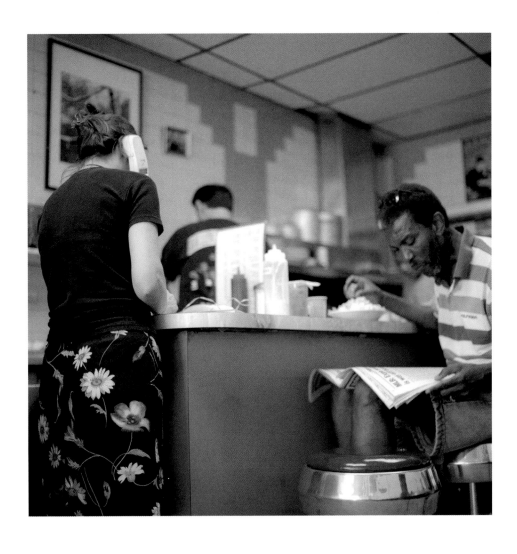

"It doesn't have to be a big thing that you do."
George's, Vanderbilt Avenue, 2001.

It doesn't have to be a big thing that you do.

George's / The Usual, 637 Vanderbilt Avenue

I really like this place. Besides the fact that you see different people, you just hear people talking, joshing around. . . . It's a very mixed crowd in here, race, sex, age. You see people from all different backgrounds. You see cops come in here, you see Sanitation, you see park police, plumbers, accountants, politicians, and you hear people talking trash . . . it's funny! Mike gives the place its life, 'cause he'll talk to anybody and he'll talk crap with anybody!

Here in New York . . . America . . . you have this whole thing about being somebody and being somebody of a certain level, the doctor, the lawyer, the Wall Street whatever. . . . And you have people here who have a life, they run a luncheonette, and they make people happy, and they know they make people happy. They like it? They come back. They don't like it? They don't come back. It appeals to me very viscerally.

It makes me realize, yeah, you need some money, but you don't need to be chasing, just chasing a dollar to the exemption of everything else. And it doesn't have to be a big thing that you do . . .

I feel that they love it, and that makes me like it also. If I'm in a bad mood and I come in here, I walk out in a better mood. It's just the place. It's comfortable, you know?

—Tanya, 2002

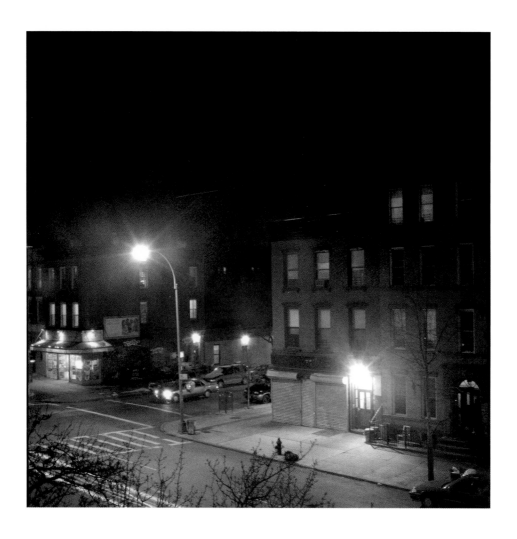

From our window, Vanderbilt Avenue, 2001.

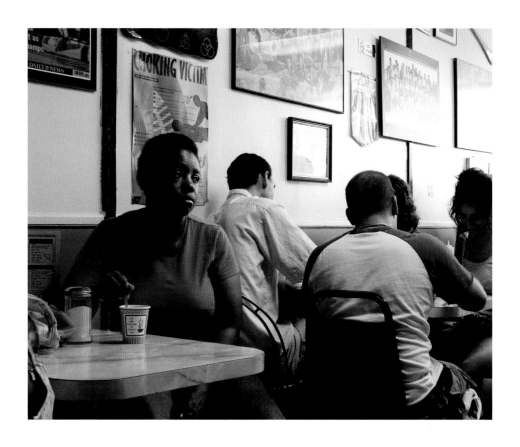

At George's, 2002.

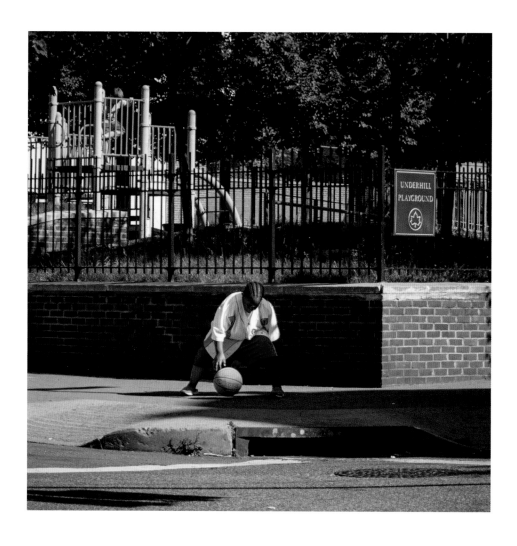

Kids at play, Underhill Playground, 2002.

Underhill Playground under renovation, 2006.

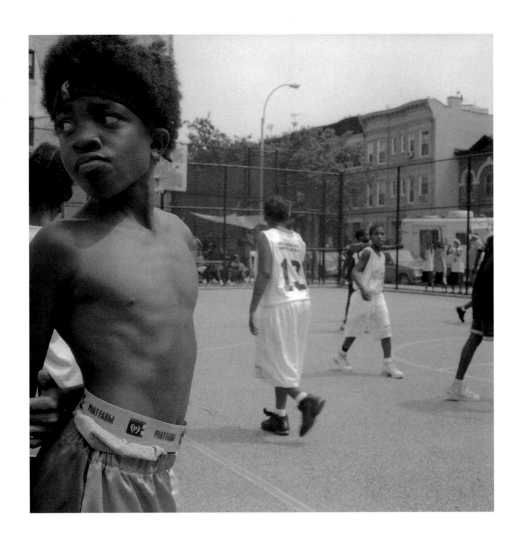

At one of the first annual Conrad McRae basketball tournaments,
Dean Playground, 2002.

Vanderbilt Avenue, 2003.

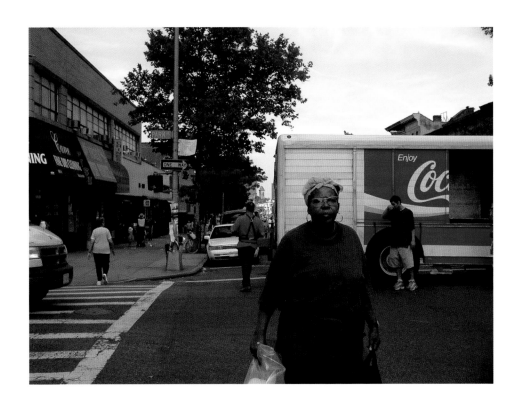

Vanderbilt Avenue, 2004.

3

I BE ALL OVER

From behind the blue donut case in George's diner, Mike introduces me to David K. one afternoon after school. A soft-spoken, enthusiastic teenager, David agrees to take me for a walk around his neighborhood. We head out the door and onto Vanderbilt Avenue, turning up Saint Marks Avenue. We walk past the brick storefront on the corner which houses the Baptist church his family attends, past the community garden, past the rows of low buildings with small stoops and iron fences. Some of these are set far back from the sidewalk with front gardens; one has small stone lions guarding its stoop, painted so many times they look like they're melting in the rain. On the left we pass an open expanse of flat tarmac—the playground of the elementary school—and turn again toward Underhill Park, the most important place in the neighborhood for him. As David described the neighborhood and what was important, it was clear that all the ways he moved through it physically, all the places he'd explored with his friends, all the places to play, all the places from behind or under which he'd retrieved a ball, were central to the story. Once we arrived at the park, David told me of his handball prowess, but mostly told me about how the park had changed as he enumerated every thing that "never used to be like this." Every physical experience of this place was writ large in David's description of it. Arriving at the park, I could easily imagine his movements as David explained, "See, the handball courts used to be over here where the grass is, and they changed it and put it over there and separated it into two. But when it was over here, it was a gate, so if the ball went out, you had to go through the gate and get the ball wherever it went. But now they put it there, so if you hit the ball over, you gotta climb over the wall."

David knew that park in his body; there was nothing dispassionate about the way he spoke, and each change held meaning, loss, and potential. Every single spot in that park had been significant and now all the new ones were becoming important. Central to everything was the handball court, which hadn't changed, although now the ball went out of the park less often.

His stories about the park had a great deal to do with his understanding of the changing place and neighborhood over the time he'd been there. But what stood out to me was his confidence in himself, in his abilities, and the stature that this confidence gave him, all of which seemed deeply rooted in his body's freedom of movement in this park. The park was all about his own conception of himself as a teenager, an athlete, and a champion.

Those spaces which David knew in his muscles, in his bones, with his friends, did not simply happen to exist. They were imagined, shaped, and then reshaped. In Robin's story, told during the *Intersection | Prospect Heights* oral history recordings twelve years after my walk with David, she explained her first experience of the park in 1968—long before David was born—when she first moved to the neighborhood.[1] She described what the 1940s era playground had become by then, as "a place for drug sales and use, boom boxes late into the night, shootings . . . It was not considered safe, especially for children." And because this was not a space in which children's bodies could feel free, she would go on to form a park cleanup committee, which eventually changed the space in bigger ways:

I wrote to several nearby colleges to propose . . . a collaboration. Pratt Institute . . . took on this project of creating a new playground. . . . Students visited the site, interviewed parents and designed individual plans for the playground. . . . The students presented their plans at Duryea Church to a large community turnout. [The] head of the Parks Department . . . was so impressed with the research, the designs, and the community involvement that he promised that the Parks Department would fund a final plan. Needless to say, the process took time and endless meetings and hearings. However, we had a ribbon-cutting ceremony in 1987 with great fanfare.[2]

It was this 1987 version of the playground that David had first loved. By 2015, the playground had been renovated two more times—once in the late 1990s (the changes that David noticed) and again in 2006. The third renovation focused on the needs of younger children due to the many new families in the area; kids even left their old riding toys at the park for others to use. But with this success, allowing

young children a cherished freedom of movement, what happens to the freedom that this place once afforded teenagers like David? He had noted the shift even in the earlier renovation, telling me, "They used to have the flat big kids' swings, but the kids used to take them and flip them over, so they put the baby swings, 'cause they don't want the big kids on it." Seventeen years later, twenty-year neighborhood resident Gina would tell me that this restricted freedom—or the trade-off in freedom from big kids to little ones—weighed on her: "I would love for the teenagers to have a safe place to go. The Underhill Park used to be for everyone, big and small. We used to live on Prospect by that handball court and the ball would always break the window—so we just left it; it was more important that the kids had a place to play."

It isn't just David; we all feel space in our bodies; where our bodies can move teaches us about our world. Can't you feel, for example, that at some point in the journey back to your house, you are nearing home? We all feel distinctions in the streets we do not cross, the distances we stray from our houses, the shadier side of the street, even the familiar feel of our foot on our rough or smooth front step.[3] As abolitionist scholar Ruth Wilson Gilmore insists, getting free "starts from the homely premise that freedom is a place."[4] That place is made, Gilmore argues, when we "combine resources, ingenuity, and commitment to produce the conditions in which life is precious for all."[5] How our bodies are allowed to move through everyday spaces significantly contributes to whether we feel our lives are precious. How places enable physical freedom is one part of how they do the placework of supporting our selves; freedom is in both our bodies and our minds.

**

Identifying the important placework that lets bodies feel free even in something as simple as a park is not to be taken lightly—especially as the control of bodies, and the resistance needed to free them, is embedded in both Brooklyn and Oakland—as it is in cities and towns across America.

Traveling to the opposite coast, and back in time, we find that people have lived in what is now called the Bay Area for over fourteen thousand years. The people who lived in present-day Oakland were the Chochenyo-speaking Lisjan people of the territory of Huchiun, one of the largest of around fifty small independent groups, often known collectively as Ohlone.[6] Lisjan Huchiun culture had craft, political, and secret societies; Coyote and his grandson, the falcon Kaknu, grounded their

storytelling tradition.[7] Their land was full of salt marshes, grizzlies, condors, and sea lions. In winter, people lived by the bay; in summer, they went up to the hills.[8]

Huchiun shellmounds of earth and organic matter shaped the landscape. Corrina Gould, tribal spokesperson for the Confederated Villages of Lisjan and co-director of the Sogorea Te' Land Trust, describes these thousands of years old places as "ceremonial places and as burial sites," as well as places where people "would trade with each other, and . . . would have ceremony at the top of these mounds."[9] One of the largest shellmounds was in what is now the small city of Emeryville, just a few blocks west on Fortieth Street from this book's bit of Oakland. More than three stories high and 350 feet in diameter, this site that once held at least seven hundred graves is now flattened and marked only by the IKEA on Shellmound Street, around the corner from Ohlone Way.[10]

Thousands of years of bodily freedom and cultural agency in the Bay Area ended in 1775—the year before the American revolution. The San Carlos sailed into San Francisco Bay to expand Spanish colonial rule into "Alta California" and was met by Sumu and Jausos, with Supitacse, Tilacse, Mutuc, Logeacse, Guecpostole, and Xacacse—a diplomatic delegation of Huchiun people.[11] Fewer than twenty years later, Supitacse, Guecpostole, Mutuc, and hundreds of other Huchiun people would be living at Mission Dolores, part of a system of military *presidios* and Franciscan missions where Native people were forced to live, convert, and labor, and were rounded up by landowners and soldiers if they escaped. It was a cultural demolition archaeologist Randall Milliken has described as a process of "religious conversion/psychological disintegration."[12]

Yet in 1795, people of the Huchiun territory at Mission Dolores resisted and escaped back to their lands in the East Bay. Two years later, the Spanish military raided the Huchiun villages, in present-day Richmond, forcing the people back to Mission Dolores and punishing resistance leaders at the San Francisco Presidio.[13] By the summer of 1806, all the Huchiun villages were empty; by 1820, twenty thousand Native people were held within the California mission system, their bodily freedom almost nil.[14]

That same year, Pablo de Sola, the last Spanish governor of Alta California, gave a land grant of forty-five thousand acres of Huchiun territory to Spanish soldier Luis Maria Peralta—land that would become Oakland (including our little neighborhood of Mosswood), Berkeley, Albany, El Cerrito, Emeryville, Piedmont, and part of San Leandro.[15]

Mexico (and its Alta California) won independence from Spain in 1821, but the mission system was not ended until 1834.[16] While the land of the missions had supposedly been held in trust by the Franciscans for Native people, and the 1833 law that secularized the missions implied that every "mission community would become a town with its own government," almost no Native people gained land from the disbanding of the missions.[17] Most mission lands were given away as rancho land grants to white Californians or recently arrived, well-connected Mexican citizens; as the only option for survival, many Native people ended up in servitude to the rancho landowners.[18] By then, sixty-five years of exposure to Europeans had reduced the number of California's Native peoples by half; just as on the East Coast two hundred years earlier, thousands of people had died in epidemics of diseases like measles that the Europeans had brought with them. Yet Ohlone people have persisted in the Bay Area: after so many years, in 2022, Oakland returned five acres of Joaquin Miller Park to the East Bay Ohlone people, a space which will do untold placework.[19]

**

Back East, it was Native people who created what would become one of Prospect Heights' boundaries. Flatbush Avenue began life as a main Canarsie trail, stretching across Brooklyn, as it does still. By 1827, it was the "road to Flatbush," and when shifted to the west in 1852, it became the avenue we now know.[20] The Canarsie people lived in this place now called Brooklyn for thousands of years—and by the 1500s, their Brooklyn had a vast network of trails and villages.[21] The Canarsie—meaning "grassy place" or "fenced-in place"—were one of the thirteen Algonquian tribes of Long Island, and in the 1500s, there were over fifteen thousand Algonquian people in the area that would become New York City. The Canarsie—part of the Lenni Lenape—were the main traders of the area, with trading routes stretching south to the Gulf of Mexico (and beyond) and northwest to Lake Superior, an expansive freedom of movement and relationship building.[22] In 1635, the Dutch made incursions to lay out a few villages in Canarsie territory, and within a few years, disease epidemics from the Dutch occupation had killed much of the Canarsie population; those who survived moved to the lands that would later be New Jersey and Long Island.[23] By 1640, the Dutch governor of New Amsterdam, Willem Kieft, had begun a bloody war against all the Lenni Lenape peoples—including the Canarsie—and the governor who inherited Kieft's War, John Underhill, deepened the brutality of that

war. By 1644, Underhill—the leader of several massacres—had driven the Canarsie out of their Brooklyn homeland completely; within twenty-six years, the Canarsie land of Brooklyn was ceded to the British.[24] In 1985, a playground in Prospect Heights would be named for John Underhill, after the street it sits on, and a boy we know would come to love it—as a site, it would embody both freedom and unspeakable oppression.[25]

The large Dutch and British farms that took Canarsie land had much in common with plantations all over the colonies; slavery was an essential element of seventeenth- and eighteenth-century Brooklyn and New York. By the late 1700s, nowhere in New York State had more slaves per capita than Brooklyn; Black people made up a full one third of Brooklyn's population and the vast majority were enslaved.[26] In 1799, the enactment of New York State's Gradual Manumission Act meant that all children of enslaved women born after July 4, 1799, would be free at age twenty-five or age twenty-eight (for women and men, respectively).[27] This was a slow walk to abolition, which was finally made law in New York State in 1827—just when those male children born in 1799 would have been freed. This history makes the free Black communities founded in Brooklyn in the present-day neighborhoods of Crown Heights and Bedford-Stuyvesant (usually called Bed-Stuy)—including, among others, Weeksville (the earliest, founded in 1838) and Crow Hill, which may have abutted Prospect Heights—even more significant. These Black communities reshaping Brooklyn in pre-Civil War, post-emancipation New York State had been made by African American investors getting together to buy land to create intentional communities, which would provide them the voting rights of full citizens through landownership.[28] Brooklyn was also a major destination for people escaping slavery from the South—as houses across Brooklyn, and the women who ran them, became an important part of the hidden network of the Underground Railroad. As historian of Brooklyn's abolition movements Prithi Kanakamedala writes, "Though the archives might be silent on their contributions, women were at the center of the anti-slavery movement."[29] In both Oakland and Brooklyn, making space for oneself to be free has been no small thing.

ALL OVER, REALLY

Back in the twenty-first century, those Brooklyn streets around David K.'s playground did an important placework of embodied freedom for another one of my tour guides; no one I spoke with made his place in the world more through his

body's movement than Ulysses.[30] And no one I had spoken to made more clear the *power* of this freedom of movement than Ulysses. Mike had introduced Ulysses and me, so it made sense for us to start our walk from in front of the diner one afternoon in 2002. Having lived and worked in the neighborhood for almost thirty years, doing itinerant construction and cleaning jobs, he had a unique perspective on the place. Later, I would be strongly reminded of his walk when I read writer and walker Raja Shehadeh's remembrance of his grandfather's need to go on a *sarha*, "to roam freely, at will, without restraint. . . . not restricted by time and place, going where his spirit takes him to nourish his soul and rejuvenate himself."[31]

Ulysses talks with a soft southern drawl—so softly that I have to work to catch what he's saying. He starts off, but chokes on his words. "Agh . . . This is the first time, you know, I've been . . ." It's the first time he's been interviewed. He explains that he had come to Brooklyn from South Carolina twenty-seven years earlier in the mid-1970s because "the jobs up here were more easy to get than down there," taking part in the tail end of the Great Migration of Black people leaving the American South for Northern cities.[32]

As we meander down Vanderbilt Avenue, our conversation moves like a leaf on water, this way and that, gently touching on where Ulysses had lived, worked, and walked in the neighborhood. I get the sense, as we ramble, that this is what Ulysses does; there aren't destinations, there are journeys. He doesn't have places he goes to regularly; he doesn't have just one fixed routine as an itinerant worker. We walk past bars and places where bars had been, and Ulysses explains the difference between a bar and a social club. "They sell drinks, you know, like, dancing—a social club. . . . It's a lot different [from a bar]; they can't have no liquor on the shelf."

Although walking the streets of Prospect Heights seems to be the place he's been most, on our walk I keep asking about more specific places, and he tries to come up with something he thinks I am looking for. He offers: "Well, I mean . . . where I be? Or where I go? Well, round in here—I work . . . Barbershop there. I go in there. Or, the liquor store, that's right there."

Further up the block, a little stupidly, I ask again, "Where do you go most around in this area?" "Like, where do I go, where I be at?" Ulysses asks, thinking. "Well, just hanging around, in this area here, by the park up there, standing out here—talking to friends, people . . . Around here, these places, mostly. I be all over, really. Yeah, walking around, looking . . ."

At some point, probably to appease me, Ulysses tells me he'll take me to his favorite place, and I ask if that's where we're walking to, or are we "just walking

around?" Ulysses's reply expresses how complex the answer to that question is: he talks about a place, at which we never actually arrive, and describes the feeling of that place so reverently that I think he may have experienced it only once or twice. "Well, by the park up there—I go up there because on Sunday, you know, they come with the truck, they be selling stuff up there. . . . I just like to walk though, all over, sit out on a bench, you know." And when I press and press again for his "favorite place," I finally see how wrong this is for Ulysses's conception of the place. He says, simply but profoundly, "I like this neighborhood. It's nice."

I realize there and then that *this*—the whole neighborhood—is the place that does the crucial work of letting him feel free, because of the way that he is free to walk, unconstrained, at home, secure in belonging, his right to be in these streets unchallenged. I think back to both Shehadeh's grandfather's soul-nourishing wanderings, and Garnette Cadogan's writing on what it is to walk while Black. This freedom that Ulysses has here is what helps him be, what helps him be himself. What would it be like for Ulysses twenty years later, in the greatly gentrified neighborhood this area has become? Is there a space that still allows him this peripatetic freedom, this unproductive, unsanctioned movement?

WE COULD PLAY FOOTBALL IN THE STREET

In Oakland one afternoon, Marty and I drive through the dark of the freeway underpass to come out on Thirty-Fourth Street, the Walgreens sign rising up on the left and the tall orange sign of Neldam's Bakery on the right. Slowing, Marty tells me, "I'm sixty-two, and my first birthday cake came from here. That's a good place!" We pull over and go in to meet his neighbor and childhood friend Lois, who works here.[33] He begins to tell me about her with a story about when they would play games in the street and "hit the plum trees" near Telegraph Avenue. "Everyone wanted to choose Lois first, because Lois was a better athlete than most of the boys," Marty explains. Lois nods and starts to talk with me: "I loved to play with the boys. I was a real tomboy." She continues, "We could play football in the street, but now they'd run you over and not even stop." Quickly, Marty has his own muscle memory: "Actually truth just came . . . we were coming from the grocery store, and I was running from her, and I fell down in front of Gandy's house across the street." Later, Marty drives me past this house, close to the corner of Thirty-Fourth and West, reprising, "This is Gandy's house, where there was the plum tree where I broke my tooth."

Marty recalls how as a young African American boy in the early 1960s he ranged, unconstrained by physical or gender barriers, across swaths of the neighborhood. As we drive up Telegraph, Marty traces his childhood walks and neighborhood boundaries, and the centrality of Mosswood Park in his sense of place: "We'd walk straight up Telegraph, because we felt that the neighborhood border was Fortieth Street. . . . Mosswood was the gathering place for the young Black boys, or Negro boys, of my generation. We'd all meet up there from the different schools in the neighborhood and . . . we'd play football all day long, or baseball—whatever sport was in session."

By contrast, Lois remembers that her world was a bit more constrained. "I was allowed to go up to MacArthur that way, and as far as Twenty-Eighth that way, but I couldn't go further. . . . Telegraph was too far. I couldn't walk to Neldam's on [Telegraph]. No, uh-uh." There is a pause and she considers Neldam's Bakery, where she now works, and then thinks about this neighborhood as it once was for herself as an African American little girl. "You know, back in that day, they didn't hire Black people?!" She is almost shocked herself as she says this quietly. But then she jumps back into the present, laughing as she remembers taking a recent trip over to Mosswood. "Oh, we used to love Mosswood Park! All the kids played at Mosswood. . . . Now I go there and it seems so tiny! When I was little, it was just the biggest thing ever!"

**

One sunny afternoon, I walk into the rec center next to the large Victorian house in the middle of Mosswood Park to ask if they know about the park's history. An older gentleman rifles through a filing cabinet and pulls out a many-times photocopied sheet with a flourish. He tells me in his lilting voice, "OK, this is what we have about that piece right there." I read, "J. Mora Moss, a pioneer resident of Oakland, must have been an early advocate of women's rights when he married Julia Wood in the 1860's. He bowed to her wishes that their estate located 'way out' on Broadway be named Mosswood." As I read this, I realize I'm standing at what was once the edge of the city of Oakland. Everything north of Thirty-Sixth Street, including the Mosswood estate, was considered "Temescal." The name overlaid one colonized place on another—the Spanish people of what was Peralta's land grant had given a Hispanicized version of the Nahuatl word *temazcalli*, or sweathouse, to the Ohlone structures across the area.[34]

Before he became the wealthy businessman who established this estate in Temescal, Joseph Moravia Moss had arrived in California from Philadelphia in 1850,

at the end of three momentous years for the Bay Area.[35] In 1847, the United States had won the war to seize California from Mexico, a war that white Americans entering California had pressed for. In 1848, gold was discovered in California and soon a whole new population rushed in. And, the same year Moss arrived in San Francisco, Horace W. Carpentier, Edson Adams, and Andrew J. Moon founded the city of Oakland. These founders had, like other gold rush settlers from the East Coast, squatted on the land the Spanish had taken from the Huchiun territory and given to Luis Peralta in 1820, which Vincente Peralta later inherited. Carpentier, Adams, and Moon subdivided portions of the Peralta land into lots along new avenues modeled on the propriety of East Coast towns and European cities; they stole the land through real estate deals—selling off the lots they'd drawn on a map—and a new city was founded.[36] By the late 1850s, the Alta Telegraph Company installed a portion of the first telegraph line between San Francisco and Sacramento on one of Oakland's new avenues, near the future Mosswood estate, and the new technology lent its name to the street.

Forty-seven years after Oakland's beginning, in 1897 Temescal would be annexed into the city of Oakland (one year before Brooklyn would be incorporated into New York City). Joseph Moss died in 1880 and Julia Wood in 1904, and community advocacy resulted in the estate being opened in 1912 as a public park, with Julia and Joseph's house at the center.[37] The road forming another side of the park, intersecting Telegraph, was called Moss Avenue until World War II, when it was renamed a boulevard in honor of General MacArthur and was a main thoroughfare for soldiers and army vehicles leaving for the war.[38]

**

One night in 2016, a fire would rip through the community center in Mosswood Park, destroying a dance studio, a computer lab, a kitchen, a preschool, an afterschool, and the filing cabinet from which that gentleman had pulled out the notes about the park's history for me with such a flourish. In the wake of that tragedy, it was clear that it wasn't just my tour guides who found freedom in that park, whose bodies needed it; interviewed on ABC7 News after the fire, neighbor Janice Johnson declared, "You have to have Mosswood. Like you have to have water in your body."[39]

**

Land theft and displacement have a long history in our neighborhoods, as we've seen, and have been one of the many things that challenge how freely our bodies can move, challenging the capacity of everyday places to do the crucial placework of helping us feel free. This is by no means relegated to times before living memory. In their stories, Lois and Marty remember an intact Black neighborhood before the freeways were built; yet the places that did the essential placework of affording them such highly prized freedom are no longer. That demolition of a highly functional Black neighborhood has its roots in the deep American history of controlling Black people's bodies, leading to a continuous discontinuity of place, what psychologist Mindy Fullilove calls trying to build community across an "archipelago."[40]

Twentieth-century planning decisions played a clear role in this discontinuity. From 1935 to 1940, the Home Owners' Loan Corporation (HOLC), created by the New Deal legislation to provide emergency loans to homeowners at risk of losing homes during the Depression, had a significant impact on how bodies could feel free. The HOLC's "security maps" were made to advise banks on investment risks, and graded residential areas of American cities from 1 to 4, or A to D. By essentially ensuring or denying investment, these maps solidified spatial segregation and systematized disinvestment.[41] Colored green, first-grade or A-rated areas encouraged lending; the map key described them as racially "homogenous" with room for growth. Blue second-grade or B-rated areas were judged to be completely developed. Yellow-colored third-grade or C-rated neighborhoods were described as older and "obsolete," with an "infiltration of lower grade populations." Finally, colored red on the map, the fourth-grade or D-rated neighborhoods were deemed to have poorer-condition housing and an "undesirable population."[42] Perhaps it will come as no surprise that race was a major predictor of what grade a neighborhood would get; scholar Amy Hillier has shown that African American neighborhoods always received grade 4 or D ratings, and tracts with a higher percentage of immigrants and Jews also garnered grades of 3 or 4 (C or D).[43] Of course, where banks were advised not to lend were often places where emergency loans were most needed; based on race, people were systematically denied access to the lending that would have allowed them to take out mortgages to become homeowners or to take out loans against their properties for necessary upkeep, closing a major pathway to building generational wealth.

The HOLC was not unique; from the 1920s onward, government officials, real estate industries, community groups, and individual residents organized to

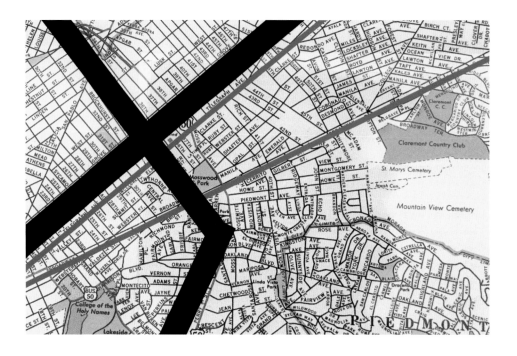

Mosswood and surrounding area on a 1938
map, before the freeways were built. Added
dark lines show where the freeways were
built in the late 1960s, and the streets
they removed. Added red lines show the
"buffer zone" of the Telegraph Avenue/
Broadway corridor. Base map: H. M. Gousha,
Street Map of East Bay Cities, prepared for
Standard Oil Company of California (Chicago:
H. M. Gousha Company, 1938). Map
courtesy of Earth Sciences and Map Library,
University of California, Berkeley.

"protect" middle-class white neighborhoods by placing racial restrictions on Black and immigrant renters and buyers. For example, the Federal Housing Administration (FHA), which provided mortgage insurance, called for "restrictive covenants" in their 1938 manual, to prohibit "the occupancy of properties except by the race for which they are intended."[44] Even earlier, the 1924 Code of Ethics of the National Association of Real Estate Boards—which would be adopted by local boards in both Brooklyn and Oakland—stated in part: "A Realtor should never be instrumental in introducing into a neighborhood a character of property or occupancy, members of any race or nationality, or any individuals whose presence will clearly be detrimental to property values in that neighborhood."[45]

All of these rules are the origins of what's called the redlining of American cities—red lines drawn on real estate maps, following the borders of those earlier D-graded neighborhoods—in which financial investment via mortgage lending was denied to neighborhoods based on their racial and ethnic composition. In Prospect Heights and Mosswood, the effects of these graded areas are clear. Although neither neighborhood was itself fully graded D, they were both at the intersection of D-, C-, and B-graded neighborhoods; indeed, Oakland historian Robert O. Self has described Mosswood as being designed as a "buffer zone" among the red lines.[46]

IT WAS NEVER PUT TO A VOTE

The years of systematic disinvestment from neighborhoods made it possible for the urban renewal of the 1960s to argue that these neighborhoods were blighted and that, for example, the construction of freeways in Oakland could cut broad swaths into neighborhoods like Mosswood. Thousands of homes were bulldozed in the long period of constructing two intersecting freeways—the MacArthur Freeway, or 580, which opened in 1966, and the six-mile Grove-Shafter Freeway (the 980 and the 24), begun in 1964 and only completed in 1985—as well as by the BART suburban commuter train that now connects San Francisco to cities and suburbs around the bay. The enormous structures were in essence the HOLC and FHA red lines built in concrete, tearing through the community fabric and the Telegraph Avenue and Grove Street business districts.

The racial aspect of this development is not only visible in hindsight, but was perfectly clear at the time, as spelled out in the *Oakland Tribune* coverage on July 24, 1969:

The first section of the Grove-Shafter Freeway through north Oakland was opened yesterday with appropriate ceremonies—and the blessing of the Italian-Americans who live along its route. Alameda County Supervisor Emanuel P. Razeto, who represents north Oakland and is a native of Genoa, Italy, suggested during a lunch, following 11 a.m. ribbon-cutting ceremonies, that the freeway be named for some distinguished "Italian-American." . . . "The Grove-Shafter cuts through an Italian community," Razeto said. "America was named after an Italian." Oakland City Councilman J. R. Rose, a Negro, good-naturedly told Razeto the freeway "also passes through a good black neighborhood."[47]

It wasn't a mystery to residents at the time, either. Marty recalled his father's views on the subject of the 580 freeway, "which white folks thought was progress," explaining, "My dad was a progressive, a leftist, he was an ex-communist and a socialist, so he recognized . . . that this would destroy the base of the Black community, the business community. Somehow, Berkeley voted to keep BART underground, and in Oakland it was never put to a vote. My dad voted against BART, because . . . [he] said that the BART would not improve rail transportation in this area, and it didn't! It brought people from the suburbs here."[48]

BART was never meant to serve people who lived around those stations, and the parking lots—like the enormous one around our neighborhood's MacArthur BART station—would isolate the stations from their surrounding neighborhoods.[49] Driving through Mosswood, as we pass through the vast no-man's-land swath of the intersecting overpasses of freeways 580 and 24, Marty gestures out the car window. "It was a lot more prosperous commercially because there were houses in here," he says, and I see where whole city blocks of houses were razed between Telegraph Avenue and Grove Street.[50] The Louisiana and East Texas people of these now-gone blocks come alive as Marty continues: "There were people here. Right here . . . I babysat for my friend who was a Malveaux Bell, Creole, from Lake Charles, her mom was born in Mamou, and her father's East Texas. And her brother-in-law was Pete Escovedo. So, I would babysit for all the kids here, just as they would babysit for me. So in this block here, you had all these people, the Garcias, the Escovedos."[51]

The construction changed even the area's names. While it had once been considered part of North Oakland, now it was West Oakland; the freeways split this old neighborhood of Hoover Durant into Mosswood Annex and what came to be called Ghost Town because, as Marty says, "the freeways depopulated this neighborhood."[52]

Another afternoon, Lois drives me across Forty-Second Street, underneath the freeway overpass that now dominates the street, and recalls her walk to high school in 1966: "I used to walk down this street; you know [Oakland] Tech is right there on Forty-Second and Broadway. . . . That was after the freeway was built, when it was fairly new." She gestures at where the pylons sit under the soaring concrete mass of the 580 freeway, and the intersecting roads fly above us: "All this used to be houses over here. Mm-hmm. Small streets." Just a few blocks south, driving across Thirty-Third Street, she mutters again, "All down here we used to know." In her voice, I can hear the depth of emotion that emphasizes the truth behind psychologist Marc Fried's research showing that forced displacements are among "the most serious forms of . . . psychosocial disruptions and discontinuities."[53]

I ask if Lois remembers when this freeway was built, and she nods emphatically. "Yes! Cause when they tore down the houses, I had friends who lived all in here. But when they tore it down, it was just a dirt lot. And we'd play in the dirt lot before and while they were building. We used to run wild all through there, playing in the lots, climbing trees." As she recalls this place of demolition and childhood play, I understand that there were two places from which she and her childhood community were displaced, two places in which her body felt free that are no longer: her friends' homes reduced to rubble, and then the odd world of a construction site that became their own unorthodox play area through the tactics of childhood exploration. Neither of these remains in the concrete maze that now dwarfs all the surrounding buildings.

Later, looking at photographs of the freeway arching over and cutting through, her neighborhood, Lois saw only the neighborhood of her childhood that had been demolished. "I don't want those freeway pictures," she said, pushing them away.

PORTFOLIO THREE: MOSSWOOD

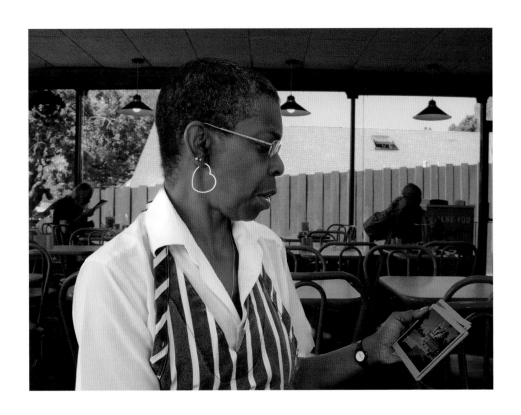

Lois looks at pictures, 2006.

MacArthur BART station, 2006.

Gas station, 2006.

"All this used to be houses over here. Mm hmm. Small streets."
Thirty-Fourth Street and Martin Luther King Way, 2006.

Lois's block, Thirty-Fourth Street, 2007.

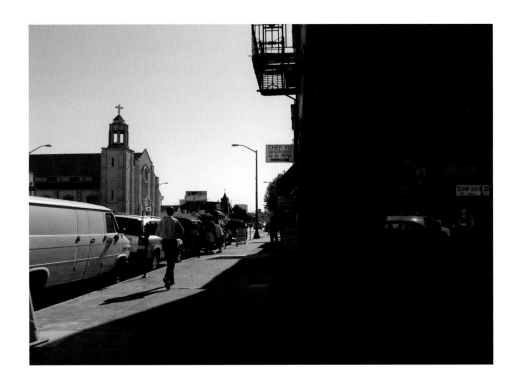

Telegraph Avenue, 2007.

You can see the sun setting.

Thirty-Sixth Street

You know when you stand out, and you can see where the freeways are and you can see the sun setting? That part right there.

—Amanjot, 2007

"You can see the sun setting."
Thirty-Sixth Street, 2007.

4

LANDING SOMEPLACE SAFE

Sitting on her stoop one day, Julia looks up the tree-lined block of low brown buildings and describes what Prospect Heights felt like when she moved there in the mid-1980s. With a deep breath, she begins, "That's the thing about Saint Marks Avenue, predominantly owned by women. Prospect Heights was primarily a lesbian neighborhood when I first moved here. Gay men on Prospect Park, gay women in Prospect Heights." She continued, "It was like, all these girls sort of not feeling constrained. You could just see there was a breeziness about them—'I live here, I live in Prospect Heights.' It was a bit more rough-and-tumble then, like somebody running someplace, and landing someplace safe."

Hearing Julia, I thought there was nothing that could more eloquently explain the need for places that help us feel that we belong. Our physical bodies need to feel free, and our complex persons need to feel that we belong, we have values, we are valued, we are safe.[1]

**

Finding belonging by finding home was particularly apparent with Marty and Cynthia in Oakland and David W. in Brooklyn. Their stories of home, and how their homes came to be, are part of both regions' postwar histories. They're also part of my own family history. In the national postwar housing crisis, my socialist, secular, Jewish grandparents—my grandfather just back from serving in World War II—found a small ground-floor apartment in Prospect Heights. With my two-year-old

mother, they moved to Park Place, the same block on which David W. (as well as Kaushik and I) would live over fifty years later.

So, who else needed, and was able to, make home in these places? During and before World War II, Brooklyn and Oakland both had booming shipbuilding industries, and there was lots of work to be had in these two places. During the war, between 1940 and 1945, seventy thousand workers built seventeen huge warships in the Brooklyn Navy Yard; across the country, workers built 747 cargo ships, troop transports, and Liberty ships in Henry Kaiser's enormous Richmond shipyards.[2] Many African Americans migrated to Northern cities like New York and to Western ports like Oakland for these jobs—even while they had held more middle-class professions in the Jim Crow South they so needed to leave.[3] Yet just as in housing, Black people had long been excluded from defense industry work. It took many people's advocacy, led by Bayard Rustin and A. Phillip Randolph, to result in President Franklin Delano Roosevelt's creation of the Fair Employment Practices Commission in 1941, which finally gave Black people equal access to these jobs in Brooklyn and Oakland and across the country.[4] The number of workers required for these industries led to tremendous housing pressure in both regions—resulting in many single-family houses in Oakland and single-family brownstones in Brooklyn being divided up into rooming houses.

By 1950, Prospect Heights residents included African Americans, Jews, recent immigrants from the Caribbean, and some older white residents; fifteen years earlier the neighborhood had been primarily Italian and Jewish immigrants. Prior to that, from the 1880s to the 1930s, it had been predominantly elite and upper-middle-class white people.[5] As American industry turned to creating consumer goods for the new suburbs, the loss of war jobs in Brooklyn meant that Brooklyn's economy began to spiral into decline. Historian Thomas Campanella describes the years from 1955 to 1970 as being marked by the shuttering of the institutions that held Brooklyn together: in 1955 the *Eagle* newspaper closed; that same year the Brooklyn Dodgers won the World Series against the Yankees, and promptly moved to Los Angeles; the last trolley car that had connected Brooklyn ran on October 31, 1956; and in 1964, the Brooklyn Navy Yard, which had brought so many thousands of workers to Brooklyn, closed its gates.[6]

In Oakland, similar forces were at work. Both the Bay Area's war industries and the government and shipyard housing that had supported their workers began to disappear, and while unions had admitted Black members during the war, many

Black workers found themselves shut out of union jobs and protections once the war was over. The same forces that demolished the streetcars in Brooklyn—the automobile, oil, rubber, and highway industries, in concert with voters sold on a highly individualistic America—led to the demise of Oakland's effective Key System too; on April 20, 1958, the last streetcar ran on the Key System Transbay route.[7] Marty remembered the Key System as his childhood link across the East Bay and beyond:

I can remember being on a train with my grandmother who lived in what's now called University Village in Albany—it was Codornices Village then. It was built for war housing and to house people who worked in the shipyards. And you could get on a train with your grandma, your mom and dad, and go all the way to San Francisco. . . . I can remember coming up here when my grandmother would get her little social security, and we'd go into the Sears here, and of course there were all these businesses up and down this street. Now, like I said, this was a real viable neighborhood.

In addition to the loss of jobs, the tax base in both Oakland and Brooklyn was decimated. In these redlined areas, financing for the upkeep of properties was hard to come by, yet government-guaranteed Veterans Administration (VA) and FHA mortgages were plentiful for white residents if they chose to move away to white-only suburban developments. It was a decline Brooklyn historian Craig Wilder describes as "written into government policy," a phenomenon often called *white flight*, but which Oakland historian Robert Self defines as white people being explicitly *drawn* to the suburbs for all the aforementioned financial reasons as well as "the assurance that a new home, spacious yard, and garage signaled their full assimilation into American life and its celebration of modernity and consumption."[8]

People had to reinvent again in Oakland, this place that Self calls a scrappy city always "on the make."[9] African Americans who had come to Oakland from the South to work in the railroad and war industries found that as shipbuilding jobs disappeared, they needed to move out of West Oakland into other Oakland neighborhoods.

Yet postwar Oakland, like Brooklyn and most American cities, had a housing segregation that "sorted the city by race and class."[10] In a discriminatory response to Black families' moves out of West Oakland as the defense industry waned, the real estate and lending industry began establishing a broad set of racial barriers across the city. In his book on the segregation of American cities, Richard Rothstein told just one story of many of this kind about the Bay Area:

> In Oakland, California, DeWitt Buckingham was a respected African American physician who had been a captain in the Army Medical Corps. . . . After the war he established a medical practice serving the city's African American community, and in 1945, a white friend purchased and then resold a home to him in Claremont. . . . When the identity of the true buyer became known, the Claremont Improvement Club, a neighborhood association that controlled a covenant restricting the area to those of "pure Caucasian blood," sued. A state court ordered Dr. Buckingham to vacate the residence.[11]

The eviction was only halted by a 1948 Supreme Court ruling that forbade state court enforcement of restrictive covenants. Throughout the 1950s, the area of Mosswood west of Grove Street (now Martin Luther King Jr. Way) became increasingly integrated as African Americans replaced older Italian residents who had emigrated to the area from the Genoa and Piemonte regions in the early 1900s.[12] These intersecting communities figured prominently in Marty's childhood memory: "You could go to Genoa's deli, right here up the street—the old timers there, babe? Aw shoot! You could put a bet there, they ran a book back there! And Luigi Cerrallo did the same thing down in Dogtown. Luigi had a cash register that wouldn't ring up more than three dollars at a time, but you know, he smoked bacon, he made prosciutto, everything down there. But my dad would take in his venison, and he'd make venison jerky for us and stuff like that."

But Fortieth Street remained a racial barrier between Mosswood and Temescal to the north, and Telegraph Avenue was a crucial color dividing line; Black families were only allowed to buy or rent on the west side of Telegraph. It would take California's ground-breaking 1963 Fair Housing Act—spearheaded by African American state assembly member William Byron Rumford and inspiring the national act a year later—to make it possible for Black people in search of housing to cross Grove Street and then one block further to cross Telegraph Avenue, just before the freeway would be built right along that line. By 1970, the lending industry had moved the red line east to Broadway, and real estate brokers maintained the Telegraph/Broadway corridor (our Mosswood) "as a steep racial gradient."[13]

When I lived in each of these two neighborhoods almost 70 years after any of this grading began, the red lines were still palpable via collectively accepted neighborhood boundaries, along streets like Telegraph Avenue in Oakland and Flatbush Avenue in Brooklyn that had been some of the regions' earliest byways for physical movement.

For Marty's childhood, home in Oakland—with the legacy of this history—was about running and landing someplace safe, but also a place of building power. His own family had a trajectory away from and back to Mosswood: "I was born in West Oakland, my parents lived in Berkeley, when I was three, my parents moved to East Oakland, then came back to this part." And these moves were impacted greatly by the pervasive redlining of Oakland: "It wasn't so easy for a Black family to buy just anywhere." When they did buy, the neighborhood was a place of home, of positivity for him, and as he was living there still, I could see that its change through urban renewal and systemic disinvestment felt like a betrayal of the values that had formed him as a child.

Driving west on Thirty-Fourth Street, under one of the many freeway overpasses that crisscross the neighborhood, Marty explains that this part of the neighborhood was "pretty solidly Black" and that having Lois's dad, a Pullman porter, as a role model played a large part in his own sense of self and belonging:

Her dad was a redcap—you know, the redcaps were the porters. I can never forget, Jack would be coming home from work with that uniform on, and I'd say I always wanted to [be like him]—and he'd say, "No, no, boy you don't want to do this kind of work! This is the same kind of work your great uncle did." My great uncle Frank was a Pullman porter, too. . . . Uncle Frank got a master's degree from the University of Chicago in 1921. Where the hell was he going to work? No one was going to hire him. But this was why you had this degree of progressivism among these Pullman porters, because so many of them were so much better educated than the people that were actually on the train.

Although Lois's dad encouraged Marty to seek different work, the neighborhood's solid Black middle class was due in part to the many people who worked on the Pullman cars. And the fact that these *were* middle-class jobs was due to the organizing of the Pullman porters' union: the Brotherhood of Sleeping Car Porters, powerfully advocating for themselves across the country, the first African American labor union to successfully negotiate with a major American corporation.

For a young boy, the placework of a neighborhood full of people who inspired belonging, values, and a feeling of being valued cannot be overstated. Driving down the block where he grew up, Marty makes clear that this block was once vibrantly populated by people who have since left. "My uncle lived further down the block,

and he owned rabbits, so we ate rabbit once a week. And they used their little turds for fertilizer." This vivid place echoes Marty's assertion that "what we saw on this block was not the kind of blight that you see now . . . but people going to work every day. Black men going to work every day."

THIS WAS HEAVEN

Back in Brooklyn, by the 1970s, all those housing crises, those redlinings, those disinvestments in Black and immigrant communities led to a housing stock in Prospect Heights and New York City more broadly that was full of landlord-abandoned empty buildings, but also homes that still sheltered their residents.

New York City's Department of Housing Preservation and Development had gained a substantial number of residential buildings through landlord abandonment and real estate tax foreclosure (referred to as *in rem* properties), and it began to sell them back to community residents at extremely low cost for rehabilitation into low- and moderate-income housing.[14] Crown Heights (of which Prospect Heights is a part) was one of the original neighborhoods designated for local and federal funds under the federal Neighborhood Preservation Program.[15] In 1964, in one small part of that larger neighborhood the Prospect Heights Neighborhood Program celebrated the signing of a $35,000 contract with the Housing and Redevelopment Board to establish a local field office as part of the city's goal to "fight poverty, eliminate slums and combat blight and deterioration."[16]

By the mid-1960s, the larger West Indian community had become the backbone of the neighborhood, which was the endpoint of the West Indian Day Parade (begun in Manhattan's Harlem in the 1940s and moved to Brooklyn's Eastern Parkway in 1967) after a route through the rest of Crown Heights.[17] The neighborhood would remain so central to this community that thirty years later, Garry Pierre-Pierre would headquarter the *Haitian Times* on Prospect Heights' Vanderbilt Avenue.

At the same time, since as early as the 1940s and picking up pace by the 1960s, there had been a flow of young, college-educated, mostly white progressives moving to Brooklyn and buying and renovating the old row houses. They called themselves *brownstoners*.[18] Their buildings of choice were brick-and-timber buildings faced with stone made brown by hematite. This type of building had originally been built as homes for the wealthy, but came within reach of a middle-class budget through mass production in time for Brooklyn's population to surge when the Brooklyn

Bridge opened in 1883.[19] By the turn of the century, developers were building few new brownstones, and by the Depression and World War II, many brownstone owners had broken their buildings into rooming houses.

While the brownstone movement was largely white, the in rem property program for abandoned buildings and Prospect Heights' history of community organizing led to a more diverse mix of homeowners there than in other brownstone neighborhoods. Historian of "brownstone Brooklyn" Suleiman Osman stresses that the brownstoning in Prospect Heights and other predominantly Black neighborhoods like Bedford-Stuyvesant and Prospect Lefferts Gardens was not solely white, and was often driven by local homeowners, many of them Black women. Some of the first brownstoners in the late 1940s and 1950s were West Indian immigrants who bought those broken-up rooming houses and converted them back to single-family homes. And brownstoners did not only act as individuals; for some, brownstoning was a purposeful and politically organized act. As Osman writes, "Starting in the late 1960s, groups of African American homeowners concerned about white flight and city redevelopments plans organized new civic groups and block associations to fight redlining, improve the image of the area, and encourage potential brownstone renovators both black and white to move to their area."[20]

It was in this way that one of my tour guides, Neville, originally from Guyana, bought his shop and building on Vanderbilt Avenue in 1977. He described the experience as *homesteading*, with working families trying to make something good for themselves there. "I bought that building as an abandoned building," he remembers. "You couldn't walk up the front stairs."

In the same month of that same year, David W., originally from Maine, would also buy a building that held all of these histories. David and his wife walked through Prospect Heights and were amazed by the size of the brownstones. In an enchanted tone, David explained that "these places were like castles." As we walked down his street, the one my grandparents had lived on so many years before, David, still starry-eyed, conjured for me how they'd found the house in which he still lived:

So we were just walking down here, and this was this Volkswagen bug driving up the block with four women in it. She . . . honks the horn and yells out the window, 'You looking for a house? You don't have to worry, I'm not a real estate agent.' [She] said, 'We got all these old rooming houses just waiting for somebody like you to come and pick it up real cheap and fix

it up.' [She] knew everyone on the block [and] dragged us down here and said this house is available. It had been available . . . on the market for two years, two sales had fallen through.

As we stood there, I imagined back twenty-five years to that overstuffed VW, cruising down the street, about to change David's life. I imagined it as yellow, though I don't know that it was. Standing in the middle of the sidewalk, David described a whole life beginning in one moment, as he said, "So we went down to Underhill and turned and went down Park, and that's where it all began to happen. You know? I became a father. It was just that quick."

This tall brownstone that would come to do the cherished placework of building belonging for David had previously done that crucial work for someone else. On his tour, David told the story of Pearl P. Jefferson—one of the Black women so central to investing in this neighborhood—a story he had taken it upon himself to steward and to hold:

We came back the next day and went through it and it was as if the woman still lived there. I mean, everything she had owned was still there in pretty much the place where she had left it. I think she died when she was eighty-nine, Pearl P. Jefferson. . . . Everything I pulled out of the house, I looked at. So I found out things about her, her family, a few pictures. . . . She came in and this was really heaven to her. She had worked hard her whole life to get something together, and she got it here, thanks to an insurance policy from a son, who didn't make it out of a knife fight on the streets of Newark. She bought this house and this was it. She lived here about fifteen years. The last years of her life.

Back at his house, David continues to tell me about Ms. Jefferson and her house: "It was crammed full of stuff, and it had wall-to-wall carpet, very heavy drapes, double drapes on all the windows. Clearly she was trying to conserve on the heating bill. This was her sewing chair," he says, gesturing to the favorite chair he's sitting in. Patting its wide upholstered arm in a familiar way, he explains, "This was a sewing chair, so she had room to put all her stuff, and this was her pincushion."

As he gently pats that chair's arm, I think of all the things Ms. Jefferson must have made in that house, how in many ways she made the house itself, and the power of that creation. I can think of no better description than of bell hooks's word *homeplace*: home as a place made by Black women, radically political in that it resisted white supremacy by creating "that small private reality where black women

and men can renew their spirits and recover themselves."[21] And I grieve a little that when Ms. Jefferson passed, she had no one to whom to give that home.

BUT THEN I FOUND THIS NEIGHBORHOOD

In Oakland, several years after my walk with David W., Cynthia began to tell me stories about belonging and "her place" that reminded me of David's life-changing house-finding. Comparing Mosswood to her old upper-middle-class neighborhood, she explained, "I actually feel more comfortable in this neighborhood than I ever did there. . . . I come from a working-class background, and there would be sort of a snooty feeling to some of the people there." Continuing, she described another prior neighborhood, where she said she had often been "hassled." Cynthia explained, "It was mostly the teenage boys who were just uncomfortable with the presentation that I make, you know? I am so clearly a butch dyke. . . . So I would get hassled there more than I've ever been hassled anywhere that I've ever been." Continuing with relief, as if narrating a story with an inevitable ending, she sighed, "But then I found this neighborhood." Yet this surprised her a little based on the neighborhood's past reputation. "In the '70s," she explained, "[I was] warned, don't go walking in this park, because . . . people get shot just for walking through." Her tone changed when she described what she'd actually seen in the mid-1990s: "But . . . as I was driving through here, I wasn't seeing any of that. I was seeing kids playing in the park. I was seeing people out talking to the neighbors."

She eventually moved in and fixed up a house with the woman she would later marry. Cynthia remembered the repairs vividly, starting from scratch, moving in "by myself, while the walls were all torn apart." Finally, she described quite simply and with love how she began to be a part of the place: "JoAnn finally moved in and I started to get to know the neighborhood."

**

People also told me painful, violent stories, stories that nonetheless highlighted how much of a sense of home, belonging, and trust they had in their neighborhood—and how hurtful it was when that was shaken. In 2006, Julia told a story that both contradicted and cemented her sense of belonging in Prospect Heights:

Well, I'll tell you, I was mugged the April before last. The guy came toward me and he said, "Don't move, I have a gun." So, I was really incensed. My neighborhood? No, dude, you're really wrong! I live in a really nice neighborhood and now you're proving me wrong. So I screamed my bloody head off and what I screamed was the descriptions—he has on a quilted jacket, he has on blue jeans, he's bald-headed, he's six feet tall—people came out. . . . By the time I'm in the house . . . the cops were there, they said, we've been looking for you—it wasn't long enough to change shoes! So, I go identify the guy, and it's kind of a done deal, the cops drove me back. And then the next day, everybody who saw me said "You're the girl. We called." And that's what this neighborhood is like—if you're in trouble, say it. People will come. People handed me their cell phones, dogs came . . . and I was like, looking at the guy, going, dude, do you not understand that this is a very friendly neighborhood?

A few blocks from Julia's house, we turn up Park Place, and Mike points out the beautiful brownstones. Then he tells me what he really thinks of when he looks at that block. He mourns Amy Watkins, a young woman, my age, who was mugged and stabbed to death on that block in 1999.[22]

My plumber lives in the middle of this block. It's a really nice block. I don't know if you remember Amy [Watkins]? I think I just missed that scene, 'cause I was blading around. . . . When Amy went down, I was freaking out. She was like you. Saw her all the time. She was always in my store. Good girl. Yeah, talk to her, you know, "Amy!" We used to have little convos, you know? It really hurt me. I couldn't believe it. I couldn't believe it in a neighborhood like this. It sent this neighborhood back ten years. This neighborhood is really nice. It was really nice when Amy lived here too! You can't relax and keep your guard down, this is New York! . . . Every girl that comes here, I give them mace.

Mike's personal sadness is thoroughly mixed with his sense of what Amy Watkins's murder meant for the progress of the larger neighborhood. Another Prospect Heights resident, around Amy Watkins's age, told me that long after the crime happened, on this tree-lined, brownstone block, she would still cross the street to avoid the unnoticeable spot where Amy Watkins had been killed.

**

It is because placework that builds belonging is so powerful that it is essential to understand how its loss deteriorates functional cities and societies. Early studies

of loss and displacement, like Herbert Gans's work in Boston and Michael Young and Peter Willmott's work in East London, highlight the power and importance of this relationship to place. In fact, psychologist Marc Fried's 1963 study of forced relocation from the West End of Boston found a parallel between the grief response to the loss of significant people in one's life and the grief response to the loss of important places.[23] Mindy Fullilove's later work deepens this psychological thinking in her writing on what she calls *root shock*. She underscores the deep connection between people and their places: "Our emotions flow through places . . . when a part is ripped away . . . root shock ensues." This kind of loss is not just an emotional or intellectual or practical one, but, as Fullilove writes, it is a very physical one, a kind of traumatic stress reaction that "threatens the whole body's ability to function . . . the fight for survival after a life-threatening blow."[24] These kinds of threats to place-work, these losses of place, are existential for the people who experience them and can stay with people for a lifetime, even being passed down through generations.

In Prospect Heights, there had been fears of displacement, and action to avoid it, since the 1980s. In 1988, a *New York Times* article that heralded Prospect Heights beginning a climb to gentrification also stressed the strength of community organizing in the neighborhood. It noted that "what may ultimately distinguish the Brooklyn community from other centers of renewal such as Park Slope or Cobble Hill is the tenacity with which long-time Prospect Heights residents are organizing to hold on to a place for themselves amid the co-op conversions and escalating prices." Haddie Bowers, head of the Prospect Heights Housing Development Corporation, which created low-cost housing, told the *Times* about the challenge of keeping the neighborhood diverse and the need for community-developed affordable housing: "Prospect Heights has been a community that has struggled for years to keep our neighborhood economically diverse, and we are going to see that it stays that way. . . . Unless we hold these buildings for the other people of this neighborhood, we will end up with a community that is exclusively upper income, with no place for anyone else."[25]

At this same time, whether Prospect Heights would end up more connected to Park Slope or to Crown Heights became an important part of the neighborhood's story. In 1986, a local organization, Prospect Heights Neighborhood Corporation, argued that a New York City development plan was trying to split Prospect Heights from the rest of predominantly Black Crown Heights and tie it to what had become a whiter, more affluent Park Slope by using what they called the "red line" of Washington Avenue. In the plan, all city-owned buildings available for market rate development were located west of Washington, and all low- and moderate-income sites

were east of Washington Avenue, toward Crown Heights and Bedford-Stuyvesant.[26] Similarly, my tour guide David W. recalled the community discussion in that period about whether to become part of Park Slope's seventy-eighth police precinct or remain part of the seventy-seventh, which served the rest of Crown Heights. The decision was contentious and split. Most, though not all, of the neighborhood remained part of larger Crown Heights' seventy-seventh precinct; the neighborhood hadn't just made a decision about safety but also a statement of allegiance and identity.[27]

MY TRUST IN PEOPLE

Even from my very first tour, fear of impending loss had been a theme, and often one unevenly felt and reproducing larger discourses of political and racial power.[28] For many of my tour guides, by the time I returned to them to show them photographs, they had moved out the neighborhood, meeting me elsewhere or on an emotional trip back to the old neighborhood to follow up. Each time I walked in the neighborhood or met with a tour guide, I kept thinking back to Shehadeh's *Palestinian Walks* and how he worried, "Now when I walk in the hills I cannot but be conscious that the time when I will be able to do so is running out."[29] While I knew it wouldn't be checkpoints and barbed wire that would make familiar places off-limits, as it was for Shehadeh, I still worried that the neighborhoods we walked would be irrevocably changed, gone.

Neville began our walk in Park Slope in 2001 by telling me what *had* been so important. He seemed to see a past neighborhood while also taking in the undeniable physical reality of change, and the tension didn't sit well with him. Walking up Seventh Avenue, almost to the corner of Flatbush, where Park Slope meets Prospect Heights, he quietly, and then more forcefully, declared, "I love this neighborhood! I love this neighborhood." Carrying on, he explained: "But when I was ready to buy, I could not buy in this neighborhood anymore, so I went over in that [area, in Prospect Heights]. When I was in it [Park Slope], it was a mixed neighborhood. Young, working people. And I get most everything here that you used to get in the Village. The stores . . . Believe me—I enjoyed living in this neighborhood more than Vanderbilt Avenue!" In 2001, he saw Prospect Heights' future. "Nothing has really changed with this neighborhood. But as time goes on, you know it will. It's nothing like what Park Slope is now. But it's going to change. I know it. It's going to change."

As we walked up to Vanderbilt Avenue, Neville came to explain why neither Vanderbilt Avenue nor Park Slope was his neighborhood any longer:

I went into Vanderbilt Avenue when most of the buildings were abandoned. And I was there until now. My building was abandoned. You couldn't walk up the front stairs. When I moved over I set up a darkroom and I started to do photography.

About twenty-four years I was there. I had the second floor and the store. I bought the building because of the store. I wanted to have a business of my own.

My trust in people is why I'm out of the building. I shipped merchandise down to the West Indies, but they didn't send the money back. I had the building all paid up, but I had a small commercial loan on the building.

I would still have it, if I hadn't been introduced to a company that helped people in financial problems. They were a fraud. They said they'd do the work I needed and then hand the building over to me. They didn't do anything, and the bank foreclosed on them. That's why I'm out of Vanderbilt Avenue, and all my stock is in the dumpster.

It's a long story, and it makes me sick and my kids said look, let it go.

Now I'm in East New York. My wife just told me that that owner wants a rent increase already! Not even a year. I have to look for some place.

Nothing has really changed with this neighborhood. But as time goes on, you know it will.

This kind, trusting man's voice was now almost cracking over a tragedy that had occurred two years earlier, and in which I felt in some way implicated.[30]

Fifteen years later, Neville and his family had long since relocated yet again and closed his business. As I kept returning to Prospect Heights, I saw that what Neville had said had come to pass, and more so. In 2015, two long-time residents recorded oral histories about living in Prospect Heights as part of our *Intersection | Prospect Heights* project, in which it was clear that these fears and the real risks had only grown. Long-time neighborhood resident and elder Rhoda explained, "Everything is topped up, and with my husband not well, I need a bath and two bedrooms. But you cannot find it, not in this neighborhood. If I have to go out of the neighborhood to find what I need—not want, but need—that's what I'll do, but I would hate to leave here, because I know everybody on both blocks."[31] As an older person, and a renter, Rhoda had very little stability and her fears about being priced out were very real. These fears were echoed by the experience of another long-time resident, Akosua, who explained: "I enjoyed living here, it was just a matter of being priced out. It really is displacement of people who have been living here, for generations,

or ten, twenty, thirty years. This neighborhood is no longer affordable for the average New Yorker."

And finally, in a public event for *Intersection | Prospect Heights*, a newer resident of the neighborhood would stand up to encapsulate her own search for belonging, as well as at the same time her bewildering sense of the loss of belonging, through familiar places made strange. During one of our *Intersection* story circles, Samantha, then a new resident of Prospect Heights with deep family roots in the Black community in the neighborhood, would share how she grappled with coming back as an adult and finding the neighborhood utterly changed: "I grew up in Brooklyn. I knew Crown Heights/Prospect Heights as where my aunts lived. This was a place to get my hair braided, to go to the parade. When we were looking for apartments, it was really strange to be looking at spaces that used to be my elders' homes. . . . I kind of felt like this was a home away from home, but things were not looking completely familiar . . . and that's really frustrating because growing up, it *did* feel like a community."[32]

<div align="center">**</div>

Of course, change is central to place, as Marc Fried explains: "If we grow and age in place, the environments in which we are born and reach adolescence are no longer the same as the places in which we become adults."[33] Yet the displacement spurred by gentrification and large-scale development is not inevitable, and it benefits only very specific people; it rarely benefits existing residents, and usually benefits people who don't live in the neighborhood at all. But the changes these Prospect Heights and Mosswood residents experienced have been normalized as natural, rather than acknowledged as the result of treating homes as investments. Displacement is also the result of cities with a patchwork of constantly expiring series of affordable housing policies and incentives that mask the fact that housing in the United States is nothing more than physical capital, and that housing stability and humane places to live and play have never been the goal. Yet feeling a sense of belonging at home and finding—and being able to stay in—your home remain some of the most essential parts of becoming ourselves. Landing someplace safe allows us to go out into the world as stable, contented people, able to contribute all we can to the world.

PORTFOLIO FOUR:
PROSPECT HEIGHTS

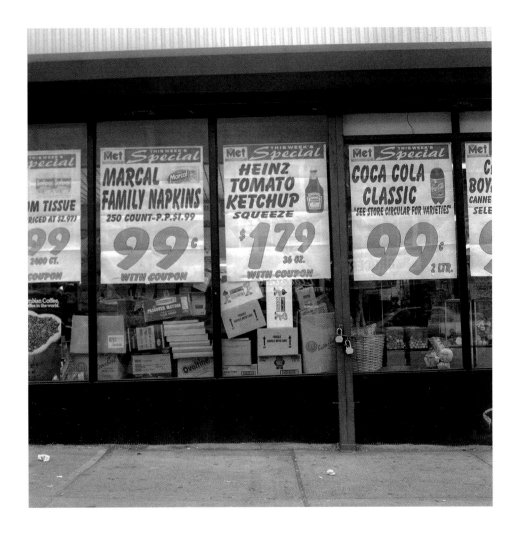

Met Food, Vanderbilt Avenue, 2002.

Met Food, Vanderbilt Avenue, 2006.

Met Food, Vanderbilt Avenue, 2006.

It's probably the supermarket.

Met Food supermarket, 632 Vanderbilt Avenue

Talk about capturing the sense of the neighborhood, Met Food. "You're homebound, don't worry. Call us and tell us what you need and we'll get it to you." I haven't heard of that kind of service in New York since I first came to visit my aunt who was an always unemployed actress, living where Lincoln Center is now. I just wish my aunt could be here to enjoy it. She died with a Bloody Mary in her hand. It was her Sunday morning ritual. She mixed it, sat down, boom.

If there were one thing that talks more about this community than anything else, it's probably the supermarket. Because of the people that are there and what they try to do. They do it to make money, granted, but they seem happy to be here in this neighborhood, concerned about people, concerned about delivering service to the whole neighborhood. It's not that they came in and decided, "Oh, we're getting rid of the Goya stuff here, you know? We're going upscale." No. Still got ham hocks there. Still got pig's ears.

It's what made this neighborhood for us. I mean, we got very lucky on the house—but it's the fact that it's a comfortably mixed neighborhood. Now, I can't pull down my veil of ignorance, I'm part of the dominant society, but it just feels to me like a comfortably mixed neighborhood.

—David, 2003

Brooklyn Public Library, 2002.

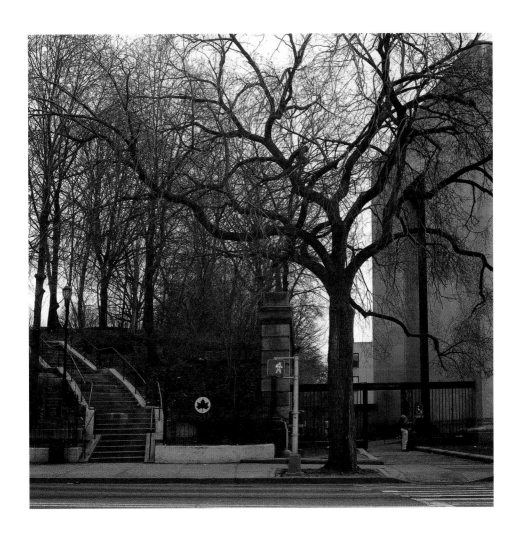

Brooklyn Public Library, children's room entrance, 2002.

Neighbor-made patch, Park Place, 2002.

New houses, Underhill Avenue, 2002.

"All kinds of people used to be over there."
Saint Marks Avenue, 2006.

All kinds of people used to be over there.
Saint Marks Avenue and Vanderbilt Avenue

These two guys lived here. We used to have wild parties there. The first year I was here, we'd go to their house and, you know, girls and guys, all kinds of people used to be over there, and I'd get sloshed. When I used to come back, I used to be so alone.

When you're drunk the day before, I don't know how drunk you've gotten, but you don't feel like doing nothing the next day. And me, I get mad at the world. Her fault. That bitch made me do it—she gave me that first drink. Or, that son of a bitch, if it wasn't for him coming by with two bottles I would've never drank.

Then, at the end of the day, I look in the mirror and say, nobody's fault but mine. I could have said no. Finally, I said, my god, enough is enough, now I'm gonna see, because everyone tells me that these people from AA can help me. Let me see what these people can do for me. I'll give it a shot, for heaven's sakes. Then, when these people used to come by, I'd tell them, "Not today." Maybe tomorrow, but today, I can't.

—Mike, 2002

5

PROBABLY THE SUPERMARKET

As we stand on Eastern Parkway in front of the Brooklyn Museum one September day, Julia describes when this street was new. "There was a concept, 'Brooklyn is the world'—you don't need to go anyplace else," she says. She then imagines what it was like in 1915 for the subways to connect the newly joined cities of Brooklyn and New York: "The day that the subways opened up, people came to far reaches of Brooklyn that they had never been to, and they walked back . . . and they said, I'm going to live here, I'm going to live here. And the next year, half of the population of Manhattan moved out and moved to Brooklyn."[1]

Brooklyn, incorporated as its own city in 1834, always thought of itself as a grand city, grander even than that one across the East River, so it's not surprising that in 1859 it was decided that Brooklyn needed an impressive public park to rival the "central park" being built in New York City.[2] Frederick Law Olmstead and Calvert Vaux—famous designers of that New York park—would have to wait until 1866, after the Civil War and Olmstead's return from designing Oakland's Mountain View cemetery, to make a proposal for a Brooklyn park intended to give visitors "a sense of enlarged freedom."[3] While the Canarsie had created one of the borders of Prospect Heights—the road that would come to be called the "road to Flatbush," and eventually Flatbush Avenue—the Prospect Park development project would create the second boundary, Eastern Parkway. Planned for "pleasure-riding and driving," the parkway would connect the new Prospect Park with other places of leisure throughout the cities of Brooklyn and New York. The first stretch, from Grand Army Plaza to Washington Avenue, opened in March 1874; by the end of that year,

it stretched to Ralph Avenue (now Brownsville, then considered Prospect Heights), thereby sparking the construction of one whole side of Prospect Heights and Crown Heights when hundreds of lots along the new "parkway" went up for sale.

The area abutting this new street had been far removed from the village of Brooklyn until the mid-nineteenth century; around 1825, it was a horticultural garden way out in the country.[4] Although the garden was broken up into streets and lots by the 1840s, there was little built development of the area until the 1860s. By the next decade, the area along the new Eastern Parkway as well as the area down one side of Prospect Park (the area now known as Park Slope) would all be known as Prospect Heights, though the name was up for debate. An irate 1889 letter to the editor of the *Brooklyn Eagle*, signed by "Residents of Prospect Hill," explained, "You will hear such remarks as this: 'When I moved to this hill,' or 'they are building some fine houses on this hill,' or 'This hill is growing rapidly,' but they never say 'When I moved to these heights.' . . . Yet some people are trying to fasten upon it the name of Prospect Heights, a name which is never used in common conversation, and which smacks a little of affectation."[5] But ten years later, newspapers like the *Brooklyn Times* were often writing about the "little society on Prospect Heights" in reference to the whole larger area.[6]

The papers would be filled with references to men's civic groups—such as the Prospect Heights Board of Trade, which had been meeting for several years in the Cribbage Cafe on Franklin Avenue and Sterling Place and which advocated for new firehouses and subway and elevated train expansions (while also opposing a new playground).[7] Another influential group of men called the Prospect Heights Citizens Association, whose membership included mayors, politicians, and other elites, would wield considerable power in the shaping of the areas we now consider Park Slope, Prospect Heights, and parts of Crown Heights, weighing in on traffic islands and the expansion of the subway in Brooklyn, and opposing plans that included a new police headquarters on Sterling and Flatbush, new shops on Underhill Avenue, and the development of apartment buildings.[8] Whatever the elites of these civic groups thought, by the 1920s, large apartment buildings in keeping with the grandeur of Eastern Parkway and beyond would demolish the small buildings built forty years earlier. And around the same time, the name Prospect Heights was regularly in use by everyone from local bowling clubs to Boy Scout troops.[9]

Imagining a cultural, recreational, and educational district around their Prospect Park, another group of elites, the Brooklyn Park Commission, set aside a location for a central library in 1889, and the following year planned a museum. The

museum opened within the decade, but the library only broke ground in 1912, after Brooklyn and all its neighborhoods, and its grand civic pride, were incorporated into the city of New York in 1898. Library construction was halted by World War I and the Great Depression, its delays much complained about by the powerful folk of Prospect Heights, and finally opened to the public in 1941 more than fifty years after its initial planning.[10]

THIS IS BIGGER THAN ANYBODY

While the Brooklyn Park Commission's whole nineteenth-century development had lofty, even elitist goals, the work its monuments now do might not always be the work their boosters intended; they build belonging and support people's becoming themselves in sometimes surprising ways. As we're looking at my stack of neighborhood photographs together, with great enthusiasm Tanya picks out an image of the library's front entrance, with kids waiting outside. "Now this!" she exclaims "You walk across and you see this and it's just gorgeous. 'BROOKLYN PUBLIC LIBRARY.' I look at this, and think, wow, there used to be creativity in this country." Tanya makes me laugh.

She pauses a moment, and as she goes on, I realize that it isn't just home places that do the placework of helping us belong:

I mean, it's a public library, but you have all these magnificent carvings and sculptures and things up here, you know, and all the sayings about the "longing noble things"; I don't know what the whole thing says . . . but, this is written in stone, this is what we really believe, this is for everyone. You can't miss this. There isn't a little sign saying this is for the public; this is huge, this is bigger than anybody. . . . You see people standing outside, waiting for the place to open, even on freezing cold days . . . it's a mecca, it's a place that people like to go to. I mean, you see all kinds of people in there. And it's for everybody, you know? It may be this big place, but it's not a place that you can't go into. It's very accessible. The public library at Forty-Second Street isn't. Yes, you can look at the lions, but do you go in?

Julia too loves the Brooklyn Public Library, and indeed, cares very much about everyone who goes in. As she and I look through the stack of photos on another day, she pulls out a different image showing the entrance that goes straight into the children's room, on the side of the building where the art deco library nestles up to the trees of Mount Prospect Park, a hill that had been an American stronghold

in the Revolutionary War's Battle of Brooklyn.[11] Julia points to the photograph and begins to explain her pride in her neighborhood and her hope for the neighborhood's children. "This is the children's entrance to the public library. It's just a gem that belongs to us. How am I so lucky? And the sweet little children that go in there—they come out with their little books, and they're like . . ." She trails off, imitating the kids' sounds of proud, deep breathing. She sees how this place does the work of not only providing books to kids, but that doing so in this special place does the work of making all those kids—and Julia herself—feel lucky, feel like they have values, they are valued, they belong.

Another day in early September, after Julia and I have breakfast together at what she calls "the boys' place"—Mike and John's diner, George's—she explains, "I'm going to take you up to Grand Army Plaza first and I'll tell you why that's important." Yet as we walk, smaller monuments also show up. At the corner Julia says, "Oh! Let me show you the front of this building. [It] was just horrible . . . but . . . now, it's called the Prospect and it has Corinthian columns and this beautiful cupola on top of it and it just really saved the block. And the guy who did this development was a young African American man, so we're also very proud of him." We make it to the maze of crosswalks, rushing traffic, and circular roads of Grand Army Plaza at the start of Eastern Parkway and the entrance to Prospect Park. We brave the traffic to reach the island in the center, where stands a massive triumphal arch, built in 1892 to honor those who fought for the Union in the Civil War, officially called the Soldiers' and Sailors' Memorial Arch. There we stop, and Julia shows me another monument that for her as an African American woman stands for national belonging and accomplishment: "Grand Army Plaza, the statue is a phenomenon—I'll tell you why. Ok, you stand on the right-hand side, facing the arch, lower bottom is an African American with a gun. That's phenomenal. That says we trust. That says America. It blew me away when I figured it out. And it's just a casual little thing. You wouldn't catch it. It says we fought. We were there. He put his life on the line! Because running away could have seriously been an option." In the midst of this bewildering intersection, and in the guise of a military arch, the idea that this place can do the work of fostering belonging takes my breath away.

MET FOOD

Places like the library, the museum, and the Grand Army Plaza arch are the kind of capital-letter Important Places we might read about in a guidebook—and we expect

things of them. But it turns out that a simple, one-story building with aluminum siding might be even more powerful. In every neighborhood, there are places like the Met Food supermarket in Prospect Heights that have obvious practical uses—a supermarket sells food—but that may also do a much more complex placework cementing belonging in the neighborhood.

This first became clear when Tanya pulled out a picture of the street in front of Met Food from the pile of photographs we were perusing in our second interview and explained to that she liked this one, saying she knew the man in the photo and it made her think, "The original guys, I look at them now, and I'm going, ooh, they're getting older, and then I'm like, well, so am I." For her, this black and white photograph I'd made of an unassuming supermarket opened up questions about mortality and the passage of time. When I asked her what was missing from the picture of Met Food, she replied, "Maybe the cashiers . . . 'Cause they're always, 'Hi, how're you doing? Oh the baby's getting big . . .'" Thinking about Tanya's relationships with the cashiers, and that the supermarket really required a color photograph, I made some more photos for her, and also later showed them to David W.

Although David had only given the aluminum-sided supermarket a cursory glance on our walk, when I asked him later to pull out the photographs that most felt like his neighborhood, he pulled out the ones of Met and began to explicate the surprising placework it did, saying:

If there were one thing that talks more about this community than anything else, it's probably the supermarket. Because of the people that are there and what they try to do. They do it to make money, granted, but they seem happy to be here in this neighborhood, concerned about people, concerned about delivering service to the whole neighborhood. It's not that they came in and decided, "Oh, we're getting rid of the Goya stuff here, you know? We're going upscale." No. Still got ham hocks there. Still got pig's ears.

It's what made this neighborhood for us. I mean, we got very lucky on the house—but it's the fact that it's a comfortably mixed neighborhood. Now, I can't pull down my veil of ignorance, I'm part of the dominant society, but it just feels to me like a comfortably mixed neighborhood.

For David W., while he says you'd never put this supermarket in a guidebook to the neighborhood, it is terribly important to him. This place supports David's sense of belonging and the kind of place in which he wants to live. Although it is a supermarket,

not a home, this can still be a place that houses his sense of self; it could even be a place to dwell, in that Heideggerian definition of *dwelling* as a place that "shelters . . . men's lives."[12] This supermarket helps define what kind of neighborhood this is that makes him feel at home. There, David, an older white man, experiences people who value the diversity of his community, who do things (like delivering to the home-bound) that are part of the kind of community in which he wants to live. The physical building itself reminds him of all this, and when he walks by, he waves at Frank and Abdul, who own the store.[13] In short, he sees in the supermarket a place that supports his values. It is easy to identify the practical use of places like supermarkets, but the emotional work a place may do isn't always so obvious.

Met Food supermarket also helps the other David, the teenage David K., build his sense of values, which he makes clear when he tells me about work, honesty, and care. As David K. and I walk on Washington Avenue, past the barbershop where he gets his hair cut, we pass a different supermarket. He dismisses this other store because he says they just allow kids to come in and ask for change for bagging people's groceries, whereas he has a proper afterschool job at Met Food that he's proud of. He points out a kid leaving the supermarket, William, and tells me not to be fooled: "He look nice, but he's not. He's bad." Carrying on, he tells a story that begins on a day when he heard a big boom outside his window. William's brother had "a three-forty firecracker, and he was playing with it, and he lit it, and it didn't go off. So he used the hose and outed it . . . and he picked it up, and it blew up in his hand. And blew his finger off. He's still got this part, but it's a stub on his hand. Now he know *not to play with fire*."

LITTLE WHITE HOUSE

Consequences and the struggle to live one's own values system are not far from Mike's mind either. When we looked at photographs of a small white house on Saint Marks Avenue that he had only noted in passing when we walked, he told a story I could never have predicted. On our tour, Mike had said: "These friends of mine used to live in this little white house here."

So, as I was going back to photograph all the places Mike's tour had touched on, I took a picture of the house, more interested in its architectural uniqueness in the neighborhood than in Mike's brief mention of it. I was interested in the contrast of the clapboard with the empty lot next door, as well as in trying to make a photograph imagining how it might feel to walk through that gate as a familiar

place. But when I showed it to Mike, the photos offered a second chance to tell me the important story that was embedded within the house:

These two guys lived here. We used to have wild parties there. The first year I was here, we'd go to their house and, you know, girls and guys, all kinds of people used to be over there, and I'd get sloshed. When I used to come back, I used to be so alone.

When you're drunk the day before, I don't know how drunk you've gotten, but you don't feel like doing nothing the next day. And me, I get mad at the world. Her fault. That bitch made me do it—she gave me that first drink. Or, that son of a bitch, if it wasn't for him coming by with two bottles I would've never drank.

Then, at the end of the day, I look in the mirror and say, nobody's fault but mine. I could have said no. Finally, I said, my god, enough is enough, now I'm gonna see, because everyone tells me that these people from AA can help me. Let me see what these people can do for me. I'll give it a shot, for heaven's sakes. Then, when these people used to come by, I'd tell them, "Not today." Maybe tomorrow, but today, I can't.

The photograph served as a jumping-off point for both a memory of the site itself and a story that Mike needed to tell of his struggle-and-rebirth identity that undergirds his personal code of values. When I put this story and the image of the house into one of the *Intersection | Prospect Heights* guidebooks years later, Mike collected copies of that guidebook to give to the people he sponsored in Alcoholics Anonymous (AA). The house was a monument to the ability to say no, and having the story printed was proof that it had happened, that he had, indeed, said no; that other people could say no, too.

We read this story on the public walking tours of *Intersection | Prospect Heights* in 2015, by which time the small white house had been torn down and a new condo building built in its place. Participants would begin by laughing, giggling at the language, at "I don't know how drunk you've gotten"—but as it wore on, as one of them read the story aloud on the street, the giggles died away, and the impact of this place, the way that people's struggles are just below the surface, that we all carry so much, some of us carrying things that are very heavy, began to sink in.

IT DOESN'T HAVE TO BE A BIG THING THAT YOU DO

While an unusual house helped Mike stay on the straight and narrow, and both Davids dwelled at the supermarket, Tanya dwelled at the diner. When I asked her to

pick a photograph that felt most important to her from the large stack I had made, she picked one of the inside of George's—the diner run by siblings Mike, John, and Mary. The picture shows the diner's counter, with John behind it and Mary in her flowered skirt standing at the end of the counter, her head at the same height as a customer sitting on a vinyl-covered stool, eating breakfast and reading the paper:

I really like this place. Besides the fact that you see different people, you just hear people talking, joshing around. . . . It's a very mixed crowd in here, race, sex, age. You see people from all different backgrounds. You see cops come in here, you see Sanitation, you see park police, plumbers, accountants, politicians, and you hear people talking trash . . . it's funny! Mike gives the place its life, 'cause he'll talk to anybody and he'll talk crap with anybody!

Here in New York . . . America . . . you have this whole thing about being somebody and being somebody of a certain level, the doctor, the lawyer, the Wall Street whatever. . . . And you have people here who have a life, they run a luncheonette, and they make people happy, and they know they make people happy. They like it? They come back. They don't like it? They don't come back. It appeals to me very viscerally.

It makes me realize, yeah, you need some money, but you don't need to be chasing, just chasing a dollar to the exemption of everything else. And it doesn't have to be a big thing that you do. . . . I feel that they love it, and that makes me like it also.

Tanya's stories about George's are not about the diner as a restaurant but rather about a place that reinforces her own values—for example, relating to people from many different walks of life. Perhaps surprisingly, it's in a business space that she finds reassurance that there is more to life than the bottom line. This diner appeals to her "very viscerally," giving us a sense of how crucial its work is in fostering Tanya's values of family and care.

And Mike would echo these values many years later, and their loss, at one of our *Intersection | Prospect Heights* events at Brooklyn Public Library, after he and John had closed their diner, which they had renamed since Tanya had frequented it.[14] "The Usual was a place that was exceptionally friendly—you'd hear me and my brother screaming all day—*Gaby* would come in and we'd say, '*Gaby!* What's happening?!' . . . The neighborhood in twenty-three years that I've been here has changed very very much. When I was here, it was nothing *about* money. Everybody does need money in the world, but what I see right now is its become cutthroat—it's

beautiful still—but if you don't have money, you're not welcomed and be gone! There's no such thing as 'I'll pay you tomorrow,' not that I know of."

EVERYTHING THEY LOVED

If these monuments and supermarkets, libraries and diners do the powerful work of building belonging, other factors can create the opposite—what Roberto Bedoya has called *disbelonging*.[15] Places change, stores close, things get more expensive, neighbors move, by choice or by displacement; loss of community creates enormous personal stress.[16] Yet people's connection to place continues even as the place changes around them. For my tour guides, still connected to their disrupted neighborhoods, loss of belonging was as dramatic a player in their senses of self as the feeling of belonging itself had originally been. In Mosswood, Marty, Lois, and their friends and families lost partial neighborhoods to urban renewal yet lived on in a physical neighborhood persistently scarred. This and the later disinvestment of West Oakland from the 1960s to the early 2000s had made the neighborhood feel foreign to Lois. But looking at a picture of the corner of Market Street and Thirty-Fourth Street, which now houses a dilapidated corner store but which in earlier times had housed a local market owned by a Chinese family, Lois enthuses, "Oh! Teddy's! This was Teddy's Market when I was a kid. We loved it there. You know, this guy, an Asian guy, came into the store [where I work] the other day, and he said he'd lived in the neighborhood growing up. And I said, 'Oh did you know Teddy's Market?' And he said, 'Yes!' And we just laughed and talked about how great it was—you know it was always better then—before was so much better. I love meeting people from the old neighborhood. It makes me so happy."

Influential Oakland dancer Ruth Beckford was also born in the neighborhood, in 1925. She lived on Thirty-Eighth Street before it was turned into MacArthur Boulevard, and like Lois and Marty (and Huey Newton) went to Oakland Tech, albeit two decades earlier. Beckford's memory of her walk to high school echoes both Lois's love of the neighborhood and her loss of people who made the place, a loss directly caused by government violence:

Our neighborhood (which was called North Oakland then, now it is called West Oakland) was very integrated. There were a lot of Japanese and we were all friends. The war started on my sixteenth birthday, December 7, 1941. That was a Sunday. When we went to school the

next day, everyone was crying and carrying on. People had scrawled on the sidewalk, "Go home Japs!" We cried. They were our friends. After a half-day, they sent everyone home. We lost all our Japanese friends. From one day to the next they were gone, and they never came back after the evacuation. We were very depressed. It was almost like science fiction. They were just gone.[17]

<center>**</center>

Although paling in comparison to this wholesale internment of a group of innocent people, across Oakland and Brooklyn people mourned many smaller losses too. They mourned how those lost experiences had made them feel—reminding me of a man anthropologist Setha Low interviewed in a Costa Rican park who was devastated by the cutting down of a palm tree because he missed "how it felt to sit in the shade of that tree."[18]

Sometimes the loss was physically visible—a favorite store gone; and at other times it was felt—a loss of shared values. Sometimes it was both. This was particularly noticeable in the ways that people talked about how gentrification was making their neighborhoods feel unfamiliar, how they sometimes felt like unwelcome strangers in their own places. In 2015, at an *Intersection | Prospect Heights* event, Rocky reflected on this experience more eloquently than I ever could: "It's sad for those of us who have been here a very long time and know that the people coming in won't have similar values. They'll come in and they won't want you to sit on their stoop. . . . They'll look around and wonder how they can change everything they loved about this space in the first place." She continued by explaining one way that recent arrivals had suggested she did not belong, recounting an event that happened in the park that had made teenage David K. feel so free thirteen years earlier: "This has been a mixed community for a very long time. . . . I am an African American woman. A lot of my friends aren't. Occasionally I will take my friend's kid to the playground. And people say to me, "Um, do you take care of children around here?" It's enraging. There are a lot of women of color who are caregivers. Not all of us. I say, "This is my best friend's child, and we have a day in the park together. Just like you have a day in the park with your kids. This is my godson."[19]

Just as Marty had said his childhood in Oakland was shaped by seeing "Black men going to work every day," Tanya and Paulette in Prospect Heights talked about how gentrification had changed what Prospect Heights could now model for them and for their kids. As we walked, Tanya talked about how one of the things she had

always liked about Prospect Heights was seeing a lot of Black faces like hers in a "nice neighborhood"; she loved that it was a "mixed-up" place. Yet, she continued, she was concerned about seeing so many new white faces, so many more people that perhaps didn't see the place the way she did. Fifteen years later, Paulette would also mourn the loss of places that had done that important work for her child, and could do so no longer for other Black children. In 2019 she contributed a story to *Intersection / Prospect Heights*, in response to the earlier tour guides' stories, writing on one of the story cards: "All the Black-owned businesses are gone. Even the restaurants. Nothing but bars, bars, bars. My son grew up seeing Black-owned businesses. This is necessary for our children to see that we also can own businesses."

In 2019, thirty-eight-year resident of the neighborhood Cleone—a neighborhood elder—had told me how much she loved her neighborhood, its scale, its trees, "the landmark homes. I didn't appreciate that at first but now I understand—all the high rises are just horrible. People who come to visit appreciate the block and the tree-lined parts; I'm so happy the landmarking protected that." But then she went on to explain that while the familiar physical forms were protected, the feeling of the place had changed, especially as real estate prices rose astronomically: "Some of the neighbors are not as nice—they see you're a person of color and assume you don't belong here. But I've had really great conversations with people who don't look like me, too—who treat people based not on the color of their skin but the content of their character."

Just after I talked with Cleone, local business owner Myriam told me her story. She too had experienced being a long-term resident of color who had had her right to be at home in Prospect Heights challenged by new white residents: "I have been harassed from a new neighbor about my/our patrons because we have a safe space for POC and LGBTQ people and unfortunately this may sometimes create discomfort in a particular population. We are there! And will always be a piece of the neighborhood's fiber."[20] At this, I'm brought right back to Julia's story of Prospect Heights as a place to run and to land someplace safe, and how much that's changed. While no one is legally excluded from the park, or from owning a bar, for example, the casual racism of gentrification excludes and undermines the possibilities for creating coherent social life in excruciating ways. The experiences of Paulette, Tanya, Cleone, Rocky, and Myriam—and the places that they've lost that once fostered their belonging—make visible the true violence of urban renewal, gentrification, and so many other things so often passed off as progress.

PORTFOLIO FIVE:
MOSSWOOD

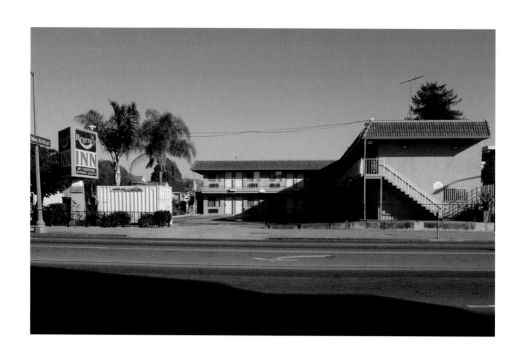

The pink and the motel are one.
Telegraph Avenue and MacArthur Boulevard, 2005.

Laundromat, 2006.

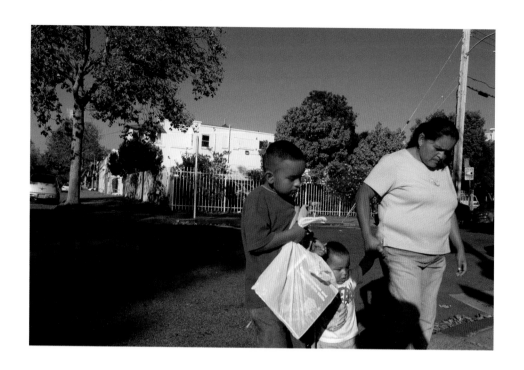

Holding hands, Telegraph Avenue, 2007.

On the bus up Telegraph, 2007.

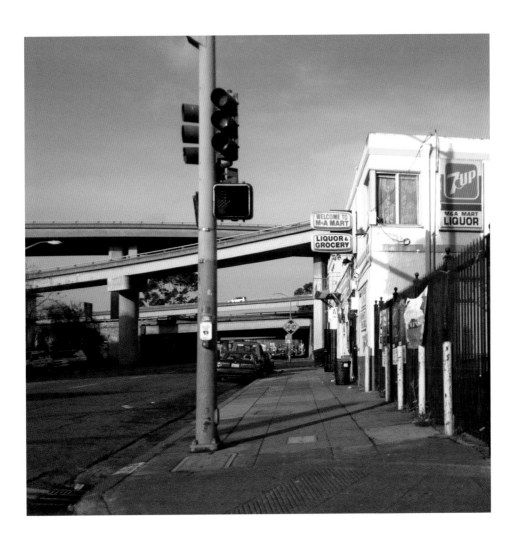

Teddy's, Thirty-Fourth Street and
Martin Luther King Jr. Way, 2006.

People from the old neighborhood

Thirty-Fourth and Martin Luther King Jr. Way

Oh! Teddy's! This was Teddy's Market when I was a kid. We loved it there. You know, this guy, an Asian guy, came into the store the other day, and he said he'd lived in the neighborhood growing up.

And I said, "Oh did you know Teddy's market?" And he said, "Yes!" And we just laughed and talked about how great it was—you know it was always better then—before was so much better. I love meeting people from the old neighborhood. It makes me so happy.

—Lois, 2006

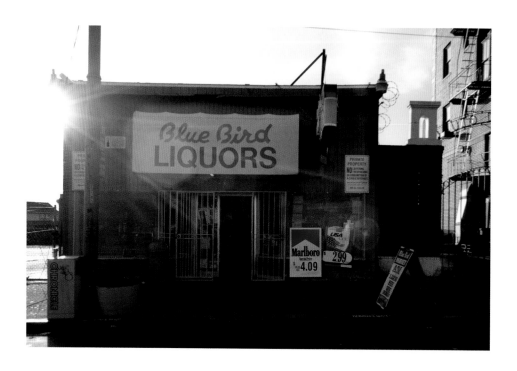

Blue Bird Liquors, 2007.

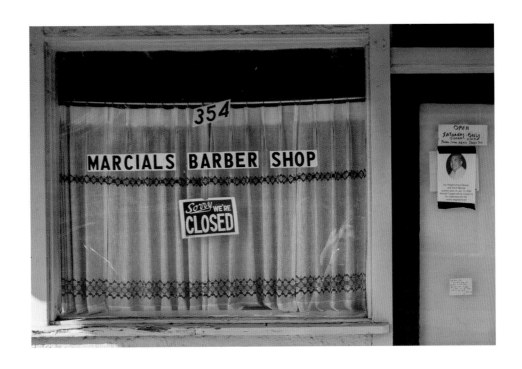

RIP Marcial, gone January 2006,
W. MacArthur Boulevard, 2007.

You sometimes get to say hello to your neighbors.
Thirty-Sixth Street between Webster and Telegraph

Nobody walks anywhere in LA. You walk from your kitchen table to the garage, you get in your car, and then you drive. . . . And that's not true here, because most of the houses don't have attached garages! So at least you have to walk from where you parked your car to get to your house. And in that walking, you sometimes get to say hello to your neighbors.

—Cynthia, 2006

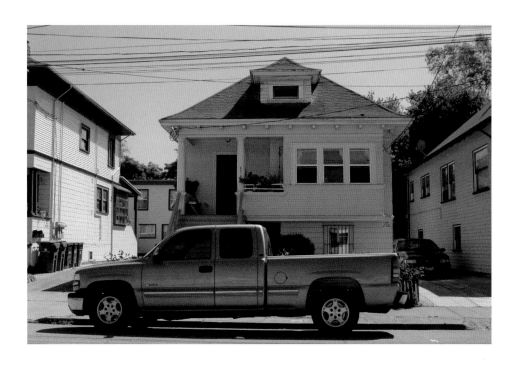

Cynthia's block, Thirty-Sixth Street, 2006.

BECOMING COMMUNITY

6

ENDURING TALK AND CASUAL TALK

When Rocky recorded her oral history for *Intersection | Prospect Heights* in 2015, she was thinking back on the public walking tour we'd just been on, all the places we'd heard neighbors talking about, and she told me a story about what was bothering her lately in this neighborhood she'd lived in for years. She told me:

One of my great distresses right now in terms of the neighborhood is that new people come in . . . they have no idea how to be neighborly. . . . So I'm sitting on the stoop one afternoon, and this lady comes out, and she's like, "Can I help you?" "No, I'm just sitting here." "Do you live here?' "You know I don't live here. It's Brooklyn. It's a stoop. I'm your neighbor." I said, "This is something that will happen. This is how you get to know people. Some evening, just come out here, sit down, smile at all the people walking by. Wave to them." Everybody, even if they don't know your name, or remember your name, they will know there is this neighbor that's there, and we form this community.

Places can help us become ourselves, to feel we belong, to shape our values, but they can also do important work helping us be together with others, maybe even to become a community, fostering social capital and emotional support. Places that do this work—like a stoop might—are part of how we understand who our people are, who we identify with. Telling stories and shooting the breeze help us navigate time and place as deeply connected. As the novelist Javier Marías writes, "Space is the only true repository of time, of past time. . . . When you go back to a familiar city, time undergoes a brief, sudden compression."[1] Walking the spaces of a familiar

place immediately brings stories that are important to us into the present, even if those things happened many years in the past.

Beyond the power of moving through places for individual memory, moving through places is a kind of practice of culture. In Cibacue, Arizona, the Western Apache people use places as mnemonic devices, compiling their stories, values, and cultural heritage in the landscape; and in Australia's Western Desert, people's individual sense of self as Pintupi is linked with a cultural and spiritual history and belief structure told through, and of, the land of the Pintupi people.[2] These landscapes are not just intertwined with stories but themselves tell stories that can be felt. These connect the living and the dead, and connect us over time in natural places as well as in urban places. In Minneapolis, the inimitable bookseller Tookie in Louise Erdrich's novel *The Sentence* wonders if "perhaps before the Dakota War, her ancestors were connected to this spot of earth, or to the ground beneath the bookstore itself."[3] And grounding us in Oakland, Tommy Orange's characters in *There There*, his "urban Indians," are deeply connected to place, and in their connection, they describe the place itself:

> We came to know the downtown Oakland skyline better than we did any sacred mountain range, the redwoods in the Oakland hills better than any other deep wild forest. We know the sound of the freeway better than we do rivers, the howl of distant trains better than wolf howls, we know the smell of gas and freshly wet concrete and burned rubber better than we do the smell of cedar or sage or even fry bread. . . . Being Indian has never been about returning to the land. The land is everywhere or nowhere.[4]

Who we identify with in a cultural sense, writes social theorist Stuart Hall, is continually "becoming," pushed and pulled between similarity and difference, inclusivity and exclusivity, working at a personal and a structural level.[5] This is about "feeling yourself through the contingent, antagonistic, and conflicting sentiments of which human beings are made up. Identification means that you are called in a certain way, interpolated in a certain way: 'you, this time, in this space, for this purpose, by this barricade with these folks.'"[6]

Places help us be together, help us make culture together, and are where we are called to "this barricade" when they foster two kinds of talk: the *enduring talk* that comes from long-term relationships, and the *casual talk* that is fleeting and sometimes lets us take small risks with less commitment. This talk, and the negotiation

inherent in it, is essential in a city, which by its nature is what political theorist Iris Young called "the being together of strangers"—strangers who need to navigate place together.[7] I think about this kind of work that places do as the work of helping us be together: not even necessarily to become a community. Just being together, acknowledging each other's humanity can be hard enough without the reciprocal care community implies. I also take the word *community* very seriously, and often use it with trepidation. Its potency is compelling, and the coming together of people who share a place or experience can be powerful and sustaining. Yet, as a word community can be dangerous because it can be used too simplistically, can mean entirely different things for different people, and, most dangerous of all, easily lends itself to being exclusionary, rather than what cultural theorist Raymond Williams has called the "warmly persuasive" way the word is often thought of.[8] It's too easy for a group of people, in defining what draws them together as a "community," to simultaneously define who is outside of it, who is different and hence not welcome.[9] Hence, here I'm working with a notion of a *neighborhood*—made up of many overlapping, intersecting, and sometimes oppositional communities—and the possibilities of city life, in what Young elaborates as not just strangers being together, but being together "in openness to group difference."[10]

Yet this vital openness while being in the same place at the same time does not just happen; it requires acknowledgement of each other, talk as negotiation, and places in which that acknowledgment and that talk can be enacted. As I began to notice the amount of talk on the tours people took me on, I wondered if some of it could even be called *dialogue*. The work of radical educator Paulo Freire has most informed my thinking on how interpersonal dialogue engages with, and is part of, the larger community. Freire's *Pedagogy of the Oppressed* and later works imagine a liberatory potential for praxis-based dialogue, "the encounter between [people], mediated by the world, in order to name the world."[11] This kind of talk has power to awaken consciousness and enable resistance to structures of oppression, and it can be of particular power for people who have connections to multiple places and cultures, who critical theorist and linguist Donaldo Macedo calls "forced cultural jugglers."[12] On a modest scale, we can see the need for a similar kind of dialogue in those heterogeneous neighborhoods like Prospect Heights and Mosswood that struggle with the legacies of American segregation, class structures, and discriminatory history. Places that enable the kind of talk that allows individual realities to negotiate with each other, and with the larger neighborhood, are vital, in whatever form they take.

At the Valois Cafeteria in Chicago, a place that evoked the social life of an old neighborhood now mostly gone, one of sociologist Mitchell Duneier's interviewees explained it this way: "Lots of people—even though they don't live in the neighborhood—make a point of coming to Valois to eat. It's sort of like a meeting place. You suddenly run into someone you haven't seen for a while."[13] When I read this, I can hear Tewolde's voice in my ears, telling me about the Oakland donut shop where his diaspora community came to "just smoke and sit" and, most importantly, "just got to be friends." Places that foster these kinds of talk are special, and the people who facilitate them (or, to be clearer, run them) are often what make them what they are.

To reap real benefits from this talk, for conversation to rise to the level of dialogue, there needs to be trust, respect, a willingness to listen, a bravery to risk one's own opinions, and an inclination for people to work together in a cooperative process.[14] It is this kind of talk that builds social capital, that builds networks that allow us, in social scientist Xavier de Souza Briggs's words, to get ahead and to get by. These places make space for this kind of trust and risk-taking, the engagement and conversation with friends, acquaintances, and strangers that validate a sense of self-worth and relationship to community.

These kinds of interactions between place and people are essential for a functioning community, functioning neighborhood, or, we can imagine, even a functioning nation—shared by strangers together. A wide range of sites can do this placework, as long as residents feel they are safe and they are heard. In the following chapters, we'll look at the work places can do to support the kind of enduring talk that happens regularly over a long period of time—in Neville's words, "we still meet every Thursday"—and the kind of talk that is more casual but no less potent—in Tanya's inimitable words, "where are you able to connect?"

PORTFOLIO SIX: PROSPECT HEIGHTS

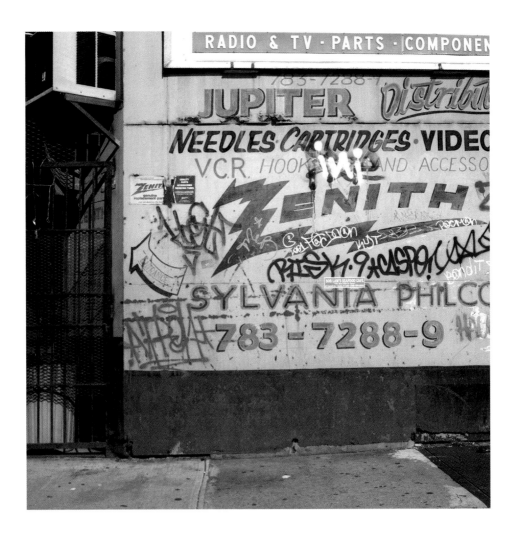

"The store hasn't been touched."
Vanderbilt Avenue, 2001.

The store hasn't been touched.

641 Vanderbilt Avenue

My friend, who was in the same electronics business like me, died. And they closed the store with all his stuff inside. . . . He was a cricketer in the West Indies, and his friends, who were his old cricketers, they always used to meet every Thursday, around that table—have their drink. Two years ago, he passed away—they still meet every Thursday afternoon—still the same way.

He went to the hospital for a checkup and they found something, and they operated—and when they operated, he died.

See, everything's still here. The store hasn't been touched. If I need anything, I'm short of anything, instead of buying it, I get it from him.

—Neville, 2001

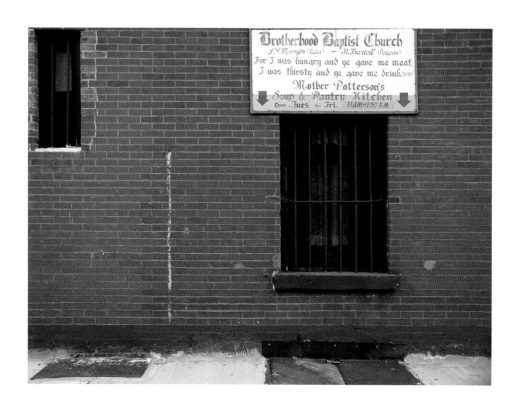

Brotherhood Baptist Church,
Saint Marks Avenue, 2004.

Candy store,
Vanderbilt Avenue, 2002.

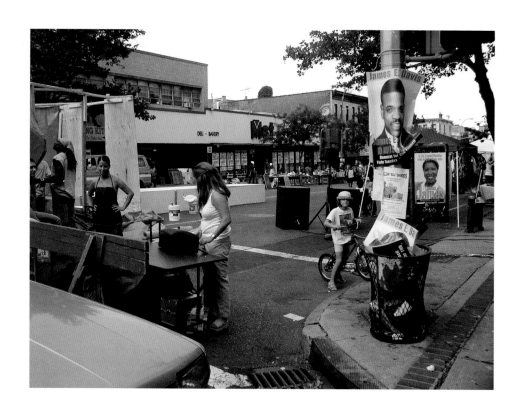

Street fair setup,
Vanderbilt Avenue, 2001.

Dixon's Bike Shop,
Union Street, 2001.

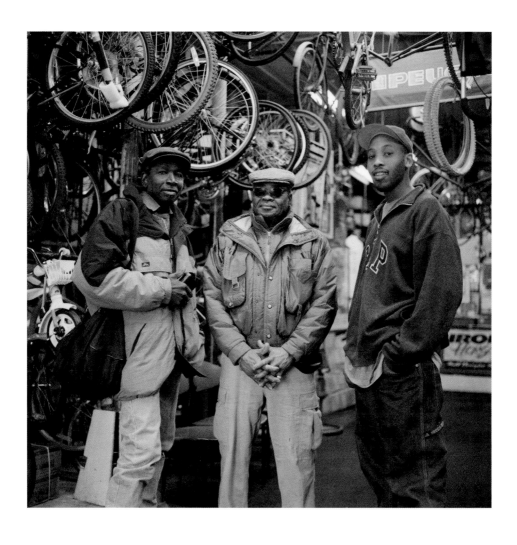

Neville with Lester and David Dixon,
Union Street, 2001.

We used to have a club upstairs.

Dixon's Bike Shop, 792 Union Street

Dixon's Bike Shop is one of the only places in New York you can buy a big-wheel bicycle. Still working. And he rides it too!

David: Remember, you had one like this! Oh! The green Dawes! Them guys joking all the while talking about all you guys used to ride back in the day, and Neville and him Dawes bicycle!

Lester: That's the sprinter! With the Dawes! No one could mess with Neville's Dawes! Nobody could touch it!

Neville: Yes. Yes. I still have it! I still got it! And I won't part with it. I used to store it away, and then I went to the supermarket, and somebody steal it! And a couple of days afterward, it appeared at the supermarket, and I got it back—it had a flat!

We used to have a club upstairs, and we all formed a band! We used to play together. [I played] percussions. And bass guitar. We had a bass guitar, missing the strings, and we strung it with wire, and we still used to play it like that—missing a couple of strings.

Oh, yes, we used to go to the park, and ride. I was on my Dawes, and these guys all wanted to beat me, but . . . never!

—Neville, 2001

7

WE STILL MEET EVERY THURSDAY

As David K. is bringing me into his apartment building, the key sticks in the front door lock, and no amount of shaking or jiggling will get it open. "Oh man, stuck again? This be happening," he sighs. "Hold on, I'm going to get somebody to buzz us." When he pushes a neighbor's intercom button, they immediately let us in. It's these kinds of long-term (though not always particularly close) relationships built on trust that help us succeed in an imperfect environment and that also sometimes let us change that environment thorough collective action. To build these kinds of relationships, places that allow us enduring conversations are critical; these conversations happen within our ordinary spaces but also transcend them—and transform the way we think of a donut shop or the back room of an electronics store.

Neville's Brooklyn neighborhood tour was made up of men's friendships and the sites of men's rituals that have sustained him over time; yet when we walked, these places and what they fostered were beginning to fade. Tewolde's long-term relationships helped him build a stable Eritrean community in Oakland—a community that formed the basis for his long-term political organizing for Eritrean independence as well as the customer base for the restaurant his sister and he later opened. Enduring talk in places where people met over time fostered a rich social capital for many of my tour guides, offering both a *social support* that allows them to get by and sometimes also the *social leverage* that helps them get ahead—such as when Mike offers a local kid a job and starts training him how to cook.

The enduring talk not only serves the creation of community trying to grow in a new place but also can be particularly potent for navigating a diaspora, and creating

something new. It's a way to acknowledge that place is never simple, no matter what pseudohistories of homogeneity people like to invent; as geographer Doreen Massey writes, a *global sense* is central to the essence of place.[1] Almost every place has at some point had a global migration story that has shaped it.

Migration changes place and changes the people and cultures that migrate to a place, creating something new, culturally distinct. As Stuart Hall writes, "The diaspora is a place where traditions operate but are not closed, where the Black experience is historically and culturally distinctive but not the same as it was before."[2] Marty, who'd grown up in Mosswood in the 1940s and 1950s, remembered that Oakland's Thirty-Third Street was once called "Shreveport" because, as he said, "there was a lot of Shreveport northern Louisiana Black folks there"—echoing historian of the Great Migration Isabel Wilkerson, who describes Oakland of the early 1950s as "a satellite of colored Louisiana."[3]

One of the many things those folks had brought with them on that two-thousand-mile journey was barbeque—and once in Oakland, that tradition was very clearly "not the same as it was before." In her eloquent blog posts about her family business, Everett and Jones Barbeque, Shirley Everett-Dicko explains Oakland-style barbeque's "secret recipe": "Take a southern, restaurant-owning pastor, a preacher's wife, some traditional African-American southern soul food, add some West Coast Blues, mix in a Black Power Movement, season it with the scars from urban removal, mix it all together, smoke it over oak wood inside a mason-built brick pit; add a sweet, spicy tomato-base barbeque sauce and there you have it. It's Hella Bay!"[4]

This new creation, this infinitely creative reinvention, also made its own special places, and Marty showed me one. With windows plastered with hand-painted signs advertising Southern-style meat cuts, Fair Deal Meat Company was the main butcher supplying the barbeque joints of Oakland and their highly defended barbeque style, but it also did some other crucial work. Everett-Dicko and Yvette Jones-Hawkins described Fair Deal as the place where in the early morning, barbeque business owners would "gather inside the back of the store. . . . A family of butchers in starched white smocks greeted you on those cold mornings with free coffee . . . lots of smiles and bad jokes. Like men in a barbershop—laughin', gaggin' and raggin' on one another, Fair Deal Meat Market was the barbershop for BBQ joints."[5] This talk sustained a complex community, and the people of Fair Deal who helped it do this work further enriched this narrative. The shop was started in 1934, and in 1937 Harry Mock began working there. Born in China in 1919, Mock would go on to run the store for the rest of his life. Mr. Mock and Baptist minister Reverend Memphis Jenkins were the first

inductees into the "BBQ hall of fame" because, in the words of Dorothy Everett and her family of Black women barbeque experts, it was Mock and Jenkins who "worked together to create Oakland-style barbeque."[6] When Mr. Mock passed away in 1995, his son-in-law Ron Sato and Ron's brother Gary, both born and raised in Oakland and of Asian descent, took over the shop and ran it until it closed after eighty-four years, when they retired in 2018. Traditions operated, but were not closed—making something unique to this place, something not the same as it was before.

<p style="text-align:center">**</p>

Sometimes placework that creates community comes from the places built through the process of organizing to make change. Susan Saegert's work on tenant organizing in the Bronx offers a way to understand the means by which place connection, place attachment, place identity, sense of community, and territoriality are "resources" for neighborhoods "to withstand social and economic forces that can lead to displacement through property abandonment or gentrification."[7] For example, when Mike and David W. talk about the park that gave young David K. a sense of freedom they focus on the park as a community effort that brought people together, that in David W.'s words "shows you what people working together can do." Mike talks passionately about how this park was full of drug paraphernalia and how, with a lot of work and the effort of "a whole lot of people," it improved to be the shining example he saw it as when we walked.

In Oakland, a nondescript fast food joint reminds Marty of what used to be on that site and evokes the struggles for civil rights that are embedded in Oakland: "There was a restaurant here, called Hy's, that wouldn't hire Black folks . . . [so] right here on the corner of the MacArthur and Telegraph we had picket lines."[8] In front of another small storefront, which was once his uncle's shoe repair shop, Marty's pride surfaces when he tells me that his uncle was "the first Black man to get out of Laney College with a shoe repair trade." On Telegraph Avenue and Thirtieth Street, surrounded by funeral homes and what were at one time white-only hospitals, he tells me, "My boys' godfather, Kenny, was the first Black boy to be born in Providence Hospital." The lessons learned by Marty at a young age—of struggle, of navigating in-between—exemplify what Stuart Hall calls "black subjects," creating an identification (or identity) of "reworking" which "transmits the capacity to be both the same and different, both located in a tradition and yet not constrained by it." Hall writes, "That reworking is almost musical and it has to be. What else is

any successful blues, any successful jazz standard, or any gospel song but the given ground and the performance that translates it? But you couldn't listen to it if all there was was just the same damn thing once over again."[9]

One block away from Providence Hospital, at St. Augustine's Episcopal Church on Twenty-Ninth Street near Telegraph, sits the heritage of some of Oakland's most famous reworking—the Black Panther Party's Survival Programs. In the church basement one Monday morning in late January 1969, when this congregation was located three blocks away on Twenty-Seventh and West Street, Reverend Earl A. Neil and renowned dancer and St. Augustine's parishioner Ruth Beckford (who had grown up on Thirty-Eighth Street and gone to Oakland Tech) served breakfast to eleven children before school. By the end of the week, they were feeding 135 children, and the Black Panther Party's first Free Breakfast for School Children Program was born.[10] Each morning in the Free Breakfast Program, children would get a range of food including "bacon, eggs, grits, milk, and hot chocolate. . . . Fruit twice a week as donations allowed." And on special occasions, half a donut from Neldam's, Marty's favorite bakery and where Lois worked when she took me on her tour.[11] By the end of that year, there was a Free Breakfast Program in every city with a Black Panther Party chapter, including Philadelphia, Seattle, and New York City—from Harlem to the Bronx to Brooklyn.[12]

With the breakfast program, breakfast was more than food; it supported Black children's ability to focus at school and to have a sense of themselves—and was akin to the ideas Beckford had instilled in her work founding the modern dance program at the Oakland Department of Parks and Recreation (the first in the country), not for professionalism or perfection, but to "teach the whole little girl."[13] The breakfast program insisted on a reworking of Black children's well-being, a thinking about education and nutrition together. Perhaps inspired in part by, or even fearful of, the Free Breakfast Program's success, the federal government instituted its own permanent school breakfast program in 1975.

In Prospect Heights, in 2020, reworking was in full effect in a different way, transforming the place, and the placework, of a space that had been the catalyst for substantial displacement into a site of protest and racial justice organizing in the wake of the murder of George Floyd. The plaza in front of the Barclays Center basketball stadium, the centerpiece of the Atlantic Yards boondoggle, the home of the Brooklyn Nets basketball team, was radically reworked to become the place where the many racial justice protests of the Black Lives Matter movement would meet, would occupy, and would go out into the city from. It was, in the words of protest photographer Gabriel Hernández Solano, "totally appropriated for the protests."[14]

And this wasn't a reworking that was amicably supported; the first protests there met with brutal responses from the New York City Police Department (NYPD). Local reporter Jake Offenhartz described it this way: "In both the level of rage from demonstrators and total lack of restraint from NYPD, last night's protest was unlike anything I've seen in NYC."[15]

The plaza, formally known as Resorts World Casino NYC Plaza, was made as a replacement for a building that would be moved elsewhere in the development. This space, wrote long-time watchdog critic of the Atlantic Yards project Norman Oder, had "accidentally" fulfilled the big talk of its owners and architects to become something "civic." Until 2020 it had done nothing of the kind, sitting as an empty corporate space in front of a stadium and a subway station. It is not public, nor has it ever been; at the time of this book's writing, it is owned by the billionaire co-founder of the online shopping site Alibaba, Joseph Tsai, who bought the Brooklyn Nets and the arena operations from Russian oligarch Mikhail Prokhorov in 2019.[16] It remains contradictory in doing this work—both an "accidental town square" and a driver of displacement, a space powerfully and strategically located at the crossroads of two of Brooklyn's biggest streets, Flatbush and Atlantic Avenues, and a space itself the subject of protests about the whole development.

WE USED TO RIDE

Neville had an electronics repair shop on the ground floor of the building in which I lived on Vanderbilt Avenue in Prospect Heights. A gentleman in his early seventies with a gentle and slightly distracted manner, he had come to New York from Guyana and had run a series of small shops in Brooklyn. This one, on Vanderbilt, was no ordinary shop, but one that overflowed onto the street with radios and record turntables never picked up by their owners, wires sprouting from every nook and cranny. You could barely see into the dark space, let alone go far inside, as it was packed to the ceiling with metal shelves, cardboard boxes, and unruly electronics parts.

I got to know Neville one day in 2000, as I stood on the sidewalk outside that building where we rented the fourth-floor apartment and in which he had his shop downstairs. I was holding my old-fashioned twin-lens reflex camera, the kind with a viewfinder into which you look down, and Neville started talking with me about photography. He told me that he loved photography and that years ago he'd had a portrait business in the building. Later that day, Neville dug out a box of camera equipment and some old photographs of friends and neighbors—brides and

grooms with wedding cakes, a young woman with an electric smile, several families having dinner together in one of the apartments of that Vanderbilt Avenue building.

At that time, I only knew Neville had lived in Prospect Heights a long time and knew that he was also selling his store, but I didn't know why. About a year after we first met, I asked him if he'd give me his tour of the place. He agreed and speaking softly, stuttering every now and then, he took me across Flatbush Avenue into Park Slope—to Dixon's Bike Shop on Union Street. This storefront with a large picture window featuring a Victorian "big wheel" penny-farthing bicycle had once been the center of his world. Pushing open the door to the large, cool, dim space filled with bicycles and parts, we were greeted from behind the counter by a tall young man with a lilt to his voice, welcoming, "Come on in Neville!" Neville's face relaxed, his voice became warmer: "Hello, hello, hello, hello!" he called out. Neville and Dixon's son Dave engaged in the banter of long time no see, and Neville explained that he was giving me his tour of his "old neighborhood." Dixon's son nodded that Neville had been there a long time indeed, while Neville recalled that he had taken some "fat-cheeked!" pictures of this tall young man as a baby, telling Dave that now he himself had grandkids, and even a great-gran.

In awe, Dave replied, "That's really beautiful. Long long time. You still on Vanderbilt?" At this question, Neville's voice became quieter, as he said he was no longer in Prospect Heights, beginning to explain that he'd sold the store, before interrupting himself and showing me the "big wheel bicycle" he'd pointed out before we came in: "And it still works!" Sensing that Neville wanted to shift the conversation, Dave pointed to another bicycle in the shop: "Remember, you had one like this!" At this, Neville's face lit up: "Yes! I still have it! I still got it! And I won't part with it." Bursting out laughing, Dave shouted, "Oh! The green Dawes! Them guys joking all the while talking about all you guys used to ride back in the day, and Neville and him Dawes bicycle!" Laughing, but proud, Neville carried on reminiscing about his days of riding in Prospect Park. As he looked up into the high, dark ceiling, Neville remembered more of that time past: "We used to have a club upstairs, and we all formed a band! [I played] percussions. And bass guitar. We had a bass guitar, missing the strings, and we strung it with wire, and we still used to play it like that—missing a couple of strings."

As he talked, the door jangled open and a shorter, stockier man walked in, Dave's Uncle Lester. He laughed as he spotted Neville: "That's the sprinter! With the Dawes!" "I still got it!" Neville exclaimed again. "No one could mess with Neville's Dawes! Nobody could touch it! So, how's everybody?" Lester asked.

In answer to this, Neville began to answer in earnest, "Yes, everybody's OK. You know I'm out of Vanderbilt Avenue now." Shocked, Lester asked if he had sold it, and Neville carried on hesitantly, and with careful use of the passive and active tenses: "Yes . . . the building sold, and I sold the store and everything. I don't have a business anymore. I am just . . ."

"Cruising," Lester suggested kindly. Noticing me, Lester introduced himself: "I'm the best-looking brother!" he laughed. As they posed for a picture, Dave looked around and stated for the record, "I'm the best looking one here! A new generation of good-looking Dixons!" To which Lester replied, "You can take over from me!"

Drifting out of the scene, Neville walked around the shop, touching things. "You can see where my collecting comes from—we like old stuff. See, he's got a lot of old pot-bellied stoves, and antique things. Old bikes. Old collection." Neville drifted toward the door, all the reliving having been done. With a forceful but melancholic "Alright!" he began an exchange of *nice seeing yous* and pointed out a few last pieces, before he reluctantly pulled open the door and we walked back out into the bright sunlight.

WE USED TO JUST SIT THERE ALL DAY

Across the country, Tewolde's place that fostered his long-term relationships had little to do with Oakland itself. Having emigrated from Eritrea in the 1980s, Tewolde made diasporic meaning of the physical environment of Oakland by overlaying it with the reality of another place: "All the things that I remember about this area relate to what stage the struggle was at with Eritrea." The places that had meaning for him across the neighborhood were the disparate sites—"bases," Tewolde called them, quasi-militarily—where Eritreans in Oakland had met to organize, raise money, and support the thirty-year fight for independence thousands of miles away. Continuity, exchange, and a sustaining kind of long-time men's talk were the reasons he took me to the local donut shop.

Gesturing at the corner restaurant, lit from within by a yellowish-green light and empty but for one or two people in its mottled Formica booths, he says: "Golden Gate Donut café—we used to just sit there all day." Noting the donut shop's current emptiness, he begins to remember that when he and other members of the Eritrean diaspora community in Oakland used to meet there, they took it over completely. They were drawn there to meet other people who hoped for Eritrean independence, and the donut shop get-togethers were a first step toward later political organizing. But before that could happen, the donut shop did even more essential work: it was

where a dispersed community of Eritrean immigrants met regularly over weeks and then years and, Tewolde explained, "just got to be friends."

When I later show him several photographs I've made of this place, he recognizes the pink of the donut shop wall and exclaims: "Now you're talking! This one! Those of us who didn't work on weekends, we'd get in in the mornings, we'd have donuts, and just sit there. Smoke and sit, until it's time for the meeting. . . . Was just the same way, hardly anyone else in there! The guys didn't mind us sitting there all day! And you know, filling the place up with smoke. This—we sat here, and this is what we saw. . . . Actually, people still frequented this long after independence, too. But I haven't been there since then."

"Different *buildings*," he continues, "have different emotions and different memories"—and I think of Fullilove's phrasing, that buildings "insinuate" themselves into us. One building, which housed the rented rooms where they met for the bulk of planning for independence, where they had celebrated the achievement of their final goal in 1993, and that later came to house his sister's restaurant, had "more happy feelings—because it's independence after thirty years." He exclaims that even though it "looks very different from then . . . still, there's that old feeling!"

Tewolde pulls out a last photograph, one I made by peering through the plate glass of the empty storefront where they met during the 1998 border conflict war between Ethiopia and Eritrea. There was physical labor embedded in this place: "We did some of the finishes here. . . . We prepared food, fundraising you know." Yet more important was the political labor, and what this kind of labor cost the people who took part. It was clear that this empty spot still made him deeply sad when he explained, "After independence, people were, 'OK, we got independence,' everybody went about their own business. But in 1998, when the war with Ethiopia started, everybody came to that place. . . . What do we do? How do we help? So, that has bad memories . . . because nobody likes war—especially after you experience peace." The meanings inscribed in Tewolde's everyday geography synthesize the complexity of time and diaspora—the politics of here and the politics of there—as well as the intersection, or even clash, of individual life goals with those of a larger national and political nature.

Tewolde's latest base was the light-filled corner café that his sister started. It stems directly from all those prior spaces; even its name links it to the independence movement. The café is called *dejena*, which Tewolde explains means "meeting place" in the Eritrean language of Tigrinya. "Meeting place," he says, "but also it's a meeting place behind the trench."

Walking again with Neville in Brooklyn, he takes me to a hidden spot that was his neighborhood anchor just up the street from Mike's diner on Vanderbilt Avenue. As we pass a boarded-up shop with images of electronics painted on its yellow plywood front, Neville gestures to it, explaining, "My friend, who was in the same electronics business like me, died. And they closed the store with all his stuff inside. . . . He was a cricketer in the West Indies, and his friends, who were his old cricketers, they always used to meet every Thursday, around that table—have their drink. Two years ago, he passed away—they still meet every Thursday afternoon—still the same way." Looking up at the storefront with *Zenith* painted across its face, and then down again at his watch, he says, "And in fact, they meet at two." Neville rings the bell outside, and a man who recognizes Neville lets us in. Walking through the dimly lit aisles to the back of the shop and calling, "Hello, hello," Neville greets a group of men gathered at a table in the back of a fully intact electronics parts store. Everyone looks up from the plates and aluminum foil trays of homemade food. Slightly perplexed by my presence, they greet Neville, who in turn explains, "This is a friend of mine, we're doing a tour of the neighborhood. Gentlemen!"

Neville promises to return in a little while, and he and I head out of the store. Walking back through the dusty aisles, pointing to the rows of tall metal shelves, filled with neat boxes of electrical parts, Neville says quietly, almost reverently, "See, everything's still here. The store hasn't been touched. If I need anything, I'm short of anything, instead of buying it, I get it from him." This regular gathering of men of about the same age and a shared Caribbean background created a stable place within the context of neighborhood change—a gathering so essential even death couldn't displace it.

**

Sometimes the most unlikely locales do the work of fostering the enduring talk, the long-term relationships, and the reworking that allow people to get by, help someone get ahead, help change a neighborhood, organize for racial justice, or even help people organize a movement for national independence thousands of miles away.

PORTFOLIO SEVEN: MOSSWOOD

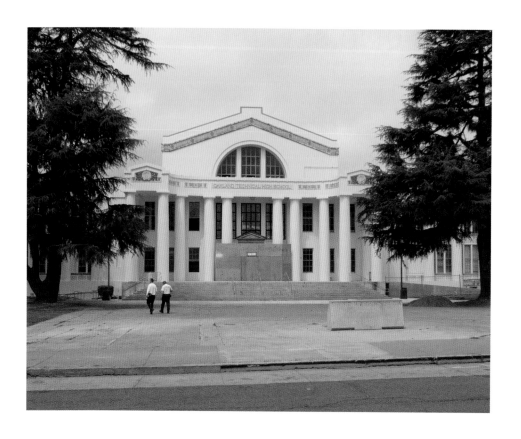

Oakland Tech High School, 2006.

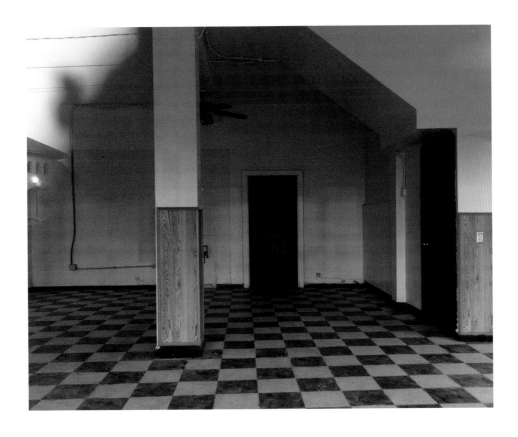

"We did these finishes!" Shattuck Ave, 2006.

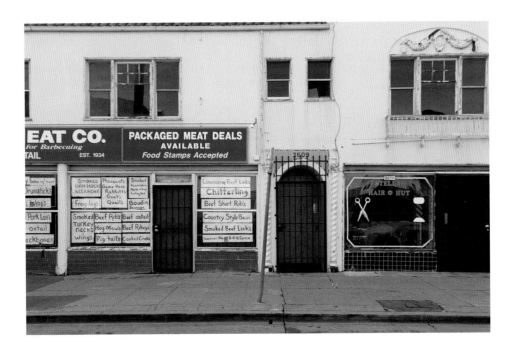

Fair Deal Meat Company, Market Street, 2006.

Shreveport
3605 Market Street

See "Fair Deal Meat Company"? This company's been here ever since I can remember. It's run by the original Asian family; I think Ronny Sato still works there, who is approximately my age. Now, if you look at what they sell here, look how they sell the meat—short ribs, country-style bacon, hog maws, pig tails—they cater to Southern clientele! You can go in there and get James sausage. You know what that is? That's pork sausage from Oklahoma City. There were lots of Okies in this neighborhood! People who came out of the South, you know, they came here.

This neighborhood—we used to call Thirty-Third Street "Shreveport"—'cause there was a lot of Shreveport northern Louisiana Black folks there. And Brockhurst had older people—like the Dellums family lived on Brockhurst. The Irvin family lived over here—Avey Irvin Sr. grew up with my dad in Luther, Oklahoma.

—Marty, 2006

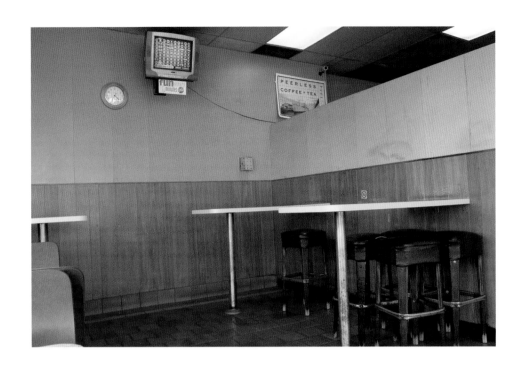

"We used to just sit there all day."
Golden Gate Donuts, Telegraph Avenue, 2006.

We used to just sit there all day.
Telegraph and Forty-Second Street

I was one of the first Eritrean refugees that came into the United States in the 1980s. And there were lots of organizations to support the Eritrean People's Liberation Front, fighting for independence from Ethiopia.

Golden Gate Donut café—we used to just sit there all day. I'm not kidding you. When I say all day, I mean all day. There are hardly any people there now. But you know, it's always been like that.

Those of us who didn't work on weekends, we'd get in in the mornings, we'd have donuts, and just sit there. Smoke and sit, until it's time for the meeting. At that time it was not political so much as getting to know other Eritreans, just being friends and starting in this new place.

The guys didn't mind us sitting there all day! And you know, filling the place up with smoke. This—we sat here, and this is what we saw. People would come in, buy donuts and coffee and leave, but we just sat there. Actually, people still frequented this long after independence, too. But I haven't been there since then.

So, different places, different buildings, have different emotions and different memories.

—Tewolde, 2006

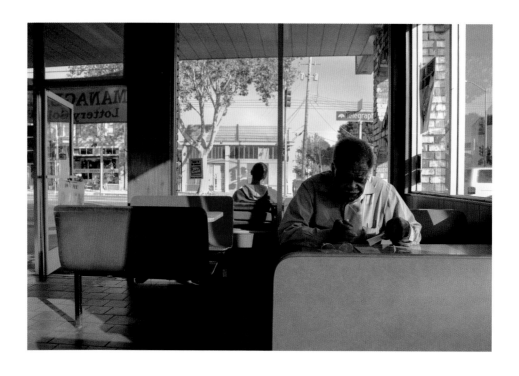

Lotto, Golden Gate Donuts,
Telegraph Avenue, 2006.

MacArthur BART station parking lot, 2007.

Moon and Mosswood Park, 2004.

Mosswood Park, 2004.

8

WHERE ARE YOU ABLE TO CONNECT?

When Tanya had told me how much she loved Mike's diner, she had explained that it was the talk that cast that special spell: "You just hear people talking. . . . It's a very mixed crowd in here, race, sex, age . . . and you hear people talking trash. . . . Mike gives the place its life, 'cause he'll talk to anybody and he'll talk crap with anybody!" Philosopher Yi Fu Tuan elaborates, "The kinds of words and the tone of voice used seems to infect the material environment, as though a light—tender, bright, or sinister, has been cast over it."[1] While Tewolde's closeness to his companions in activism and Neville's profound relationship with his bike riders are important ways that people relate to each other over time, low-stakes casual talk—talking trash!—between people who might have little in common also contributes to building the kind of social capital that helps us "get by."

This kind of casual talk can sound simply like, "How about this weather?!" while also being an act of respect, boundary-crossing, and recognition of shared humanity through simple banter. These kinds of conversations can be simultaneously both boring and extraordinary, becoming, in geographer Ash Amin's evocative phrase, "sites of banal transgression."[2] Place identity is, as social psychologists John Dixon and Kevin Durrheim write, "something that people create together through talk."[3] For this kind of talk to occur requires places where people bump into each other, share small similarities, have a few minutes to chat. Certainly not every neighborhood site sustains dialogue, or even good conversation. Moving toward better conversation can be dependent in part on people, in part on the physical form of a place, and in part on the time and rhythms in that place.

In Prospect Heights and Mosswood, an idea of mixedness was central to many people's discussions of their neighborhoods—from reminiscences about a Prospect Heights realtor who sought to make mixed-race couples feel at home in the neighborhood in the 1960s and 1970s when not everywhere did, to Marty's descriptions of the Mosswood of his childhood as "a solidly Black, middle-class neighborhood, a lot of Japanese, a few Portuguese left, and a few Italian old-timers." In this celebrated diversity—or to return to Iris Young's unsentimental phrase, a "being together of strangers in openness to group difference"—these are neighborhoods where meanings may be contested, claimed by multiple groups or even directly at odds with one another. How values of boundary-crossing and respect are shared is idiosyncratic; rather than being fixed or static, being together as strangers requires continual negotiation, and places in which that negotiation can take place.[4]

The casual interactions and conversations in places from diners to sidewalks to driveways echo landscape architect Clare Rishbeth's work on the importance of spaces that are "shared and multiple." In her work on public spaces in the heterogeneous neighborhood of Burngreave, Sheffield, in the UK, she stresses that the "overlapping use of public space by different ethnic communities" provides two simple prerequisites for dialogue: "the opportunity for gradual informal contact and . . . a visual shared recognition to the diversity of a neighbourhood."[5] The simple regularity of seeing people who are different than oneself—and, in Freire's terms, seeing them as people, not objects—can be a real step toward the ability to engage in dialogue. Informal aspects of understanding difference as part of your everyday are significant.[6] Even when the public realm does not offer in-depth encounters, what Rishbeth calls *incidental encounters* can be a part of cohesive communities, in which people value identity both within an ethnic group and within a multicultural neighborhood. Engaging in simple ways can be a start for us to name and place ourselves in the world, testing out prejudgments, searching out meaning, potentially developing critical perspective.

FACILITATED: THE DINER

Some of the places that work most powerfully to help us be in community are made possible by someone who creates a space that can do this work. In Prospect Heights, Mike—owner of George's / The Usual—knows that he creates a place conducive to the collective life of the neighborhood. Mike himself plays a crucial role within this physical space in which the counter is the right height for comfortable conversation between those sitting and those standing; one could say that he is the kind of

person who *facilitates* everyday talk. Not only is it crucial for a community like this to have a place where all these private neighborhoods come together, it is also essential for Mike as a businessman; he must work to build a coherent sense of place, in part to keep customers happy. In a way, he realizes that this process of engaging with each other might be a start toward what Freire calls educating "each other through the mediation of the world."[7]

Tanya points again to the picture that she had pulled out of the stack—of Mary and a customer at the counter, about which she had remarked on how many different people talked to each other in this place and how the diner had helped her develop her sense of self, her own sense of ethics and belonging. She further explains about its connection to community talk as well: "This is Mike's. Of all these pictures, this one, 'cause the phone's constantly going, people sit and read their paper. . . . It's just like seeing the place full, with a bunch of people, and the waitresses just running around, you know? Talking . . . I mean, you look at it in society and where are you able to connect?"

Several weeks later, Mike picks up the same photograph from the stack. "Let me see that one?!" he exclaims. "That's Jean, of course. I know everybody. They're in my place, all the time." A few years later, a third person looks at the same picture. Duke—a local realtor born and raised in Prospect Heights—echoes Mike: "I know this guy here, his name is Jean. He's still around here. He drives a cab. You showed Mike this? I know he's happy to see this. This is our community, and although it has twenty thousand people in the community, I feel like I know or have seen the faces of many of them."

Mike tells me, "I treat everyone the same." Everyone can talk about everything in his shop. In this statement, Mike is clarifying for me the issues that are at stake in a place that has so many different people and where talk across racial and class divides is essential. He sees his restaurant as enabling people to act out, practice, and speak their negotiation: "This place, it's not like any other place, not because it's mine, well maybe it is because it's mine, because we can talk about anything in here. And with girls, guys, you can talk about sex, drugs, rock and roll, politics, anything. And you know you can talk about anything and it makes you feel good." I ask him what's missing from the photographs I've made of his place, and what might be missing if I showed them to someone who'd never been there, and I joke that they're missing the hubbub and the shouting. "Yeah, all the lingo!" he exclaims, and goes on, "You should have been here this morning, oh my god, I was freakin' screaming at everybody, you know? In a playing way, 'cause everybody's kidding me about the Raiders, you know? . . . The whole Sanitation was here this morning, because

two weeks ago, I took all their money, you know? . . . I'd cover any bet, you know, and then of course you're not allowed back in here until you pay up, you know?" He stops for a breath, then continues, "Yeah, maybe you should record. Come in and have coffee with Emily, and record what's going on—the sounds, the noise. Two eggs scrambled, you know? George's! That's all you hear all morning, you know, George's! George's!"

Mike starts to explain more about the importance of his place, and all the people who call up wanting "the usual." He tells me, "I know people's coffees like crazy!" and then recites my own order back to me: "Like you, I know your coffee, right, regular? Bagel, buttered." But he goes on, talking about certain customers in particular: "Imagine, every day, especially old people: 286 Park Place, 299 Park Place, 366 Park Place, 201 Park Place; 99 Saint Marks, 166 Saint Marks, 234 Saint Marks. Everyday day they call. They're little old ladies, little old men. And we won't see them all winter. But as soon as spring comes, then we see them."

Here the conversation is not even to express whether a coffee is light and sweet or black; rather, this information becomes secondary to a conversation held even over the phone that ties a community together. But there may also be a limit, and a limit that those who facilitate these places may impose—for the dialogue or the ability to be peaceably together, or the good of the business. Mike clarifies, remembering the months of the 1995 trial of African American football star O. J. Simpson, accused of murdering his wife Nicole Brown Simpson and her friend Ronald Goldman, both of whom were white:

Sports in this neighborhood is huge! So, sports is the topic, and whatever's in the newspaper. Me, I'll do anything to get somebody to laugh. It could go anywhere, this conversation. But—when we first opened up this store, it was O. J. crisis. I put up a sign: "The subject of O. J. is strictly prohibited." Because it's going to end up Black and white. I'm white, you're Black! I don't want it to go there. I talk about it in Manhattan, that's where it goes, I talk about it in Bay Ridge, that's where it goes. I have a business to run. It's not a discussion, it's an argument. Make noise, who cares, but if there's gonna be an argument, especially between Black and white, I'm not about that.

Am I making too much out of this chatter? Maybe it doesn't rise to the level of dialogue, but, as informal educator Mark Smith suggests, words like *talk*, *chat*, and *conversation* give us a sense of the fluidity needed when thinking of the messy everyday context.[8] Any everyday talk offers the possibility for addressing the taken-

for-granted, and Smith suggests that engaging with each other—whatever the subject matter—is significant in itself, entailing many of the same emotions noted as prerequisites for loftier dialogue.

SELF-ORGANIZED: THE FENCE

Sometimes there are no facilitators, or there is a changing cast of many facilitators and agreed-upon practices in different locations that enable this casual talk and the acknowledgment of shared humanity that it cultivates. These self-organized spaces do important work, often out in public on the sidewalk. In their Brooklyn neighborhood, both Julia and Akosua talked about "the fence," more a practice than a fixed location, but one that did crucial community placework to navigate politics, grief, and mutual aid. This fence was not one particular fence, but rather a way of interacting with a particular architecture of Brooklyn, where multifamily houses often have front yards, even if they're small, and the stoops that come down into these front yards, what Julia calls her porch, are often separated from the street by a low metal fence with a gate to the sidewalk. This way of being together, not focused on any one particular fence, is what sociologist AbdouMaliq Simone calls *people as infrastructure*, wherein an intersection of individual and institutional actions, structures, and constraints help create "highly mobile and provisional possibilities for how people live and make things, how they use the urban environment and collaborate with one another."[9]

In 2006, Julia talked about the controversy that was raging in the neighborhood around the proposed Atlantic Yards development—of a stadium and high-rises on both public land given to private developers and private land that would be taken by eminent domain. She explained the quandary in which development and gentrification had placed her. She talked about how this shaped interactions with friends and neighbors—and the ways that it shook their ways of being to the core—epitomized by what was happening in the spaces of the stoop and the fence. The development came to signify both the thing itself and the community disagreements and bitterness that it spurred, leaving her with a sense of loss and disruption in the social fabric of her community, even before anything had been built:

People had signs up—Atlantic Yards pro and con—who's a fool, you're a fool, they're a fool. "You say you're for affordable housing, how you can be for affordable housing if you're not for this project?" "You think there's actually going to be affordable housing in this project?!"

Friends of mine and I, on opposite sides of the argument, see each other and we're like, "We used to be more friendly." And we couldn't figure out what to do about being more friendly.

And I said, smile more; what I'll do is I'll sit on my porch more, I said, you sit on your porch more. We used to sit on the porch—we were so broke that was the only entertainment we had. Sit on the porch, have a cigarette, say hello to people, give 'em shots. And we didn't do it a lot, but we did it enough . . .

And the other thing that we did on Saint Marks, if you have old clothes, you hang them over your fence. When people say, "Where did you get that outfit?" I go, "From the fence." Those shoes? From the fence.

But it sort of faded away. It's less and less.

We were saying that we used to be nicer, and I said, well, we used to have less money.

Ten years later, the fence was still happening, or was still remembered by Akosua, a recently displaced Prospect Heights resident, as one of the things she'd keenly miss about the neighborhood:

One thing that I think is lovely is the habit of just leaving something on the sidewalk. I think that's a very beautiful aspect of the community . . . and it's a reflection of community, in living color. My father passed away. And you know, a lot of men like to collect caps. So, I hung out his caps. I was very tearful when I was doing this and this man [walking along] . . . picked up on my sadness. So then he starts talking to me to help me come back to the present . . . I was able to focus on what I was doing and the conversation that we were having. And he took all of my father's caps. There were shirts that I had put up, he said, "Well, let me take these things." The sharing was happening.[10]

This self-organized sharing was facilitated by fences, stoops, and sidewalks wide, quiet, and well-traveled enough for a much-needed conversation to happen between neighbors.

HAPPENSTANCE: BETWEEN CAR AND HOUSE

In our car-centric Mosswood neighborhood, where much travel takes people out of the neighborhood or to specific, self-selecting locations, the sites for casual talk in local community are often impromptu, diffuse, or in-between. Cynthia, for

example, loves to talk with people and explains where she finds her casual conversation in Oakland—in contrast to Los Angeles, where she used to live: "Nobody walks anywhere in LA. You walk from your kitchen table to the garage, you get in your car, and then you drive. . . . And that's not true here, because most of the houses don't have attached garages! So at least you have to walk from where you parked your car to get to your house. And in that walking, you sometimes get to say hello to your neighbors. You know?" Cynthia is serious. Although this is a radically different model from Brooklyn, where most people are pedestrians most of the time, these in-between/informal spaces just beyond the envelope of the home in Oakland can't be ignored. Her sense of the neighborhood hinges on her feeling that she engages regularly with her neighbors in these spaces between house and car—negotiating to cross racial and ethnic barriers, to help her neighbors accept her as an out lesbian, and, finally, to make her neighborhood feel a little more like the working-class Italian neighborhood of Chicago in which she grew up, where everyone knew her grandmother were Cynthia to be seen on the street doing anything wrong. Now, she said, people two or three blocks away don't recognize anyone.

Her reverie put me in mind of a book about a different part of Chicago from that in which Cynthia grew up. In Duneier's *Slim's Table*, about Chicago's South Side, one resident remembers the neighborhood as once being full of people who knew you as a child:

> Ted began, "On our block you would get chastised by any old lady. 'Boy, what are you doing over here? Does your mother know you are over here?' She'd get you on your toes by the ear and she'd drag you home. 'I found him over on Lafayette.' You could get chastised by anyone in the neighborhood."
>
> "That's true," Slim said. "Oh, yeah. You had about twelve mothers, seventeen fathers. Everybody knew what you did."[11]

Back in Prospect Heights, this same sort of care and correction came both on the streets and in local spaces, as local entrepreneur Bob Law reminisced about his childhood in Prospect Heights in one of the public gatherings for *Intersection | Prospect Heights* in 2015: "The candy store was a hub . . . a depository for ideas for the neighborhood, and Norma would lecture us: don't do things that cause harm. Growing up, all the adults in the neighborhood had dominion over me. I don't think there's a store like that now."

For Cynthia, this morality of the casual interaction was intersected by her sense of values—by the way her neighborhood was doing the placework of both

helping her to become herself, being valued and having values, and to become part of community:

I know how to behave! What I want is a sense that if my house were being broken into, my neighbors would call the police. I want a sense that you know, in an earthquake, if somebody was at work, and her teenage daughter was home, I would go and grab them and tell them, 'Come on, with me, we're getting to someplace safe,' and I could call my neighbor and say, 'I have your daughter, everybody's fine'—I want a sense that we're all looking out for one another! And that's not easy to create in this world—and so I try to walk my neighborhood and I try to say hello to everyone I see.

As I relisten to the recording of Cynthia's voice and her passionate "I know how to behave!" it puts me in mind of Rocky again, back in Brooklyn, several years later, who would explain that the problem of gentrification, of brownstones being sold for millions, is that she felt that people who paid a lot of money for something that was only for them would not know how to behave in a neighborhood, would not know how even to use the space of a stoop that had the potential to foster that essential casual talk that glues a neighborhood together, because they had "no idea how to be neighborly."

PORTFOLIO EIGHT: PROSPECT HEIGHTS

New entrance to the Atlantic Avenue station, 2015.

Barclays Center, Atlantic Avenue, 2015.

Sterling Place, 2002.

Fence, Bergen Street, 2002.

Bodega and Busta Rhymes,
Underhill Avenue and Sterling Place, 2002.

Craft beer bar, former bodega,
Underhill Avenue and Sterling Place, 2016.

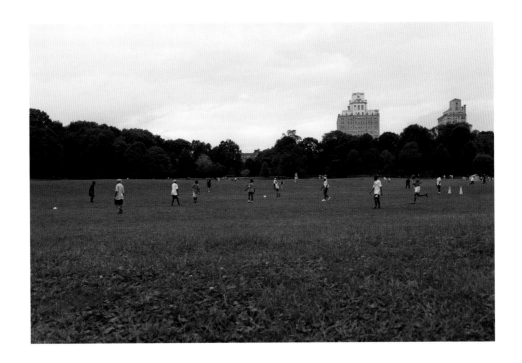

Prospect Park, 2003.

9

THE CITY WE WANT

One weekend afternoon in the summer of 2021, newly vaccinated, we go to meet a friend in Prospect Heights. COVID has kept us so close to our neighborhood uptown that it feels like an adventure. We're there for one of the days of the new and popular Open Streets program on Vanderbilt Avenue. People are everywhere—and restaurants are everywhere. It seems that if a storefront isn't a restaurant, it's a bar. Or a cupcake shop. Or an ice cream parlor. It's overwhelmingly fun. But also remarkably expensive. We sit outside and enjoy ourselves in a way we haven't since before March 2020. But it feels like visiting a place I've never been before. Down Vanderbilt Avenue, huge apartment buildings rise. There's no pizza place, no roti shop, no bevy of nail and hair salons; only the pet store and the supermarket—stalwart Met Food, now renovated and called Foodtown but run by the same wonderful people—remain.

**

One sunny Wednesday in 2023, my family and I get off BART at MacArthur. Down Mac-Arthur Boulevard, the Carl's Jr. and motel signs still stand tall. Nearing the station, our view is dominated by a new twenty-four-story apartment building. Walking out of the station, it's the same but different. No giant parking lot, but it's dark in front of the station because apartment buildings rise up in front of us. Telegraph Avenue feels familiar. There's a bike lane, some traffic calming, a new doctors' office. The giant florist, the churches are all there. New signs tell us we're now in "the historic Temescal Telegraph district." Who knew? The sky is, as always, blue. The motel is no longer pink. Painted a

hipster grey, it became a boutique hotel and is now housing for formerly homeless veterans. As we walk toward our old apartment on Thirty-Sixth Street, I'm struck by the gaping hole in the roof of the First AME Church. What felt like the most solid of buildings now feels frail. Patches of blue sky surround the cross on the pediment. The doors are boarded up. A big fire—turns out it was in February—has closed the oldest Black church in the East Bay. Down Thirty-Sixth Street, to much-loved Mosswood Park, whose sign has been painted over to read "Ohlone Land." Trash is strewn across the entrance. Just inside the park, there's a small encampment of people in tents behind the ball field. The temporary replacement for the community center and the old Moss house sit locked up tight. A man walks across the weedy and gently sloping lawn, swinging a golf club. He finds his ball in the tall grass and takes a swing. It's impossible to see where the ball winds up.

**

I have never been bored by anyone's answer to the question "Where would you take me on a guided tour?" I never know what will come out of someone's mouth, nor what surprising connections between people will emerge. Each tour makes clear the complex, contradictory people we all are.

It may seem unimportant that all these tours keep me interested, but making visible our complexity surely is not; most media does the exact opposite. To come back to that rankling question about purpose from so many years ago, how can we *use* the placework we've seen throughout this book? Or, to put it another way, what if we continue to ignore the essential work everyday places do for people?

We know that to ignore the importance of placework, to fail to consider how cities are really lived, often leads to, as psychologists Lynne Manzo and Douglas Perkins write, "negative unintended consequences, such as neighborhood demolition and dissection for highway construction and urban renewal."[1] That result is perfectly obvious from everything my tour guides have told us; and if we're honest, it's also clear that those consequences are not always unintentional or impossible to predict.

If we agree that experiencing these negative consequences, these dissections, is bad and that justice is crucial, then we need to grapple with the fact that "in an urban century," as Lorena Zárate, my friend and former president of Habitat International Coalition América Latina, writes, "the meaning of justice will necessarily include *all* the dimensions of social life: political, economic, cultural, spatial and environmental."[2] Zárate goes on to say that in the just city, "the goal of the economic

activities is collective wellbeing." *Well-being.* The goal of the city is its inhabitants' well-being. Not the city as an investment vehicle, not towers inhabited by global capital, but the city as doing necessary work for people to become themselves, to become community—for the city to work for people, for the city to do *placework.*

As we've seen, placework is a way to think about these spaces as well as an argument that everyday places are important, particularly for the ways in which people negotiate their individual lives with connections to the larger world and the development of their own worldview. People have a right to a city that works *for* them, not a city that *works them;* they have what philosopher Henri Lefebvre and later cultural theorist David Harvey famously called the *right to the city,* which Harvey defined as the "right to change ourselves by changing the city."[3] People need (sometimes expected, often surprising) places in which our complex and contradictory identities can find shelter and be worked out. People in communities of multiplicity and of contested spaces need places where they negotiate difference, both to better know themselves and to better function as a community.

It seems so simple to say that cities are for people, that they are the places where we become ourselves, where we build capacity to be with others in a society. Yet it clearly bears repeating because very few of our policies act on these ideas. This is not to pit cities against rural spaces or towns, but rather to say that cities, towns, the places where we gather, these must be planned for and valued as spaces for people, rather than as spaces for capital. Placework is not a how, it is a *why.* It is why making changes to planning, to the way we care for cities and their people, is essential.

**

I write this conclusion in 2024. Throughout this book we've cycled through time—the long histories of these two neighborhoods connecting to the small stories of their residents, the multiple moments and touchpoints in the guided tours project over the last twenty-four years—and now we're no more at an end than the year 2000 was a beginning.

While political crises are ongoing, the norm in a twenty-four-hour news cycle, I remain most concerned about the crisis of place and of dialogue. Much has been written about a "post-fact" time in the wake of leadership across the globe—Trump in the United States, Bolsonaro in Brazil, Putin in Russia, Modi in India—that has led to divided societies wherein stating facts seems to have very little bearing on many people's opinions. While infuriating, I think this is where we can learn most

from my tour guides and from the places in which they were able to build themselves and then share themselves with people they did not know and may not have agreed with. The job of placework seems more crucial, and more threatened, than ever.

We could be at an inflection point; at the very least, we're clearly at a moment of crisis. We're at a moment where simply stating a truth is seen as an impossible betrayal of the now, a threat to individual people's day-to-day lives: Why else might some white people feel threatened by the very statement, acknowledgment, that slavery existed and was core to America's founding?

We're also in a moment where polarization simplifies and dulls identity and individual stories. When so much of our time is spent on protecting our most basic human needs to stay alive—regularly being challenged by lawmakers, corporations, and police—we lose the ability to share and protect the parts of us that are the most human. We are losing the places that facilitate our sharing of the weird, specific, funny, surprising parts of ourselves—the sharing that helps us genuinely connect, and the things about people that have kept me interested in asking for guided tours for over twenty years.

Yet we can't throw up our hands and give up, we can't say it's too hard to solve, that placework is too hard to quantify or apply. It isn't. It just requires a different way of thinking about what cities are for. It's not impossible to put into practice. We *can* use placework to consider how to actively create better cities, rather than only mitigating the effects of changes that happen *to* cities. What if we were to reimagine urban planning as a *process* based on the work that places do for people, and the process of people's dwelling in place?

Civil society organizations in the global south have done extraordinary work putting these ideas into practice—creating concrete ways to get to the city we want, in part by seeing the city as a *habitat*, a coalescing of the elements people need for well-being. This global idea was codified by a coalition of civil society organizations as the UN World Charter on the Right to the City,[4] and was put into practice in the 2010 Mexico City Charter for the Right to the City / La Carta del Derecho a la Ciudad, described by the city's mayor, Marcelo Ebrard, as "the most ambitious goals of what [our] city should be."[5] All decisions made in the city, the charter tells us, should have the goal of deepening inhabitants' rights to their city, moving them closer to "the city we want"—*la ciudad que queremos*.[6] To get there, the charter maps six necessities: a full exercise of human rights, the social function of the city and of property, a democratic management of the city, the democratic production of the city, the

sustainable management of commons and resources, and, finally, the democratic and equitable enjoyment of the city.[7]

At the level of landscape architecture and town planning, there are further concrete examples. Landscape architect Jeff Hou and his *Transcultural Cities* cowriters call for a *transcultural placemaking*, using a framework that enables places to "engender diversity, hybridity, and cross-cultural learning and understanding." This framework calls for specific actions that echo many in this book, like "supporting everyday sites of interactions . . . [and] ways of sharing experience and supporting dialogue." [8] Even more on the ground, landscape architect Randolph Hester has used the lived meanings of places in his "sacred site mapping" for the replanning of the North Carolina town of Manteo, and his later work in *Design for Ecological Democracy*.[9]

All of these strategies, frameworks, and mappings suggest an urban planning that prioritizes residents' right to well-being in their cities, their rights to cities that do essential work for them. If followed, they result in real policies: from creating long-term housing affordability with the knowledge that stable homes support lives, to reckoning with the systems like unequal education funding or the lack of universal healthcare that uphold spatial segregation. They require the creation of real small business protections like commercial rent stabilization that support longer tenure, and zoning changes to allow small businesses in residential neighborhoods, which suburban-influenced planning banned in many American cities in the mid-twentieth century.[10] They would make cultural spaces free, and fully fund and expand public libraries. And that is just a start.

There is much we can do, and the reason to do it isn't that equity, justice, and fairness are simply the right way to behave. The reason to do it is existential. The work that everyday places do, that policies prioritizing a right to the city would support, this work is what enables all of us to become ourselves, to be a functional society. Without this, we are nothing but consumers, data to be bought and sold, nothing more unique than what the artificial intelligence that trawls our online detritus can create. If we want to be human, we need placework. Without it, we can't get to the cities we need.

ACKNOWLEDGMENTS

No book is made by just one person, and this book is the product of many people's care over more than twenty years.

First and foremost, at the heart of this book is the brilliance and generosity of my tour guides in Brooklyn and Oakland. Thank you from the bottom of my heart, Amanjot, Julia Bryant, Mike Halkias, Neville, Ulysses, David K., Tanya Moore, Tewolde, Earl Marty Price, and David Whitbeck. You have taught me so much. And I hope this book can do justice to honoring the memory of the extraordinary Cynthia Evangelista Astuto and the unstoppable Lois Jackson, two wise storytellers gone way too soon who I hope knew how much I valued their tours and, even more, their trust, their insight, and their friendship.

I began these tours in 2001, but this book really began long before that. My family are the best New York storytellers I know. My parents, Winifred Bendiner-Viani and Paul Viani, raised me on those stories, and taught me to be curious, to be a walker, to be a photographer like my dad and an artist like my mom, to be a New Yorker, and I thank them for all of that, but most of all for their boundless love and support always. My aunt Jessica Bendiner introduced me to some of the first places I ever really experienced placework, often as we hung out drinking cafés con leche, and I can't thank her enough for all those hours, and for her love and her unfailing listening. The memory of my grandparents Elmer and Esther Bendiner grounds everything I write.

Dear and brilliant friends contributed so much of themselves to this book and the other iterations of this project: For years, I have loved sorting through photographs

with Rebecca Tuynman, and I have treasured the close readings and brilliant comments Amy Reddinger made on every version of this writing. They each gave me my first guided tours, patiently opening my eyes to the wonders of Los Angeles and of Schaefferstown. This book would never have happened without the hundreds of diner breakfasts with Emily Harney—especially at George's—during which we talked about this project and a million other things, over two decades. Since we first met working out how to make photography our careers, Bilyana Dimitrova has been a kindred spirit of unstinting support. Kemi Ilesanmi's friendship inspired me to imagine the parts of my work into a whole. Prithi Kanakamedala suggested forming our own writing group just when I needed it most, and I can't thank her enough for our time together, her generous comments on this work, and for her own excellent Brooklyn book. Jodi Waynberg's curatorial eye was invaluable as I thought about the photo portfolios, and Connie Rosenblum's editorial generosity and encouragement is unmatched. In California, this fish-out-of-water New Yorker was so lucky to have found such photographic kinship and friendship with Susan Schwartzenberg and Janet Delaney. Margaret Morton assured me this group of photographs could be a book, and I hope it honors her memory.

At the MIT Press, my editor Victoria Hindley has at every turn truly gotten and supported the interdisciplinarity of this book, while her insightful critiques and suggestions have always made it better; I feel incredibly lucky to have found her. Thank you to my colleague Kristen Lubben for getting it too, and for helping me find Victoria and MIT. Gabriela Bueno Gibbs, Kathleen Caruso, Melinda Rankin, and the whole MIT Press editorial team have been a pleasure to work with, and my thanks to designers Yasuyo Iguchi and Jay Martsi for their patience and beautiful work. Thanks also to Nicholas DiSabatino and the whole MIT Press marketing and publicity team for shepherding this book so thoughtfully. Finally, my deepest thanks go to the anonymous peer reviewers of this book, whose comments encouraged boldness and centering my tour guides' voices.

I began asking for people's guided tours when I was in college, and since then, for more than twenty years, Gary McDonogh has been my mentor and friend through every life and intellectual turning point. I began these particular guided tours in graduate school, and I could not have made it through the dissertation I would write based on them without my friendship, conversations, and collaborations with the extraordinary Yvonne Hung, Zeynep Turan, and Judith Kubran. This project grew immensely through working with my advisors at the CUNY Graduate Center: Geoffrey Batchen, David Chapin, Setha Low, and Susan Saegert. Clare

Rishbeth has encouraged these tours across oceans since visual sociology brought us together two decades ago, and Lorena Zárate Soneyra's friendship taught me what it means to make the right to the city really real. Beyond those named in this book, many other people took me on guided tours in Brooklyn and Oakland and in other cities, and I thank them all for teaching me so much.

Writing about the Guided Tours projects in, and getting editorial and peer-review feedback from, the journals *Environment and Planning D: Society and Space*, *disClosure*, *Space and Culture*, and *Visual Studies* helped evolve my thinking over the years. The different forms of this guided tour work—each informing what is now in this book—have been supported by many organizations, including the Watson Foundation, Humanities New York, and the Citizens Committee for New York City.

In this work's public iteration, my committed and enthusiastic collaborators Gib Veconi of PHNDC and Melissa Morrone, Taina Evans, and Philip Bond of Brooklyn Public Library made *Intersection | Prospect Heights* possible. Everyone who interviewed their neighbors and everyone who told stories of place in interviews and story cards for the *Intersection | Prospect Heights* oral history project were essential; I thank Akosua, Bob, Cleone, Gina, María, Myriam, Paulette, Rhoda, Robin, Rocky, and Samantha for the way their stories deepen and nuance the arc of this book. Everyone who joined an *Intersection* walk or event, or brought this project to their students taught me the kinds of conversations that are possible. Most especial thanks to Judy Pryor-Ramirez who used *Intersection* in her teaching in ways I'd never imagined and whose friendship is so sustaining. Listening to the *Intersection* panelists Tom Angotti, Regina Cahill, Catherine Mbali Green, Deb Howard, and Letitia James apply the project to their activism and policymaking transformed the way I thought about this work in the world. Thanks always to Mike, John, and Mary Halkias for making George's such a wonderful place, and for hosting the very first trial run of the *Intersection* story cards idea. Huge thanks to Abdul Jawad and Frank Widdi for letting every *Intersection* walk begin inside Met Food/Foodtown, and for making everyone always feel so welcome.

Two people came into this book by surprise—and I can't thank them enough. Jean, who appears in the image on the cover of this book, reminds us all what place-work feels like. Though I've been unsuccessful in my many attempts to find him in the neighborhood twenty years after taking the picture, I hope he will accept my thanks. And Dave Dixon, whose shop I walked into with Neville many years ago was welcoming and generous at the time and, if possible, even more so when I called him up out of the blue and asked if he remembered our visit, which, twenty years later, he did.

In Oakland, where we had fewer roots, the people who made us feel at home were my aunt Tauny Ruymaker who's been welcoming me into her home and her Oakland since I was a teenager, and our neighbors Amanda Burton, Cynthia Astuto, and JoAnn Castillo, who were so excited to help us learn to love the West Coast. And I hope this book honors the memory of the indomitable Ethel Ruymaker whose home and worldview reminded me so strongly of my own grandparents', and who was such a joy to talk with about the Bay Area.

Books are written while lives are being lived and children are being raised, sometimes in the most difficult of times. The people and places who help us make community everyday are a big part of this book. Amy Ward and Sarah Butler, teachers at Muscota New School PS 314, reached through the Zoom screen of remote schooling in the depths of COVID into our apartment to help us still feel part of a community. And Rosa Miller grounded us and celebrated a shared love for Oakland and the 510 area code. Being in community with, hatching plans with, and learning from both Sara Kotzin and Tanya Birl-Torres have brought so much to my thinking while writing this book. Conversations in playgrounds with Deepali Srivastava-Sussman and Andrea Homer-McDonald about work, books, politics, and parenting, while knowing that they would take care of my kid as I would theirs, have been a gift.

Vicky Limberis, Santiago Miralrio, Arturo (Margarito!) Miralrio, Luis (Lucas!) Garfias, Peter Mousadakus, Erick Lopez, and Katerina Limberis-Katehis are much missed: their diner in Washington Heights, Vicky's, was one of the finest sites of placework I can think of, and their friendship was a rock for our family. And, like many of the places in this book, Vicky's was a victim of the pandemic and the unfettered commercial rents of the New York real estate market. The neighborhood hasn't been the same without them.

And not one of these things would have happened without Kaushik Panchal, my partner in the truest sense of the word in life, work, artwork, parenting, finding community, imagining, dreaming, and everything else. Since the day we met, it's been my honor to make things with him, and he's made these guided tours so much better and more beautiful. Our life together is the basis of this book—starting from when we got married on Vanderbilt Avenue in 2001. He's got my whole heart.

And finally, as always, this book is for Luca, who is my inspiration, who knows the meaning of placework in his bones, who is endlessly resilient and optimistic, who turned a magical eleven as I finished this book and will be twelve by the time it's in print, whose celebratory hugs make finishing a draft so much sweeter, who I couldn't love more, and whose own brilliant books I know I will read in the future.

NOTES

INTRODUCTION

1. For more context from two very different fields, see psychologist Harold M. Proshansky's writing on place identity and philosopher Henri Lefebvre's writing on the production of space: Proshansky, Fabian, and Kaminoff, "Place-Identity"; and Lefebvre, *Production of Space*.

2. For more on this, see Sorkin, *Variations on a Theme Park*.

3. This "everyday urbanism," as architectural historian and planner Margaret Crawford terms it, is found in spaces not generally praised as significant. See more in Crawford, "Blurring the Boundaries."

4. Bendiner-Viani, "Guided Tour: Villa 31"; Bendiner-Viani, "Walking, Emotion, and Dwelling"; Bendiner-Viani, "Guided Tours"; Bendiner-Viani, "Layered SPURA"; Bendiner-Viani, "Big World in the Small"; Bendiner-Viani, "Bringing Their Worlds Back"; and Bendiner-Viani, *Contested City*.

5. For more on reflective attention, see environmental psychologist David Seamon's writing on dwelling and applying philosopher Martin Heidgger's concept of the lifeworld: Seamon, "Way of Seeing People and Place."

6. See Henri Lefebvre's work on rhythmanalysis and everyday rhythms: Lefebvre and Elden, *Rhythmanalysis*, 27.

7. I use the names Mosswood and Prospect Heights for practical reasons of situating ourselves in space, but the names of the neighborhoods are not fixed. You could argue that this book is really about small sections of larger neighborhoods—Prospect Heights as a corner of Crown Heights; Mosswood as a corner of several places—rebranded now as "the historic Temescal Telegraph district," but also connected to the Hoover Durant neighborhood that was once North Oakland and is now West Oakland.

8. See Jo Lee Vergunst and Tim Ingold's 2006 work on urban walking with participants in Aberdeen ("Fieldwork on Foot") and their 2008 book *Ways of Walking*. See also Ingold, *Perception of the Environment*, for more on attunement.

9. Cadogan, "Walking While Black."

10. Goffman, *Presentation of Self in Everyday Life*.

11. Ford didn't say those exact words, but the *New York Daily News* summed up his policy that way. See *New York Daily News*, "Ford to City: Drop Dead," October 30, 1975, 1. For more on the co-ops, see the New York City government website's description of the HDFC program: NYC Housing Preservation & Development, "HDFC Cooperatives."

12. Woolf, *Street Haunting*.

13. For more on psychogeography and the Situationists, see Guy Debord's 1957 *Psychogeographic Map of Paris* and the concept of the *dérive* (Debord, "Theory of the Dérive," 22). Of course, other writers, artists, and researchers have set out to take walks to understand place or experience. See Rebecca Solnit's 2001 *Wanderlust* for a whole exploration of this history. Architect Kevin Lynch's "walk around the block" was concerned with urban perception of the built environment; ethnographers Setha Low, Dana Taplin, and Suzanne Scheld do transect walks; and anthropologist Sarah Pink tracks the experience of moving through space with video. Walter Benjamin and Michel de Certeau each took the role of solitary walkers, observing the city through their physical movement and their (privileged) vantage points. British artists Richard Long—who calls himself a sculptor and land artist—and Hamish Fulton—who calls himself a walking artist—have both made work wherein the walks themselves, the language that records those walks, and those marks made along the way through the natural landscape *are* the work. Both artists also work in the form of artist's books, and there are a great many of these works that have been important for me in thinking about the intersection of the walk with text and with the form of the book. See Solnit, *Wanderlust;* Lynch and Rivkin, "Walk around the Block"; Low, Taplin, and Scheld, *Rethinking Urban Parks*; Pink, "Walking with Video"; Benjamin, *Arcades Project*; Certeau, *Practice of Everyday Life*; Long, *Richard Long: Many Rivers to Cross*; and Fulton, *Hamish Fulton, Walking Journey*.

14. Cadogan, "Walking While Black."

15. Seamon uses Martin Heidegger's terminology to explain it, writing that an "emotional presence-to-hand reveals readiness-to-hand of the lifeworld in a new and vivid way." See Seamon, "Awareness and Reunion," 50.

16. This was the Barclays Stadium and Atlantic Yards proposal, which would later—perhaps cynically—be renamed Pacific Park.

17. Didion, "Fire Season in Los Angeles."

18. Jackson, "Future of the Vernacular," 151.

19. Smith, *New Urban Frontier*, 51.

20. Anderson, *My Brooklyn*.

21. Zeltzer-Zubida, "Housing Displacement in Brooklyn"; Chapple, *Mapping Susceptibility to Gentrification*. Chapple's study on predicting risk for gentrification classified the Temescal, Pill Hill, and Koreatown-Northgate (other names for areas that overlap Mosswood) neighborhoods as highly susceptible to gentrification.

22. Among other forms of transit-oriented development, this development was inspired by one that opened in 2004 at the Fruitvale BART station, but MacArthur was planned for a much larger scale.

23. See the Anti-Eviction Mapping Project website at https://antievictionmap.com, accessed October 10, 2022.

24. Rose and Lin, *Roadmap toward Equity*, 7.

25. For the median rent information, see Levin, "Oakland's 'Mega-Evictor.'" For the average rent information, see Brinklow, "Oakland Rent Spike Hits $3K/Month."

26. According to the Zumper online rent tracker (https://zumper.com).

27. Rose and Lin, *Roadmap toward Equity*; *Oakland's Displacement Crisis*.

28. Levin, "Oakland's 'Mega-Evictor.'"

29. A BRIDGE Housing project, the Mural has ninety rental apartments for low- and very low-income households with incomes ranging from 30 to 50 percent of the area median income. See BRIDGE Housing, "Bridge Housing: Mural Apartment." The websites for the market-rate developments tout their amenities. See the MacArthur Commons website at https://maccommons.com// and the Skylyne website at https://theskylyne.com, both accessed September 28, 2022.

30. Many neighborhood activists in Mosswood tried to save homes, businesses, and even at one point Mosswood Park itself. There was also infill development by both individual homeowners and developers with deep pockets, causing local concern over whether the planned buildings were out of scale with the character of the surrounding neighborhood of one- and two-story homes.

31. Johnson, "Walking Brooklyn's Redline."

32. See full timeline in Oder, "Atlantic Yards/Pacific Park Infographics"; Oder regularly updates this blog post. Many community organizations and coalitions worked to oppose the Atlantic Yards plan including Develop Don't Destroy Brooklyn, The Fifth Avenue Committee, Park Slope Civic Council, Pratt Area Community Council, Pratt Institute Center for Community and Environmental Development, and Prospect Heights Neighborhood Development Council. Once the plan was approved, further coalitions like Brooklyn Speaks, which included most of these organizations and more, used legal action and other methods to hold developers accountable for promises made to the community in the Atlantic Yards development when no government agencies would. And these watchdog groups' work to demand accountability has remained essential for over two decades. At the time of this book's writing, the most recent debacle occurred in December 2023, on the development's twentieth anniversary, when the site's latest developer—Chinese company Greenland USA—defaulted on $350 million in loans to finance the project. Atlantic Yards' / Pacific Park's shortcomings and failures for the community are legion; a promised public park has not been built, and the development is still 876 units short of the amount of affordable housing required to be built before May 2025. See Poblete, "Auction of Atlantic Yards Sites Endangers Hard-Fought Housing Promises." See also https://developdont destroy.net and https://brooklynspeaks.net, both accessed December 8, 2023.

33. This literature is extensive. The following are a good place to start: Abdul-Khabir, "From Chavez Ravine to Inglewood"; Podair, *City of Dreams*; Feng and Humphreys, "Assessing the Economic Impact of Sports Facilities"; and Baade and Dye, "Impact of Stadium and Professional Sports." For a focus on the specific example of Oakland, see Paulas, "Sports Stadiums Are a Bad Deal for Cities." And Norman Oder has been crying foul since the beginning

of the Atlantic Yards project's proposal, and has a long-running watchdog blog about it. See Oder, "Atlantic Yards / Pacific Park Report."

34. The Prospect Heights Neighborhood Development Council (PHNDC) and the Municipal Art Society of New York led the fight for these landmarking efforts. The landmarking of the brownstone historic district was successful, but the effort to landmark the Prospect Heights Apartment House district, which could have protected many more homes, did not come to fruition. See Danza, *Prospect Heights Historic District Designation Report*. The fight against out-of-scale development that will lead to displacement continues in many other locations across Brooklyn and has been led by many more organizations around the region. For example, in 2020, two rezonings on Franklin Avenue in Crown Heights, not far from Prospect Heights, were halted by the grassroots and legal action of activists from Movement to Protect the People (MTOPP), who charged that these developments would spur both displacement and gentrification and cast the Brooklyn Botanic Gardens in shade.

35. See Bendiner-Viani, *Contested City*, for a full exploration of this idea in the context of the SPURA development on the Lower East Side of New York.

36. See rent records on the rent-tracker website Zumper. In August 2022, the average rent for an apartment in Manhattan broke $5,000, signaling a housing market completely out of control; Brooklyn was very close behind. Oakland and Brooklyn, like cities across the country, had seen significant rental decreases during the 2020 portion of the pandemic, but what happened next was different in each place. In Brooklyn in October 2022, the average one-bedroom apartment was $3,805 a month; the median rent had increased 26.4 percent from 2019 to 2022, from $2,650 to $3,350 (faster growth in three pandemic years than in the previous ten). Oakland's housing cost stayed lower, with less demand for apartments at the higher end of the rental market, leading to vacancy.

37. Demographic data from the 2000 US Census and 2014 American Community Survey. Opinion research from surveys sponsored by the Prospect Heights Neighborhood Development Council in 2004 (366 respondents) and 2015–2016 (508 respondents).

38. Closson and Hong, "Why Black Families Are Leaving New York."

39. Black residents made up 55 percent of the population of Mosswood in 2000; by 2013, they were only 34 percent of the neighborhood. Zuk and Chapple, *Case Studies on Gentrification*, 60. In Oakland as a whole from 2000 to 2010, there was a 24 percent decline in the number of Black Oaklanders, a loss of almost thirty-four thousand Black residents. See Rose and Lin, *Roadmap toward Equity*, 7. See also Soursourian, *Suburbanization of Poverty*; and Chapple, *Mapping Susceptibility to Gentrification*.

40. See the Prospect Heights Neighborhood Development Council website at https://www.phndc.org/, accessed October 17, 2022.

41. Guano, *Creative Urbanity*.

42. Shehadeh, *Palestinian Walks*, xiii; and Gray, "Open Spaces and Dwelling Places."

43. Marci Reaven, personal communication, November 29, 2015.

44. For one of these events, we brought New York State Attorney General Letitia James back to the neighborhood, where she had been a city councilperson when this project first began. She and other panelists each read one of the Prospect Heights guidebook stories aloud and reflected on what that story could mean for policymaking and how it connected to their work across the city.

45. Quoted in Sundiata and Ragusa, *The America Project*, 6.

46. Thrasher, "Uprising from the Viral Underclass."

CHAPTER 1

1. Pred, "Place as Historically Contingent Process," 292. Sociologist Michael Gardiner has described the everyday as intertwining "routine and creativity, the trivial and the extraordinary," resulting in neighborhoods that environmental psychologist Susan Saegert describes as being made up of "social and individual projects that support, oppose, constrain and facilitate each other." Gardiner, "Everyday Utopianism," 232; and Saegert, "Charged Contexts," 81.

2. Castells, *City and the Grassroots*; and Lefebvre, *Production of Space*.

3. For more on homes, see hooks, "Homeplace (a site of resistance)"; Cooper Marcus, *House as a Mirror of Self*; Morris, *Inhabitants*; and Bachelard, *Poetics of Space*. For more on laundromats, see Manzo, "Beyond House and Haven." For more on plazas, parks, and piazzas, see Low, *On the Plaza*; Low, Taplin, and Scheld, *Rethinking Urban Parks*; and Guano, *Creative Urbanity*. For more on markets, see Richardson, "Being-in-the-Market." For more on sites of local public history and national monuments, see Hayden, *Power of Place*; the Place Matters website at https://placematters.net/; and Sturken, *Tangled Memories*. And for more on whole neighborhoods and planning with people, see Rivlin, "Group Membership and Place Meanings"; and Rojas and Kamp, *Dream Play Build*.

4. Massey, "Global Sense of Place," 156. For more on the way people's lives intersect with, are created by, and sometimes resist structures of social reproduction, see Hayden, *Power of Place*; Harvey, *Social Justice and the City*; Lefebvre, "Everyday and Everydayness"; and Lefebvre, *Production of Space*.

5. Bendiner-Viani and Saegert, "Making Housing Home."

6. Saegert, "Role of Housing," 288.

7. Geographer Tim Ingold writes about this as a world that "comes into being around the inhabitant." Ingold, *Perception of the Environment*, 153.

8. Fullilove, *Root Shock*.

9. Heidegger, "Building Dwelling Thinking," 361.

10. The way "Building Dwelling Thinking" and some of its later interpretations in architectural theory focus on a rural past and a notion of rustic authenticity rankles at the best of times, and is more concerning considering the timing of Heidegger's talk in the years immediately after World War II, when Nazism had lauded the authentic, rustic Germany in architecture and art.

11. See the wide range of phenomenological and cultural work on place, in particular. These are just a few samples: Buttimer and Seamon, *Human Experience of Space and Place*; Seamon, *Dwelling, Seeing, and Designing*; and Feld and Basso, *Senses of Place*.

12. Crawford et al., *Everyday Urbanism*.

13. Bedoya draws on scholar of Chicano art Tomás Ybarra-Frausto's definition of *rasquachismo*. Bedoya, "Spatial Justice"; and Ybarra-Frausto, "Rasquachismo."

14. Bendiner-Viani, *Contested City*.

15. Studs Terkel suggests that a book about work is "by its very nature, about violence—to the spirit as well as to the body," while also acknowledging resilience: people "perform astonishingly to survive the day." This is, we could also say, *grind culture*, which demands we work to the exclusion of all else for the attainment of "success." Terkel, *Working*, xiii.

16. Albers et al., *On Weaving*, 20.

17. Livingston, *Paris Is Burning*; Jackson, "Social World of Voguing," 37.

18. While both emotional and financial values may fluctuate over time, emotional values differ among people, and real estate value fluctuates despite personal connection.

19. Briggs, "Brown Kids in White Suburbs." See also Manzo and Perkins, "Finding Common Ground," 342; and Narayan-Parker, "Bonds and Bridges." In Robert Putnam's well-known work on what he saw as a loss of social capital, *Bowling Alone*, he defined *social capital* as the "networks, norms, and social trust, that facilitate coordination and cooperation for mutual benefit" (6). See also Rosenbaum et al., "Cup of Coffee with a Dash of Love."

20. See psychologists Jacqueline Leavitt and Susan Saegert's *From Abandonment to Hope* on this in the context of sweat-equity housing. For more, Susan Saegert and Gary Winkel, and Xavier de Souza Briggs have applied this idea of social capital to the "microlevel" of communities and housing. See Saegert and Winkel, *Social Capital Formation*; Saegert and Winkel, "Social Capital and the Revitalization of New York City's Distressed Inner-City Housing"; and Saegert and Winkel, "Crime, Social Capital and Community Participation."

21. See Carina Kaufman-Gutierrez and Shrima Pandey's op-ed for more on the extensive crisis of small business precarity and the need for commercial rent stabilization and protection for street vendors, among other kinds of relief in the wake of COVID: Kaufman-Gutierrez and Pandey, "Opinion: Protect NYC's Small Businesses."

22. This paraphrases Martin Heidegger's understanding of *dwelling*, which he probably never considered as happening in a supermarket, a corner store, or a diner, but which nonetheless fits.

CHAPTER 2

1. You can read María's *Intersection / Prospect Heights* card, along with many others that were contributed to the project at https://inter-section.org, accessed December 5, 2023.

2. Lewin, "Defining the 'Field at a Given Time,'" 307.

3. Proshansky, "City and Self-Identity," 155.

4. Gibson, *Ecological Approach to Visual Perception*.

5. Ittelson, "Perception of Nonmaterial Objects and Events."

CHAPTER 3

1. For detailed notes, community flyers, and photographic documentation of the park's early renovation, as well as much other community organizing in Prospect Heights, see the Robin Ketchum Prospect Heights Community Organizing Collection, BCMS.0079; Brooklyn Public Library, Center for Brooklyn History, https://findingaids.library.nyu.edu/cbh/bcms_0079/.

2. You can read Robin's whole story on the *Intersection | Prospect Heights* website at https://inter-section.org/post/132287561828/underhill-avenue-playground-i-moved-to-prospect. The inter-section.org website, https://inter-section.org/, holds all of the stories contributed in 2015 and 2016 to the *Intersection* project.

3. For more on these embodied spaces, see anthropologist Nancy Munn's work on this space created by movement, which sees place as "a symbolic nexus of relations produced out of interactions between bodily actors and terrestrial spaces." In addition, anthropologist Setha Low calls everyday places the "interpenetration of body, space, and culture." Munn, "Excluded Spaces," 449; and Low, "Embodied Space(s)," 10.

4. Gilmore, *Abolition Geography*.

5. Cheung, "Ruth Wilson Gilmore Says Freedom Is a Physical Place."

6. The Native people of the Bay Area have been described as *Ohlone*, but this term may be more connected to a linguistic group than any one people's name; it's unclear whether people ever truly used this name to refer to themselves. Seventeen thousand people from the North to the South Bay spoke eight to twelve different languages. One of the Bay Area language families is referred to as San Francisco Bay Costonoan (from the Spanish term *costenos*, meaning people of the coast), or Ohlone/Costonoan. Other language families include Coast Miwok and Bay Miwok. For more on population and naming, see Milliken, Shoup, and Ortiz, *Ohlone/Costanoan Indians*, 65, 70; Sogorea Te' Land Trust, "Lisjan (Ohlone) History & Territory"; Margolin, *Ohlone Way*; and Conrad and Solnit, "Map the Size of the Land."

7. For more, see J. P. Harrington's Chochenyo consultants in Gayton, "Areal Affiliations of California Folktales," 595. For further reference, see also Kaufman, "Rumsen Ohlone Folklore"; Milliken, Shoup, and Ortiz, *Ohlone/Costanoan Indians*; and Erdoes and Ortiz, *American Indian Myths and Legends*.

8. From around 1250, the Huchiun and other groups around the Bay Area had practiced a "complex collector" subsistence, beyond hunting and gathering. They had also created a clamshell disk bead trade, suggesting a use of a kind of money. Milliken, Shoup, and Ortiz, *Ohlone/Costanoan Indians*, 83; and Margolin, *Ohlone Way*.

9. There were once more than four hundred shell midden mounds around the Bay Area. In 1909, UC Berkeley archaeologist Nels Nelson counted 425 shellmounds around the Bay Area, and it was believed there had been more that had been demolished. For more on land practices, see Milliken, Shoup, and Ortiz, *Ohlone/Costanoan Indians*, 73, 83. For Corinna Gould quotes and more on the shellmounds of the Bay Area, see Kilvans, "More Than 425 Shellmounds in the Bay Area." See also Nelson, *Shellmounds of the San Franciso Bay Region*, and his map: Roberts and Booker, "Shellmounds in San Francisco Bay Area, 1909." See also a modern interpretation of Nelson's map: Blanchard, "Distribution of Shell Mounds in the San Francisco Bay Region."

10. The shellmound was partially leveled in 1876 to build the Shell Mound Park amusement park. When the park was closed in 1924, archaeologists excavated over seven hundred graves. The site was fully demolished for industrial uses, and then in the 1990s the toxic land was cleaned. Activists lobbied for it to become an open space again, to honor native ancestors, but it was instead developed as a shopping mall, alongside Interstate 580. Every year activists hold a Black Friday protest so that people know about the burial grounds the mall is built on.

11. This meeting is according to firsthand accounts from the Santa María in 1775. Alternate spellings of people's names included Supitaxe, Guilicse, and Mutacxe. See Galvin, *First Spanish Entry into San Francisco Bay 1775*; and Milliken, Shoup, and Ortiz, *Ohlone/Costanoan Indians*, 94.

12. Native people who acted in ways the mission disapproved of were punished: beaten, sexually assaulted, or killed. These brutal places kept expanding; between the end of October 1794 and the beginning of May 1795, the Mission Dolores population jumped from 628 to 1,095, a 75 percent increase. Entire village populations of East Bay Huchiuns and Saclans moved, via tule boat, across the bay to Mission Dolores. By the end of 1794, the Huchiun population of Mission Dolores was 260, making these Oaklanders the largest local tribe at the mission (28 percent of 917 people). See Milliken, *Time of Little Choice*, 136; and Milliken, Shoup, and Ortiz, *Ohlone/Costanoan Indians*, 103.

13. Milliken, *Time of Little Choice*, 157–162.

14. Reed, *Blues City*, 61; and Milliken, Shoup, and Ortiz, *Ohlone/Costanoan Indians*, 109.

15. Peralta was a Spanish soldier and had been the *comisionado* (mayor) of the pueblo of San Jose. The area had a population of Native, European, and African people. See Ishmael Reed's description in Reed, *Blues City*, 40.

16. News of independence reached Alta California in 1822.

17. This was also explicitly promised in a Spanish decree of 1813 and in Mexican laws of the 1820s and 1830s. See Milliken, Shoup, and Ortiz, *Ohlone/Costanoan Indians*, 154.

18. An article from the Library of Congress reads, "In the ten years before the missions were dismantled, the Mexican government had issued only 50 grants for large ranchos. In the dozen years after the missions were secularized, 600 new grants were made." Library of Congress, "Mexican California."

19. This land will be stewarded by the Sogorea Te' Land Trust. The measure passed in December 2022. Silvers and Finney, "'We Have a Vision.'"

20. *Hooker's Map of the Village of Brooklyn*.

21. Pritchard, *Native New Yorkers*, 372–373. Algonquian people had been in the area for thousands of years. There is evidence of their inhabitation in the area as far back as 2000 BCE and earlier. From 1000 to 1524 CE is considered the "golden age" of the Lenape.

22. Pritchard, *Native New Yorkers*, 91–93.

23. Pritchard, *Native New Yorkers*, 92. The Dutch called it *Breucklen*—meaning "broken land" after the Canarsie name for what is now called Coney Island, echoing a Breucklen in the Netherlands.

24. Pritchard, *Native New Yorkers*, 145, 295. The NYC Parks department has posted a sign explaining the history of the man this park honored for many years, writing that Captain John Underhill (1597–1672) "is known for his graphic account of the Pequot Massacre, *Newes from America*, where he describes the killing of the majority of the tribe and enslavement of the surviving tribesmen." While serving in the Massachusetts Bay Colony, Underhill was responsible for the Pequot massacre; in New York, he was responsible for the massacre at Pound Ridge (now in Westchester, NY), in which between five hundred and seven hundred Algonquin were ambushed. New York City Department of Parks & Recreation, "James Forten Playground."

25. The NYC Parks department renamed this park in 2021, after James Forten, a free Black man born in Philadelphia in 1766 who was imprisoned on a British prison ship and later became a successful sailmaker, who used his wealth to support abolition activities, schools, and publications.

26. In 1790, the Census recorded 46 free Black people in Kings County (Brooklyn) and 1,482 Black people who were enslaved. A mere 3 percent of Black people were free, while 60 percent of white families in Brooklyn were enslavers. See Connolly, *A Ghetto Grows in Brooklyn*, 4–5.

27. Campanella, 32.

28. Wellman, *Brooklyn's Promised Land*.

29. For more on free Black Brooklyn, see Prithi Kanakamedala's curatorial scholarship in the exhibition *In Pursuit of Freedom*, a collaboration between the Center for Brooklyn History, Weeksville Heritage Center & Irondale Ensemble Project. Prithi Kanakamedala, "In Pursuit of Freedom | Brooklyn Abolitionists," accessed May 3, 2023, http://pursuitoffreedom.org/. Also see Kanakamedala's related and deeply humane book, *Brooklynites*.

30. Anthropologist Setha Low defines an embodied space as the body's "moving spatial field . . . [making] its own place in the world." Low, "Embodied Space(s)," 14.

31. Shehadeh, *Palestinian Walks*, 2.

32. See the brilliant *Warmth of Other Suns* by Isabel Wilkerson for more on this history.

33. After eighty-one years, Neldam's closed in 2010. A cooperative of former Neldam's workers reopened it as A Taste of Denmark soon after. Initially a great success, the new business was irreparably hurt by the pandemic and A Taste of Denmark closed on October 23, 2022. Fetini, "Late Neldam's Bakery Is Reborn"; and Woodall, "Neldam's Closes Its Doors."

34. Wood, "Temazcalli."

35. Moss eventually became president of the San Francisco Gas Company (later Pacific Gas and Electric [PG&E]). Julia Wood had been his housekeeper, and in 1867, they were married. Moss died in 1880, and Wood died in 1904.

36. Reed, *Blues City*, 35.

37. *Oakland Tribune*, "Mosswood Club Would Have City Buy Tract."

38. See Beckford and Peak, *Going for Happiness*.

39. Woodrow, "Neighbors Call for Rebuilding."

40. Fullilove, *Root Shock*, 233.

41. The HOLC was a subsidiary of the Federal Home Loan Bank Board (FHLBB). The HOLC described the purpose of the maps made in their "City Survey Program" as graphically reflecting "the trend of desirability in neighborhoods from a residential viewpoint." See Wilder, *Covenant with Color*, 186.

42. HOLC, as cited in Hillier, "Residential Security Maps," 216.

43. The best-rated neighborhoods were always on the edge of the city, and African American neighborhoods were always rated a 4, though some other neighborhoods also received grade 4 ratings. Hillier, "Residential Security Maps," 225, 239.

44. This advice, found in Section 980 (3), part g, immediately followed the suggestion that there be restrictions for the "prohibition of nuisances or undesirable buildings such as stables, pig pens, temporary dwellings, and high fences." Another article of the FHA

manual—Section 982 (1)—tied together housing and education segregation, indicating that local schools "should not be attended in large numbers by inharmonious racial groups." "Part II, Section 9, Rating of Location," in *Underwriting Manual*.

45. Article 34 in National Association of Real Estate Boards, *Code of Ethics, 1924*, 7. In 1937, the Brooklyn Edison Market survey divided Brooklyn into twenty-eight neighborhoods and both noted the rents paid and cataloged the ethnic mix in each, giving a detailed description of the specific location of "less desirable groups: Jews, Italians and Negroes." Wilder, *Covenant with Color*, 184.

46. Self, *American Babylon*, 160. See also the excellent Mapping Inequality project, which provides access to all of the HOLC maps: Nelson et al., "Mapping Inequality."

47. As cited in Norman, *Temescal Legacies*, 96.

48. Adding insult to injury, once the freeways and BART trains were built, great struggles were fought by organizations like Justice on BART (JOBART) to integrate the workforce of these new trains, just as they'd had to advocate for fair hiring on the Key System streetcars years before.

49. Schwarzer, *Hella Town*, 195–196.

50. I-580 would cut into the neighborhood below Thirty-Sixth Street, completed in 1966. Construction was begun on I-24, also known as the Grove Shafter Freeway, in 1964, and the freeway wasn't complete until 1985, the year after Grove Street was renamed Martin Luther King Jr. Way. For many images of these freeways and other Temescal and Oakland resources, see "Temescal over Time: History of a North Oakland Neighborhood," accessed October 4, 2022, https://temescalovertime.org/.

51. Pete Escovedo is a legendary Latin jazz drummer and the father of Sheila E., famed percussionist, band leader, and long-time collaborator with Prince.

52. Hoover Durant is now called Hoover Foster instead of Ghost Town—or at least Google Maps has changed its naming (the Foster middle school has replaced the Durant elementary school the neighborhood was partially named for). Hoover Foster only refers to an area west of Telegraph Avenue, west of the freeway and up to MacArthur Boulevard—though Hoover Durant had originally encompassed areas east of Telegraph, and all the way up to Fortieth Street. As my tour guide Marty would say of Fortieth Street, "This was still considered by the Black folks to be Hoover Durant. The white folks didn't want it called that because Hoover Durant had become a Black neighborhood."

53. Fried, "Continuities and Discontinuities of Place," 194.

CHAPTER 4

1. Education and equity scholar Terrell Strayhorn applies this idea in educational settings with college students, using an embodied and emotional description of belonging as "a feeling or sensation of connectedness, and the experience of mattering or feeling cared about, accepted, respected, valued by, and important. . . . It is a cognitive evaluation that typically leads to an affective and/or behavioral response." Strayhorn, *College Students' Sense of Belonging*, 4.

2. There was shipbuilding in many other sites around the bay, including at San Francisco's Hunter's Point Dry Docks. National Park Service, "World War II Shipbuilding."

3. Wilkerson, *Warmth of Other Suns*, 311.

4. This organizing to be able to work was echoed in the way that Black people had had to fight for the right to work on the East Bay's Key System streetcars.

5. Danza, *Prospect Heights Historic District Designation Report*, 18.

6. Campanella, *Brooklyn*, 429.

7. For more, see Bloom, *Great American Transit Disaster*.

8. Wilder, *Covenant with Color*, 193; and Self, *American Babylon*, 16.

9. Self, *American Babylon*, 20.

10. Self, 160.

11. Rothstein, *Color of Law*, 80–81.

12. Other ethnic groups contributed to the area, particularly Armenians, one family of whom ran the triangular Kasper's hotdog stand at Forty-Fifth Street, in the island between Telegraph and Shattuck Avenues, which I photographed at magic hour.

13. Self, *American Babylon*, 161. At all costs, the real estate industry aimed to keep the area around Lake Merritt and the elite city of Piedmont white.

14. These kinds of properties are often called *in rem properties* for short because they are subject to what is called *in rem foreclosure*—where the action is against the building, rather than a person, and also takes into account the rights of the people living in the building. This is described by the New York City government as follows: "If you owe property taxes or other property-related charges for an extended period of time, your property can become subject to an In Rem Foreclosure. If taxes and charges remain unpaid, you may lose your property. . . . After an In Rem Foreclosure, the title of your property is sold or transferred to a new property owner who then renovates or resolves the outstanding bills and violations. This is done so that properties can be improved and better used for affordable housing." NYC311, "In Rem Foreclosure."

15. This program was described by the *New York Times* in 1985 as coordinating "the expenditure of local and Federal money in so-called 'neighborhoods in transition.'" Klockenbrink, "If You're Thinking of Living in: Crown Heights."

16. *Coney Island Times*, "Contract Paves Way."

17. In the 1960s, the core of the city's Caribbean community, which grew following the elimination of the national quota system for immigrants in 1965, moved from Harlem and Bedford-Stuyvesant to neighboring Crown Heights. See Danza, *Prospect Heights Historic District Designation Report*, 22.

18. Osman, *Invention of Brownstone Brooklyn*; Campanella, *Brooklyn*.

19. Brooklyn's population tripled between 1860 and 1890 (while New York's population merely doubled). Prior to the bridge, the sole connection between Brooklyn and New York was the steam ferry started by Robert Fulton in 1814, though other ferries had been running across the East River since 1632. Campanella, *Brooklyn*, 297; and Danza, *Prospect Heights Historic District Designation Report*, 10.

20. Osman, *Invention of Brownstone Brooklyn*, 202.

21. See hooks, "Homeplace (a Site of Resistance)," 46.

22. For more about the murder and its impact on the neighborhood, see Roane and Yardley, "Graduate Student Stabbed to Death"; Christian, "Man Convicted in '99 Murder"; Rashbaum, "Woman's Arrest Led to Brother as Suspect"; and Hajela, "Crime Links Parents of Slaying Victim."

23. Gans, *Urban Villagers*; Young and Willmott, *Family and Kinship in East London*; Fried, "Grieving for a Lost Home"; Fried, *World of the Urban Working Class*; and Fried, "Continuities and Discontinuities of Place."

24. Fullilove, *Root Shock*, 11.

25. Peterson, "Prospect Heights Beginning Climb," para. 36.

26. Matthews, "Fighting the Red Line Blues in Prospect Heights."

27. One portion of Prospect Heights is in the seventy-seventh precinct and one half is in the seventy-eighth, with the dividing line running down Vanderbilt Avenue.

28. For more on the power and politics of loss, see Dixon and Durrheim, "Displacing Place-Identity."

29. Shehadeh, *Palestinian Walks*, xviii.

30. In June 2022, an article published to the Gothamist website forcefully reminded me intensely of Neville's tragedy. A man who lives three blocks from where Neville's house was had woken up one to day to find that that the house I thought he owned, which he had bought with his wife in 1962, was no longer his—swindled from him by a man who was connected to his church and who promised to give him a loan, but who in actual fact had had him sign the building's deed over to him. This preying on an older man for valuable real estate sounded torn from the story that had shaped Neville's life. See Lam, "Homeowner of More than 50 Years."

31. Rhoda's story was recorded as part of the *Intersection | Prospect Heights* oral histories and is part of the Brooklyn Public Library's Our Streets Our Stories archive. You can find Rhoda's story in the *Intersection | Prospect Heights* collection of the Brooklyn Public Library Our Streets, Our Stories archive at https://ourstreetsourstories.tumblr.com/post/138152906289/since-the-60s-okay-i-would-go-over-here-to-the. You can listen to Rhoda's entire oral history at https://soundcloud.com/ososproject/rhoda-hill.

32. Samantha's story was recorded as part of the *Intersection | Prospect Heights* oral histories and is part of the Brooklyn Public Library's Our Streets Our Stories archive. You can find Samantha's story in the *Intersection | Prospect Heights* collection of the Brooklyn Public Library Our Streets, Our Stories archive at https://ourstreetsourstories.tumblr.com/post/136609262469/i-knew-the-crown-heightsprospect-heights-area-as.

33. Fried, "Continuities and Discontinuities of Place," 198.

CHAPTER 5

1. Julia's phrase echoes Elliot Willensky's well-known book, *When Brooklyn Was the World, 1920–1957.*

2. It was a reasonable desire, as Brooklyn was at that time the third largest city in the United States.

3. *Report of the Landscape Architects*, as quoted in Campanella, *Brooklyn*, 90.

4. From 1825 to 1833, what would become Prospect Heights and Fort Greene was the site of Andre and Sylvie Parmentier's horticultural garden, which sold plants to grand houses and gardens. See *Hooker's Map of the Village of Brooklyn*; and Danza, *Prospect Heights Historic District Designation Report*.

5. Residents of Prospect Hill, "Slope, Heights or Hill? (Letter to the Editor)."

6. *Brooklyn Times / Times Union*, "Joint Pastors Will Both Leave Brooklyn." In 1884, a *Brooklyn Daily Eagle* article titled "Near the Park: An Attractive and Growing Part of the City" described an area that in the present would be seen as Park Slope, in which "capitalists have awakened to the truth that Prospect Heights is not only the prettiest but the most healthful portion of the city. There is no malaria here, and the heights command an unobstructed view of the bay, the harbor and the whole of the city." Boundaries were blurry. In 1901, the Board of Estimate designated Prospect Heights to include the ninth, eleventh, twentieth, and twenty-second wards, which encompassed what is now known as Clinton Hill, Park Slope, and Prospect Heights, some of which would now be considered Crown Heights. *Brooklyn Times / Times Union*, "Home Rule to Replace the Politicians' Pull."

7. *Brooklyn Daily Eagle*, "Trade Board Won't Meet in Saloon Hereafter"; and *Brooklyn Daily Eagle*, "Not 'Citizens Association.'"

8. *Brooklyn Daily Eagle*, "Want No Bridge Holdup"; *Brooklyn Citizen*, "Flatbush Ave. Extension"; *Daily Standard Union*, "Demand Extension of Flatbush Avenue"; *Brooklyn Times / Times Union*, "Predicts Delay for Subway Extension"; *Daily Standard Union*, "Flatbush Waits for Extension"; *Brooklyn Daily Eagle*, "Lively Hearing Held on Headquarters Site"; *Brooklyn Daily Eagle*, "Make Flatbush Subway Branch of 4th Av. Route"; *Brooklyn Citizen*, "Prospect Heights Asks for Subway Extension"; *Brooklyn Daily Eagle*, "Discuss Changes in Street Names"; *Daily Standard Union*, "Demand 'Isles of Safety'"; *Brooklyn Times / Times Union*, "Civic Bodies Achieve Much"; *Brooklyn Daily Eagle*, "To Plant Trees in All City Streets"; *Brooklyn Daily Eagle*, "Join Hands to War on Store Buildings"; *Brooklyn Daily Times / Times Union*, "Urges Subway Speed-Up"; and *Brooklyn Standard Union*, "Prospect Heights Apartment Fight Enters New Phase."

9. See the *Brooklyn Eagle* for extensive coverage of the Prospect Heights bowlers and the activities of the Prospect Heights Boy Scouts Troop 59, whose dubious activities included putting on a minstrel show in January 1920 and giving themselves "Indian" names. See *Brooklyn Daily Eagle*, "Sagamore Sohahee Leads Indian Tribe"; and *Brooklyn Standard Union*, "Scouts of Prospect Heights District Preparing for Minstrel."

10. *Brooklyn Daily Eagle*, "Complete Central Library, Demand Citizens of Boro."

11. This was the first major battle of the war, in August 1776.

12. Heidegger, "Building Dwelling Thinking," 360.

13. Frank Widdi and Abdul Jawad still own the renovated and renamed supermarket on Vanderbilt Avenue, as it has been owned by their families since 1983. On the occasion of its grand reopening, they wrote an open letter to the community, inviting them to celebrate and assuring readers, "It's still us, no buy outs, no takeovers, just a simple name change." Foodtown community letter, accessed October 31, 2023, https://j4y2v5w8.stackpathcdn .com/wp-content/uploads/2016/09/Community-Letter.pdf.

14. They found that there was less demand for an affordable diner, and a chance to sell their building and retire after working seven days a week for years.

15. Bedoya, "Placemaking and the Politics of Belonging and Dis-belonging."

16. Fried, "Grieving for a Lost Home"; Fried, "Continuities and Discontinuities of Place"; Gans, *Urban Villagers*; and Young and Willmott, *Family and Kinship in East London*.

17. Beckford, "Ruth Beckford '43."

18. Low, *On the Plaza*, 139.

19. Rocky's story was recorded as part of the *Intersection | Prospect Heights* oral histories and is part of the Brooklyn Public Library's Our Streets Our Stories archive. You can find Rocky's story (who also goes by Denise) in the *Intersection | Prospect Heights* collection of the Brooklyn Public Library Our Streets, Our Stories archive at https://ourstreetsourstories .tumblr.com/post/136610532326/i-gotta-tell-you-nothing-beats-the-brooklyn. You can listen to Rocky's entire oral history at https://soundcloud.com/ososproject/denise-cataudella.

20. All three of these stories were contributed to the *Intersection | Prospect Heights* project at the Prospect Heights Together Day event on June 22, 2019.

CHAPTER 6

1. Marías, *Venice, An Interior*, 53.

2. For more on these Western Apache ideas and linguistic practices, see Basso, *Wisdom Sits in Places*. For more on Pintupi relationships to land, see Myers, *Pintupi Country, Pintupi Self*; and Rhodes, *Whichaway?*

3. Erdrich, *Sentence*, 55.

4. Orange, *There There*, 6.

5. Hall, "Cultural Identity and Diaspora"; Hall, "Question of Cultural Identity"; Hall, "Who Needs Identity?"; and Hall, "Subjects in History."

6. Hall, "Subjects in History," 331.

7. Young, *Justice and the Politics of Difference*, 237.

8. Williams, *Keywords*, 76.

9. See more on this in Iris Young's potent critique of the word in her *Justice and the Politics of Difference*, particularly in her introduction and in chapter 8, as well as Richard Sennett's critique in his book *The Uses of Disorder* on how of a "myth of community" creates a classist and racist American society. I've also written about the implications of defining community and its exclusionary possibilities within the sphere of hotly contested city planning for affordable housing on New York's Lower East Side in my book *Contested City*, particularly in chapter 3, entitled "Three Words: Community, Collaboration, and Public," which addresses those three thorny words.

10. Young, *Justice and the Politics of Difference*, 256.

11. Freire, *Pedagogy of the Oppressed*.

12. Macedo, "Introduction," 12.

13. Duneier, *Slim's Table*, 58.

14. See more on these prerequisites in the work of Juergen Habermas and Paolo Freire: Habermas, *Theory of Communicative Action*; and Freire, *Pedagogy of the Oppressed*.

CHAPTER 7

1. Massey, "Global Sense of Place."
2. Hall, "Subjects in History," 338.
3. Wilkerson, *Warmth of Other Suns*, 310.
4. Everett-Dicko, "Barbeque Legacy."
5. Everett-Dicko and Jones-Hawkins, "Farewell Fair Deal."
6. Everett-Dicko and Jones-Hawkins, "Bay Area Barbeque Hall of Fame." Mock himself exclaimed at that ceremony, "If Jenkins (Jenkins Original Barbeque) is the father of modern day barbecue, then Dorothy Everett (Everett and Jones Barbeque) is the mother": Lavoie and Crosson, "Fire."
7. Saegert, as quoted in Manzo and Perkins, "Finding Common Ground," 346.
8. Hy's Restaurant & Cocktail Lounge was at 3770 Telegraph. The servers wore "western wear."
9. Hall, "Subjects in History," 333.
10. Reverend Earl A. Neil was the Black Panthers' spiritual adviser, and they used the church as a place to meet. See Father Neil's oral history in Neil, "Black Panther Party and Father Neil."
11. Wade, "Breakfast of Unsung Heroes," 6.
12. The Black Panther Party itself comes from the extended version of this Oakland neighborhood: Huey Newton and Bobby Seale met in college on Fifty-First Street, and the Black Panthers as an organization comes, as Robert Self writes, "from the crossroads of West and North Oakland, where a particular kind of street culture met Garveyite notions of self-help, the radical internationalist black tradition, the socialist laborite culture of Oakland's waterfront unions, and the armed community defense strategies of people like Malcolm X and Robert F. Williams." Self, *American Babylon*, 228.
13. Beckford and Peak, *Going for Happiness*.
14. Oliver-Didier, Solano, and Acosta, "You're Not Going to Tell Me."
15. Offenhartz, "In both the level of rage from demonstrators and total lack of restraint from NYPD, last night's protest was unlike anything i've seen in NYC. Here's our report . . . ," Twitter, May 30, 2020, https://twitter.com/jangelooff/status/1266731790968008705; and Pinto and Offenhartz, "Thousands of New Yorkers Protest."
16. Oder, "Brooklyn's Accidental New Town Square"; Oder, "Prokhorov Deal for the Barclays Center"; and Newman, "Once-Loathed Brooklyn Arena."

CHAPTER 8

1. Tuan, "Language and the Making of Place," 690.
2. Amin, "Ethnicity and the Multicultural City."
3. Dixon and Durrheim, "Displacing Place-Identity," 32.
4. For more on this, see Ang, "Curse of the Smile."
5. Powell and Rishbeth, "Flexibility in Place"; Rishbeth, "Everyday Places"; and Rishbeth, Ganji, and Vodicka, "Ethnographic Understandings."

6. Freire, *Pedagogy of the Oppressed*, 60.

7. Freire, 32.

8. Smith, "Dialogue and Conversation."

9. Simone, "People as Infrastructure," 410.

10. Akosua's story was recorded as part of the *Intersection | Prospect Heights* oral histories and is part of the Brooklyn Public Library's Our Streets Our Stories archive. You can find Akosua's story in the *Intersection | Prospect Heights* collection of the Brooklyn Public Library Our Streets, Our Stories archive at https://ourstreetsourstories.tumblr.com/post/134269961482 /on-prospect-place-between-vanderbilt-and. You can listen to Akosua's entire oral history at https://soundcloud.com/ososproject/denise-cataudella.

11. Duneier, *Slim's Table*, 61.

CHAPTER 9

1. Manzo and Perkins, "Finding Common Ground," 346.

2. Zárate, "Right to the City for All."

3. Harvey, "Right to the City."

4. The UN World Charter was influenced by related charters around the world.

5. Wigle and Zárate, "Mexico City Creates Charter."

6. Wigle and Zárate, "Mexico City Creates Charter." This work was the "culmination of a three-year advocacy process led by the Urban Popular Movement (*Movimiento Urbano Popular*, or MUP), with support from the Habitat International Coalition-Latin America (HIC-AL), the Mexico City Commission for Human Rights and the Coalition of Civil Society Organizations for Economic, Social and Cultural Rights (*Espacio DESC*), all of whom participated in drafting the charter. An estimated 3,500 citizens also participated in the elaboration of the charter through various events and consultations." Seven years after it was signed as a charter, it was incorporated into the Constitution of Mexico City. See ESCR-Net, "Constitution of Mexico City."

7. Promotion Committee of the Mexico City Charter for the Right to the City, *Mexico City Charter*, 14; and Gobierno de la Ciudad de Mexico, "Visión 2040." It's important to note that charters can't be the end of the work as they're up against many entrenched interests. Adler, "Do We Have a Right to the City?" explores some of the challenges.

8. Hou, *Transcultural Cities*, 4.

9. Hester, *Design for Ecological Democracy*; and Hester, "Subconscious Landscapes of the Heart."

10. Often, legislation can make a big difference in supporting anchor small businesses that do so much important placework. In New York City, where commercial rents are exorbitant and landlords have been known to increase rents by 500 percent when a business tries to renew a lease, the Fair Rent NYC organization is doing important work to support the passage of a commercial rent stabilization bill for the city. Upstate New York small businesses have different problems, wherein they've sometimes been zoned out of residential neighborhoods; the "legacy shops" legislation in Buffalo, NY, is doing work to combat this.

BIBLIOGRAPHY

Abdul-Khabir, Laylaa. "From Chavez Ravine to Inglewood: How Stadiums Facilitate Displacement in Los Angeles." *UCLA Law Review*, September 25, 2018. https://www.uclalawreview.org/from-chavez-ravine-to-inglewood-how-stadiums-facilitate-displacement-in-los-angeles/.

Adler, David. "Do We Have a Right to the City?" *Jacobin*, October 6, 2015. https://jacobin.com/2015/10/mexico-city-df-right-to-the-city-harvey-gentrification-real-estate-corruption/.

Albers, Anni, Nicholas Fox Weber, Manuel Cirauqui, and Tai Smith. *On Weaving: New Expanded Edition*. Princeton, NJ: Princeton University Press, 2017. First published 1965.

Altman, Irwin, and Setha M. Low, eds. *Place Attachment*. Vol. 12 of Human Behavior and Environment. New York: Plenum, 1992.

Amin, Ash. "Ethnicity and the Multicultural City: Living with Diversity." *Environment and Planning A: Economy and Space* 34, no. 6 (June 1, 2002): 959–980. https://doi.org/10.1068/a3537.

Anderson, Kelly, dir. *My Brooklyn*. Newburgh, NY: New Day Films, 2012.

Ang, Ien. "The Curse of the Smile: Ambivalence and the 'Asian' Woman in Australian Multiculturalism." *Feminist Review* 52 (1996): 36–49.

Angotti, Tom. *New York for Sale: Community Planning Confronts Global Real Estate*. Cambridge, MA: MIT Press, 2008.

Appleyard, Donald, Kevin Lynch, and John R. Myer. *The View from the Road*. Cambridge, MA: MIT Press, 1965.

Arnheim, Rudolph. *Visual Thinking*. London: Faber & Faber, 1969.

Baade, Robert A., and Richard F. Dye. "The Impact of Stadium and Professional Sports on Metropolitan Area Development." *Growth and Change* 21, no. 2 (1990): 1–14. https://doi.org/10.1111/j.1468-2257.1990.tb00513.x.

Bachelard, Gaston. *The Poetics of Space*. Boston: Beacon Press, 1964.

Bagwell, Beth. *Oakland: The Story of a City*. Oakland, CA: Oakland Heritage Alliance, 2012.

Bandera, Maria Cristina, and Renato Miracco, eds. *Morandi 1890–1964*. Milan: Skira Editore S.p.A. /Museo d'Arte Moderna di Bologna, 2008.

Banham, Reyner. *Los Angeles: The Architecture of Four Ecologies*. New York: Harper & Row, 1971.

Banks, M., and H. Morphy. *Rethinking Visual Anthropology*. New Haven, CT: Yale University Press, 1997.

Banks, Marcus. *Visual Methods in Social Research*. London: Sage, 2001.

Barry, Ann. "If You're Thinking of Living In: Prospect Heights." *New York Times*, April 7, 1985.

Barthes, Roland. *Camera Lucida: Reflections on Photography*. New York: Hill and Wang, 1981.

Basso, Keith H. *Wisdom Sits in Places: Landscape and Language among the Western Apache*. Albuquerque: University of New Mexico Press, 1996.

Batchen, G. *Forget Me Not: Photography and Remembrance*. Princeton, NJ: Princeton Architectural Press, 2004.

Batchen, Geoffrey. *Burning with Desire: The Conception of Photography*. Cambridge, MA: MIT Press, 1999.

Becker, Howard S. "Visual Sociology, Documentary Photography, and Photojournalism: It's (Almost) All a Matter of Context." In *Image-Based Research: A Sourcebook for Qualitative Researchers*, edited by Jon Prosser, 84–96. London: Falmer Press, 1998.

Beckford, Ruth. "Ruth Beckford '43." *Oakland Tech Centennial* (blog), March 7, 2015. https://oaklandtech.com/staff/centennial/2015/03/07/ruth-beckford-43/.

Beckford, Ruth, and Penny Peak. *Going for Happiness: An Oral History of Ruth Beckford*. Accessed April 4, 2023. https://archive.org/details/csfpal_000030.

Bedoya, Roberto. "Placemaking and the Politics of Belonging and Dis-belonging." *GIA Reader* 24, no. 1 (2013). https://www.giarts.org/article/placemaking-and-politics-belonging-and-dis-belonging.

Bedoya, Roberto. "Spatial Justice: Rasquachification, Race and the City." *Creative Time Reports* (blog), September 15, 2014. https://creativetime.org/reports/2014/09/15/spatial-justice-rasquachification-race-and-the-city/.

Bendiner-Viani, Gabrielle. "The Big World in the Small: Layered Dynamics of Meaning-Making in the Everyday." *Environment and Planning D: Society and Space* 31, no. 4 (August 2013): 708–726. https://doi.org/10.1068/d17810.

Bendiner-Viani, Gabrielle. "Bringing Their Worlds Back: Using Photographs to Spur Conversations on Everyday Place." *Visual Studies* 31, no. 1 (January 2, 2016): 1–21. https://doi.org/10.1080/1472586X.2015.1120942.

Bendiner-Viani, Gabrielle. *Contested City: Art and Public History as Mediation at New York's Seward Park Urban Renewal Area*. Iowa City: University of Iowa Press, 2019.

Bendiner-Viani, Gabrielle. "Guided Tour: Villa 31." *disClosure* 11 (2002): 47–61.

Bendiner-Viani, Gabrielle. "Guided Tours: The Layered Dynamics of Self, Place and Image in Two American Neighborhoods." PhD diss., City University of New York, 2009.

Bendiner-Viani, Gabrielle. "Layered SPURA: Spurring Conversations through Visual Urbanism." *Radical History Review* 114 (2012): 206–215. https://doi.org/10.1215/01636545-1598078.

Bendiner-Viani, Gabrielle. "Walking, Emotion, and Dwelling: Guided Tours in Prospect Heights, Brooklyn." *Space and Culture* 8, no. 4 (November 2005): 459–471. https://doi.org/10.1177/1206331205280144.

Bendiner-Viani, Gabrielle, and Susan Saegert. "Making Housing Home." *Places* 19, no. 2 (August 15, 2007): 71–79. https://escholarship.org/uc/item/3qx3z8nq.

Benhabib, Seyla. "Models of Public Space: Hannah Arendt, the Liberal Tradition, and Jurgen Habermas." In *Habermas and the Public Sphere*, edited by Craig Calhoun, 73–98. Cambridge, MA: MIT Press, 1992.

Benjamin, Walter. *The Arcades Project*. Translated by Howard Eiland and Kevin McLaughlin. Cambridge, MA: Harvard University Press, 1999.

Benjamin, Walter. "The Work of Art in the Age of Mechanical Reproduction." In *Illuminations*, edited by Hannah Arendt, 217–251. New York: Shocken Books, 1969.

Berger, J., and J. Mohr. *Another Way of Telling*. New York: Pantheon, 1982.

Berger, John. *The Shape of a Pocket*. New York: Vintage, 2003.

Blanchard, John. "Distribution of Shell Mounds in the San Francisco Bay Region." Accessed December 5, 2023. https://shellmound.org/wp-content/uploads/2018/04/John_Blanchard_SHELLMOUNDS_NELSON_FINAL-MAP.pdf.

Blanchot, Maurice. "Everyday Speech." Translated by Susan Hanson. *French Studies* 73 (1987): 12–20.

Bloom, Nicholas Dagen. *The Great American Transit Disaster: A Century of Austerity, Auto-Centric Planning, and White Flight*. Chicago: University of Chicago Press, 2023.

Bondi, Liz. "Locating Identity Politics." In *Place and the Politics of Identity*, edited by Michael Keith and Steve Pile, 82–99. London: Routledge, 1993.

Brand, David, Ma-Sadio Faye, Quainat Mariam, Manuel Lozano-Velez, Nowshin Rahman, Tiara Soto, and Jaelynn Jimenez. "It's Not Just Manhattan: Rents Are Still Rising Across NYC." City Limits, September 13, 2022. https://citylimits.org/2022/09/13/its-not-just-manhattan-rents-are-still-rising-across-nyc/.

BRIDGE Housing. "Bridge Housing: Mural Apartments." Accessed September 28, 2022. https://bridgehousing.com/properties/mural/.

Briggs, Xavier de Souza. "Brown Kids in White Suburbs: Housing Mobility and the Many Faces of Social Capital." *Housing Policy Debate* 9, no. 1 (1998): 177–221. https://doi.org/10.1080/10511482.1998.9521290.

Brinklow, Adam. "Oakland Rent Spike Hits $3K/Month, but Don't Panic." Curbed SF, October 25, 2016. https://sf.curbed.com/2016/10/25/13405240/oakland-rent-spike-3k.

Brooklyn Citizen. "Flatbush Ave. Extension; Prospect Heights Association Asks to Have the Work Begun." May 11, 1904.

Brooklyn Citizen. "Prospect Heights Asks for Subway Extension." May 12, 1908.

Brooklyn Daily Eagle. "Complete Central Library, Demand Citizens of Boro; Prospect Heights Association Asks $1,000,000 Annually for Much Needed Structure." March 1, 1920.

Brooklyn Daily Eagle. "Discuss Changes in Street Names; Prospect Heights Citizens File Objections to Some of the Recommendations." May 28, 1912.

Brooklyn Daily Eagle. "Join Hands to War on Store Buildings; Underhill Avenue Residents, at Protest Meeting in Church, Name Committee." January 20, 1916.

Brooklyn Daily Eagle. "Lively Hearing Held on Headquarters Site." April 16, 1907.

Brooklyn Daily Eagle. "Make Flatbush Subway Branch of 4th Av. Route; Prospect Heights Citizens Suggest Radical Change to Public Service Commission." January 21, 1908.

Brooklyn Daily Eagle. "Near the Park: An Attractive and Growing Part of the City." February 23, 1884.

Brooklyn Daily Eagle. "Not 'Citizens Association': Prospect Heights Board of Trade Has Been Meeting Rear of Cafe." February 19, 1912.

Brooklyn Daily Eagle. "Sagamore Sohahee Leads Indian Tribe." December 2, 1923.

Brooklyn Daily Eagle. "To Plant Trees in All City Streets; 'Make Brooklyn Best-Dressed City in Country,' Is the Slogan." December 14, 1915.

Brooklyn Daily Eagle. "Trade Board Won't Meet in Saloon Hereafter: Prospect Heights Citizens Association Decides on Change of Quarters; Wives Will Be Relieved." February 18, 1912.

Brooklyn Daily Eagle. "Want No Bridge Holdup; Prospect Heights Citizens Association Members Deprecate 'Conservatism and Personal Interest.'" May 11, 1904.

Brooklyn Public Library. "Participatory Art Project Opens Conversation on Transition in Brooklyn's Prospect Heights Neighborhood." September 30, 2015. https://www.bklynlibrary.org/media/press/participatory-art-project.

Brooklyn Standard Union. "Prospect Heights Apartment Fight Enters New Phase; William F. Doyle's Appeal for Owners Contested by Citizens' Association." July 10, 1927.

Brooklyn Standard Union. "Scouts of Prospect Heights District Preparing for Minstrel." January 4, 1920.

Brooklyn Times / Times Union. "Civic Bodies Achieve Much; South Brooklyn Well Cared for in This Respect, Battled for Transit." June 19, 1915.

Brooklyn Times / Times Union. "Home Rule to Replace the Politicians' Pull: Local Boards, After January 1, Will See That Taxpayers Are Fairly Treated. Eight of Such in Brooklyn." December 14, 1901.

Brooklyn Times / Times Union. "Joint Pastors Will Both Leave Brooklyn: The Rev. and Mrs. Wright to Resign from Prospect Heights Church." December 11, 1899.

Brooklyn Times / Times Union. "Predicts Delay for Subway Extension; Dr. Brush Tells Flatbush Taxpayers They Are to Expect Obstruction." April 5, 1907.

Burgin, Victor. *In/Different Spaces*. Berkeley: University of California Press, 1996.

Burgin, Victor. *Some Cities*. London: Reaktion Books, 1996.

Burkitt, Ian. "The Time and Space of Everyday Life." *Cultural Studies* 18, no. 2–3 (2004): 211–226.

Buttimer, Anne. "Grasping the Dynamism of Lifeworld." *Annals of the Association of American Geographers* 66, no. 2 (1976): 277–292.

Buttimer, Anne, and David Seamon, eds. *The Human Experience of Space and Place*. London: Croom Helm, 1980.

Cadogan, Garnette. "Walking While Black." *Literary Hub* (blog), July 8, 2016. https://lithub.com/walking-while-black/.

Calhoun, Craig, ed. *Habermas and the Public Sphere*. Cambridge, MA: MIT Press, 1992.

Campanella, Thomas J. *Brooklyn: The Once and Future City*. Princeton, NJ: Princeton University Press, 2020.

Casey, Edward S. "How to Get from Space to Place in a Fairly Short Stretch of Time: Phenomenological Prologemena." In *Senses of Place*, edited by Steven Feld and Keith H. Basso, 13–52. Santa Fe: School of American Research Press, 1997.

Casey, E. S. *The Fate of Place: A Philosophical History*. Berkeley: University of California Press, 1997.

Casey, Laura. "Mosswood Park Neighbors Don't Want Caribbean Fest." *East Bay Times*, April 23, 2004. https://www.eastbaytimes.com/2004/04/23/mosswood-park-neighbors-dont-want-caribbean-fest/.

Castells, Manuel. *The City and the Grassroots: A Cross-Cultural Theory of Urban Social Movements*. Berkeley: University of California Press, 1983.

Castells, Manuel. *The Rise of the Network Society*. Vol. 1 of *The Information Age: Economy, Society, and Culture*. Oxford: Blackwell, 2000.

Certeau, Michel de. *The Practice of Everyday Life*. Berkeley: University of California Press, 1984.

Certeau, Michel de, Luce Giard, and Pierre Mayol. *Living and Cooking*. Vol. 2 of *The Practice of Everyday Life*. Translated by Timothy J. Tomasik. Berkeley: University of California Press, 1998.

Chapple, Karen. *Mapping Susceptibility to Gentrification: The Early Warning Toolkit*. Berkeley, CA: The Center for Community Innovation (CCI) at UC-Berkeley, August 2009. https://communityinnovation.berkeley.edu/sites/default/files/mapping_susceptibility_to_gentrification.pdf.

Chase, John, Margaret Crawford, and John Kaliski. *Everyday Urbanism*. Expanded ed. New York: Monacelli Press, 2008. http://catdir.loc.gov/catdir/toc/fy0903/2008037263.html.

Chawla, Louise. "Childhood Place Attachments." In *Place Attachment*, edited by Irwin Altman and Setha Low, 63–86. New York: Plenum Press, 1992.

Cheslow, Jerry. "If You're Thinking of Living In: Prospect Heights." *New York Times*, May 27, 1990. https://www.nytimes.com/1990/05/27/realestate/if-you-re-thinking-of-living-in-prospect-heights.html.

Cheung, Kylie. "Ruth Wilson Gilmore Says Freedom Is a Physical Place—But Can We Find It?" *Jezebel*, June 21, 2022. https://jezebel.com/ruth-wilson-gilmore-says-freedom-is-a-physical-place-bu-1849079415.

Christian, Nichole M. "Man Convicted in '99 Murder of Social Worker from Kansas." *New York Times*, May 19, 2001. https://www.nytimes.com/2001/05/19/nyregion/man-convicted-in-99-murder-of-social-worker-from-kansas.html.

City of Oakland. "MacArthur BART Transit Village Project (MacArthur Station)." Accessed September 21, 2022. https://www.oaklandca.gov/projects/macarthur-transit-village-project.

Clements, Alexis. "In Brooklyn, a Forum Focuses the Fight against Displacement." Hyperallergic, August 2, 2016. http://hyperallergic.com/314973/in-brooklyn-a-forum-focuses-the-fight-against-displacement/.

Closson, Troy, and Nicole Hong. "Why Black Families Are Leaving New York, and What It Means for the City." *New York Times*, January 31, 2023. https://www.nytimes.com/2023/01/31/nyregion/black-residents-nyc.html.

Clucas, Stephen. "Cultural Phenomenology and the Everyday." *Critical Quarterly* 42, no. 1 (2000): 8–34.

Collier Jr., John, Malcolm Collier, and Edward Hall. *Visual Anthropology: Photography as a Research Method*. New York: Holt, Rinehart & Winston, 1967.

Coney Island Times. "Contract Paves Way for Improvement of Prospect Heights." August 7, 1964.

Connolly, Harold X. *A Ghetto Grows in Brooklyn*. New York: New York University Press, 1977.

Conrad, Lisa, and Rebecca Solnit. "A Map the Size of the Land." In *Infinite City: A San Francisco Atlas*. Berkeley: University of California Press, 2010.

Cooper Marcus, Clare. *House as a Mirror of Self: Exploring the Deeper Meaning of Home*. Berkeley, CA: Conari Press, 1995.

Corbin, C. N. E. *Enclosure-Occupations: Contested Productions of Green Space; the Paradoxes within Oakland, California's Green City*. ISSI Graduate Fellows Working Paper Series 2018–2019.85. Berkeley, CA: ISSI, August 12, 2019. https://escholarship.org/uc/item/34r2d4hw.

Crawford, Margaret, George Baird, Rahul Mehrotra, Doug Kelbaugh, and Michael Speaks. *Everyday Urbanism*. Ann Arbor: University of Michigan, 2005.

Crawford, Margaret. "Blurring the Boundaries: Public Space and Private Life." In *Everyday Urbanism*, expanded ed., edited by John Chase, Margaret Crawford, and John Kaliski, 22–35. New York: Monacelli Press, 2008.

Curtis, James C. "Dorothea Lange, Migrant Mother and the Culture of the Depression." *Winterthur Portfolio* 21, no. 1 (1986): 1–20.

Daily Standard Union. "Demand Extension of Flatbush Avenue; Important Matters Discussed at Meeting of Prospect Heights Residents." May 18, 1904.

Daily Standard Union. "Demand 'Isles of Safety'; Prospect Heights Citizens Urge That Resolution Adopted by Aldermen Be Carried out—Life in Especial Danger in Flatbush Avenue, at Seventh and Eighth Avenue Crossings." October 15, 1912.

Daily Standard Union. "Flatbush Waits for Extension; Subway Committee Tells Taxpayers There Is Danger of Red Tape and Delay; Change of Route Opposed; Action of Prospect Heights Association Condemned." April 5, 1907.

Danza, Cynthia. *Prospect Heights Historic District Designation Report*. New York: New York City Landmarks Preservation Commission, June 23, 2009. http://s-media.nyc.gov/agencies/lpc/lp/2314.pdf.

Davis, Tim. "Photography and Landscape Studies." *Landscape Journal* 8, no. 1 (1989): 1–12.

Dean, Allison Lirish. "The New Battle against Gentrification." *Gotham Gazette*, August 24, 2007. https://www.gothamgazette.com/index.php/development/3642-the-new-battle-against-gentrification.

Debord, Guy. *Psychogeographic Map of Paris*. 1957. Lithograph, 595 × 735 mm.

Debord, Guy. "Theory of the Dérive." In *Theory of the Dérive and Other Situationist Writings on the City*, edited by Libero Andreotti and Xavier Costa, 22–27. Barcelona: Museum of Contemporary Art of Barcelona, 1996.

Didion, Joan. "Fire Season in Los Angeles." *New Yorker*, August 27, 1989.

Dixon, John, and Kevin Durrheim. "Displacing Place-Identity: A Discursive Approach to Locating Self and Other." *British Journal of Social Psychology* 39 (pt. 1), no. 1 (March 2000): 27–44.

Duneier, Mitchell. *Slim's Table: Race, Respectability, and Masculinity*. Chicago: University of Chicago Press, 1992.

Edwards, Elizabeth, ed. *Anthropology and Photography*. New Haven, CT, and London: Yale University Press and the Royal Anthropological Institute, 1992.

Edwards, Elizabeth. "Beyond the Boundary: A Consideration of the Expressive in Photography and Anthropology." In *Rethinking Visual Anthropology*, edited by Marcus Banks and Howard Morphy, 53–80. New Haven, CT: Yale University Press, 1997.

Erdoes, Richard, and Alfonso Ortiz. *American Indian Myths and Legends*. New York: Pantheon, 1985.

Erdrich, Louise. *The Sentence*. New York: Harper, 2021.

ESCR-Net. "Constitution of Mexico City Recognizes the Right to the City." February 24, 2017. https://www.escr-net.org/news/2017/constitution-mexico-city-recognizes-right-city.

Everett-Dicko, Shirley. "The Barbeque Legacy of West Oakland's Historic 7th Street." Everett and Jones Barbeque. Last updated October 12, 2019. https://www.everettandjones.com/7th-street-barbeque-legacy.html.

Everett-Dicko, Shirley, and Yvette Jones-Hawkins. "Bay Area Barbeque Hall of Fame." *Saucy Sister's Blog*, May 29, 2021. http://www.everettandjones.com/3/post/2021/05/bay-area-barbeque-hall-of-fame.html.

Everett-Dicko, Shirley, and Yvette Jones-Hawkins. "Farewell Fair Deal." *Saucy Sister's Blog*, October 29, 2018. http://www.everettandjones.com/3/post/2018/10/farewell-fair-deal.html.

Ewald, Wendy. *Secret Games: Collaborative Works with Children, 1969–1999*. New York: Scalo Publishers, 2000.

Federal Writers' Project and William H. Whyte. *The WPA Guide to New York City: The Federal Writers' Project Guide to 1930s New York*. New York: New Press, 1992.

Feld, Steven, and Keith H. Basso. *Senses of Place*. Santa Fe: School for American Research, 1989.

Feng, Xia, and Brad Humphreys. "Assessing the Economic Impact of Sports Facilities on Residential Property Values: A Spatial Hedonic Approach." *Journal of Sports Economics* 19, no. 2 (February 1, 2018): 188–210. https://doi.org/10.1177/1527002515622318.

Fetini, Alyssa. "The Late Neldam's Bakery Is Reborn, with Workers in Charge and Treats as Diverse as Telegraph Ave." Oakland North, September 11, 2010. https://oaklandnorth.net/2010/09/11/the-late-neldams-bakery-is-reborn/.

Finder, Alan. "City Selling Prospect Heights Parcels." *New York Times*, November 27, 1986. https://www.nytimes.com/1986/11/27/nyregion/city-selling-prospect-heights-parcels.html.

Finney, Nissa, and Clare Rishbeth. "Engaging with Marginalised Groups in Public Open Space Research: The Potential of Collaboration and Combined Methods." *Planning Theory & Practice* 7, no. 1 (2006): 27–46. https://doi.org/10.1080/14649350500497406.

Fleming, Thomas. "Segregation and the Civil Rights Movement in San Francisco." Found SF, January 9, 1999. https://www.foundsf.org/index.php?title=Segregation_and_the_Civil_Rights_Movement_in_San_Francisco.

Foulkes, Julia. "For the Love of Strangers." *Julia Foulkes* (blog), April 12, 2020. http://juliafoulkes.net/?p=1434.

Freire, Paulo. *Pedagogy of the Oppressed*. Translated by Myra Bergman Ramos and with an introduction by Donaldo Macedo. 30th anniversary ed. New York: Continuum, 2005.

Freire, Paulo, and Donaldo Macedo. "A Dialogue: Culture, Language, and Race." *Harvard Educational Review* 65, no. 3 (1995): 377.

Fried, Marc A. "Continuities and Discontinuities of Place." *Journal of Environmental Psychology* 20 (2000): 193–205.

Fried, Marc A. "Grieving for a Lost Home." In *The Urban Condition: People and Policy in the Metropolis*, edited by Leonard J. Duhl and John Powell, 151–171. New York: Basic Books, 1963.

Fried, Marc A. *The World of the Urban Working Class*. Cambridge, MA: Harvard University Press, 1973.

Fullilove, Mindy. *Root Shock: How Tearing Up City Neighborhoods Hurts America, and What We Can Do About It*. New York: One World/Ballantine, 2009.

Fulton, Hamish. *Hamish Fulton, Walking Journey*. London: Tate Publishing, 2002.

Galvin, John, ed. *The First Spanish Entry into San Francisco Bay 1775*. San Francisco: John Howell, 1971.

Gans, Herbert J. *The Urban Villagers*. New York: Free Press, 1965.

Gardiner, Michael. "Everyday Utopianism: Lefebvre and His Critics." *Cultural Studies* 18 (2004): 228–254.

Gayton, A. H. "Areal Affiliations of California Folktales." *American Anthropologist* 37, no. 4 (1935): 582–599. https://doi.org/10.1525/aa.1935.37.4.02a00040.

Gibson, James J. *The Ecological Approach to Visual Perception*. Boston: Houghton Mifflin, 1979.

Gibson, James J. *The Senses Considered as Perceptual Systems*. Prospect Heights, IL: Waveland Press, 1966.

Gilmore, Ruth Wilson. *Abolition Geography*. New York: Verso, 2022.

Giuliani, Maria Vittoria, and Roberta Feldman. "Place Attachment in a Developmental and Cultural Context." *Journal of Environmental Psychology* 13 (1993): 267–274.

Gobierno de la Ciudad de Mexico. "Visión 2040. La ciudad que queremos." In *Plan General de Desarrollo de la Ciudad de México: Ciudad de derechos y derecho a la Ciudad*. Mexico City: Government of Mexico City, 2022. https://plazapublica.cdmx.gob.mx/processes/plan-general-desarrollo-2020/f/78/proposals/6070.

Goffman, Erving. *Presentation of Self in Everyday Life*. Garden City, NY: Doubleday, 1959.

Gray, John. "Open Spaces and Dwelling Places: Being at Home on Hill Farms in the Scottish Borders." *American Ethnologist* 26, no. 2 (May 1, 1999): 440–460. https://doi.org/10.1525/ae.1999.26.2.440.

Groth, P., and T. Bressi. *Understanding Ordinary Landscapes*. New Haven, CT: Yale University Press, 1997.

Guano, Emanuela. *Creative Urbanity: An Italian Middle Class in the Shade of Revitalization*. Philadelphia: University of Pennsylvania Press, 2016.

Habermas, Juergen. *The Theory of Communicative Action*. Vol. 1. Cambridge: Polity Press, 1984.

Hajela, Deepti. "Crime Links Parents of Slaying Victim with Her Killer." *Los Angeles Times*, September 2, 2001. https://www.latimes.com/archives/la-xpm-2001-sep-02-mn-41117-story.html.

Halbwachs, Maurice. *On Collective Memory*. Translated by Lewis Coser. Chicago: University of Chicago Press, 1992.

Hall, Stuart. "Cultural Identity and Diaspora." In *Identity: Community, Culture, Difference*, edited by Jonathan Rutherford, 222–237. London: Lawrence Wishart, 1990.

Hall, Stuart. "Interview with Stuart Hall." *Camera Work* 29 (1983): 17–19.

Hall, Stuart. "The Question of Cultural Identity." In *Modernity and Its Futures: Understanding Modern Societies*, edited by Tony McGrew, Stuart Hall, and David Held, 273–326. Cambridge: Polity Press, 1992.

Hall, Stuart. "Subjects in History: Making Diasporic Identities (1998)." In *Selected Writings on Race and Difference*, edited by Ruth Wilson Gilmore and Paul Gilroy, 329–338. Duke University Press, 2021.

Hall, Stuart. "Introduction: Who Needs 'Identity?'" In *Questions of Cultural Identity*, edited by Stuart Hall and Paul du Gay, 1–17. London: Sage, 1996.

Harper, Doug. "Talking about Pictures: A Case for Photo Elicitation." *Visual Studies* 17, no. 1 (2002): 13–26. https://doi.org/10.1080/14725860220137345.

Hart, Roger. *Children's Experience of Place*. New York: Irvington Publishers, 1979.

Hartocollis, Anemona. "Evelyn Ortner, 82, a Booster of Brooklyn Brownstones, Dies." *New York Times*, September 22, 2006. https://www.nytimes.com/2006/09/22/obituaries/22ortner.html.

Harvey, David. "The Right to the City." *New Left Review*, no. 53 (October 1, 2008): 23–40.

Harvey, David. *Social Justice and the City*. Oxford: Basil Blackwell, 1973.

Hayden, Dolores. *The Power of Place: Urban Landscapes as Public History*. Cambridge, MA: MIT Press, 1997.

Heidegger, Martin. "Building Dwelling Thinking." In *Basic Writings*, edited by David Farrell Krell, 343–364. San Francisco: Harper, 1993.

Hester, Randolph. "Community Design: Making the Grassroots Whole." *Built Environment* (1978–) 13, no. 1 (1987): 45–60.

Hester, Randolph. *Design for Ecological Democracy*. Cambridge, MA: MIT Press, 2010.

Hester, Randolph. "Subconscious Landscapes of the Heart." *Places* 2, no. 3 (1985): 10–22.

Hillier, Amy E. "Redlining and the Home Owners' Loan Corporation." *Journal of Urban History* 29, no. 4 (2003): 394–420.

Hillier, Amy E. "Residential Security Maps and Neighborhood Appraisals: The Home Owners' Loan Corporation and the Case of Philadelphia." *Social Science History* 29, no. 2 (2005): 207–233.

Hillier, Amy E. "Who Received Loans? Home Owners' Loan Corporation Lending and Discrimination in Philadelphia in the 1930s." *Journal of Planning History* 2, no. 1 (2003): 3–24.

Hillman, James, William H. Whyte, and Arthur Erickson. *The City as Dwelling: Walking, Sitting, Shaping*. Irving, TX: Center for Civic Leadership, University of Dallas, 1980.

Hirsch, Marianne. *Family Frames: Photography, Narrative, and Postmemory*. Cambridge, MA: Harvard University Press, 1997.

H. M. Gousha Company. *Street Map of East Bay Cities*. Chicago: H. M. Gousha, 1938. Courtesy of UC Berkeley Earth Sciences & Map Library.

Hooker's Map of the Village of Brooklyn in the Year 1827. Map no. B A-1827 (1861?).Fl. Map Collection, Brooklyn Historical Society. https://mapcollections.brooklynhistory.org/map/hookers-map-of-the-village-of-brooklyn-in-the-year-1827/.

hooks, bell. "Homeplace (a site of resistance)." In *Yearning: Race, Gender, and Cultural Politics*, 41–49. Boston: South End Press, 1990.

Hou, Jeffrey, ed. *Transcultural Cities: Border-Crossing and Placemaking*. London: Routledge, 2013.

Ingold, Tim. *The Perception of the Environment: Essays on Livelihood, Dwelling and Skill*. London: Routledge, 2000.

Ittelson, William H. "Environment Perception and Contemporary Perceptual Theory." In *Environment and Cognition*, 141–154. New York: Seminar Press, 1973.

Ittelson, William H. "Environmental Perception and Urban Experience." *Environment and Behavior* 10 (1978): 193–213.

Ittelson, William H. "The Perception of Nonmaterial Objects and Events." *Leonardo* 40, no. 3 (June 1, 2007): 279–283.

Ittelson, William H. "Visual Perception of Markings." *Psychonomic Bulletin & Review* 3 (1996): 171–187.

Jackson, J. B. *Discovering the Vernacular Landscape*. New Haven, CT: Yale University Press, 1984.

Jackson, J. B. "The Future of the Vernacular." In *Understanding Ordinary Landscapes*, edited by Paul Groth and Todd Bressi. New Haven, CT: Yale University Press, 1997.

Jackson, Jonathan David. "The Social World of Voguing." *Journal for the Anthropological Study of Human Movement* 12, no. 2 (2002): 26–42.

Jackson, Kenneth, and John Manbeck, eds. *The Neighborhoods of Brooklyn*. New Haven, CT: Yale University Press, 1998.

Jacobs, Jane. *The Death and Life of Great American Cities*. 50th anniversary ed. New York: Modern Library, 2011.

James, William. "The Consciousness of Self." In *The Principles of Psychology*, 291–400. New York: Henry Holt and Company, 1890.

Jameson, F. "Cognitive Mapping." In *Marxism and the Interpretation of Culture*, edited by C. Nelson and L. Grossberg, 347–360. Chicago: University of Illinois Press, 1988.

Johnson, Walis. "Walking Brooklyn's Redline: A Journey through the Geography of Race." *Journal of Public Pedagogies*, no. 4 (November 14, 2019): 209–216.

Johnson, Walis, and Prithi Kanakamedala. "The Red Line Archive: An Interview with Walis Johnson." *Gotham Center for New York City History* (blog), September 3, 2019. https://www.gothamcenter .org/blog/the-red-line-archive-an-interview-with-walis-johnson.

Kambhampaty, Anna P. "Median Rent in Manhattan Reaches a New High." *New York Times*, June 9, 2022. https://www.nytimes.com/2022/06/09/realestate/manhattan-rent-nyc.html.

Kanakamedala, Prithi. "In Pursuit of Freedom | Brooklyn Abolitionists." Accessed May 3, 2023. http://pursuitoffreedom.org/.

Kanakamedala, Prithi. *Brooklynites: Free Black Communities in the Nineteenth Century*. New York: New York University Press, 2024.

Kaplan, Z., J. Rosen, and J. Shandler. *Lives Remembered: A Shtetl through a Photographer's Eye*. New York: Museum of Jewish Heritage, 2002.

Karlinsky, Sarah. *Losing Ground: What the Bay Area's Housing Crisis Means for Middle-Income Households and Racial Inequality*. San Francisco: SPUR, March 2023. https://www.spur.org/sites/default /files/2023-03/SPUR_Losing_Ground_0.pdf.

Kaufman, David. "Rumsen Ohlone Folklore: Two Tales." *Journal of Folklore Research* 45, no. 3 (2008): 383–391.

Kaufman-Gutierrez, Carina, and Shrima Pandey. "Opinion: Protect NYC's Small Businesses by Supporting Street Vendors and Brick-and-Mortars Together." City Limits, February 16, 2021. https://citylimits.org/2021/02/16/opinion-protect-nycs-small-businesses-by-supporting-street -vendors-and-brick-and-mortars-together/.

Kilvans, Laura. "There Were Once More Than 425 Shellmounds in the Bay Area. Where Did They Go?" *Bay Curious*, KQED, March 24, 2022. https://www.kqed.org/news/11704679/there-were-once-more-than-425-shellmounds-in-the-bay-area-where-did-they-go.

Klockenbrink, Myra. "If You're Thinking of Living in: Crown Heights." *New York Times*, January 20, 1985. https://www.nytimes.com/1985/01/20/realestate/if-you-re-thinking-of-living-in-crown-heights.html.

Knoll, Robert, ed. *Conversations with Wright Morris: Critical Views and Responses*. Lincoln: University of Nebraska Press, 1977.

Knowles, Caroline, and Paul Sweetman. *Picturing the Social Landscape: Visual Methods and the Sociological Imagination*. London: Routledge, 2004.

Korpela, K. M. "Place-Identity as a Product of Environmental Self-Regulation." *Journal of Environmental Psychology* 9 (1989): 241–256.

Kussin, Zachary. "NYC Rent Hits a New Record, No Break for New Yorkers in Sight." *New York Post*, August 11, 2022. https://nypost.com/2022/08/11/record-high-nyc-rents-climbed-even-higher-in-july-report/.

Lam, Chau. "Homeowner of More than 50 Years Faces Eviction from His Own House." Gothamist, June 27, 2022. https://gothamist.com/news/homeowner-of-more-than-50-years-faces-eviction-from-his-own-house.

Lane, Barbara Miller, ed. *Housing and Dwelling: Perspectives on Modern Domestic Architecture*. London: Routledge, 2006. https://doi.org/10.4324/9780203799673.

Langford, Martha. *Suspended Conversations: The Afterlife of Memory in Photographic Albums*. Montreal: McGill-Queen's University Press, 2001.

Lavoie, Steven, and Gwyn Crosson. "Fire: The Sizzling Story of East Bay Barbecue." *Oakland Tribune*, June 30, 1993.

Leavitt, Jacqueline, and Susan Saegert. *From Abandonment to Hope: Community-Households in Harlem*. Columbia History of Urban Life. New York: Columbia University Press, 1990.

Lefebvre, Henri. "The Everyday and Everydayness." *Yale French Studies* 73 (1987): 7–11.

Lefebvre, Henri. *Henri Lefebvre: Key Writings*. Edited by S. Elden, E. Lebas, and E. Kofman. Athlone Contemporary European Thinkers Series. London: Continuum International Publishing Group, 2003.

Lefebvre, Henri. *The Production of Space*. Translated by H. Nicholson-Smith. Oxford: Blackwell Publishers, 1991.

Lefebvre, Henri, and Stuart Elden. *Rhythmanalysis*. Athlone Contemporary European Thinkers Series. London: Continuum, 2004.

Lefebvre, Henri, and Catherine Régulier. "The Rhythmanalytical Project." *Communications* 41 (1985): 191–199.

Levin, Sam. "Oakland's 'Mega-Evictor,' the Landlord Who Filed over 3,000 Eviction Notices." *The Guardian*, October 31, 2016. https://www.theguardian.com/us-news/2016/oct/31/oakland-eviction-notices-affordable-housing-crisis-rent-bay-area.

Levitsky, Carolyn. "My Brooklyn: Readers Report." Brooklyn Net, August 20, 1997. https://www.brooklyn.net/my_bklyn/my_bklyn_060.html.

Lewin, Kurt. "Defining the 'Field at a Given Time.'" *Psychological Review* 50 (1943): 292–310.

Lewin, Kurt. *A Dynamic Theory of Personality*. New York: McGraw-Hill, 1935.

Library of Congress. "The First Peoples of California." Library of Congress Digital Collections. Accessed September 27, 2022. https://www.loc.gov/collections/california-first-person-narratives/articles-and-essays/early-california-history/first-peoples-of-california/.

Library of Congress. "Mexican California." Library of Congress Digital Collections. Accessed September 27, 2022. https://www.loc.gov/collections/california-first-person-narratives/articles-and-essays/early-california-history/mexican-california/.

Library of Congress. "The Missions." Library of Congress Digital Collections. Accessed September 27, 2022. https://www.loc.gov/collections/california-first-person-narratives/articles-and-essays/early-california-history/missions/.

Lightfeldt, Alan. "The State of New York City Rent Affordability in 2016." *StreetEasy* (blog), April 21, 2016. https://streeteasy.com/blog/new-york-city-rent-affordability-2016/.

Lippard, Lucy. *The Lure of the Local: Senses of Place in a Multicentered Society*. New York: New Press, 1997.

Livingston, Jennie, dir. *Paris Is Burning*. Documentary. Academy Entertainment & Off White Productions, 1990.

Llamoca, Janice. "Remembering the Lost Communities Buried under Center Field." NPR, October 31, 2017. https://www.npr.org/sections/codeswitch/2017/10/31/561246946/remembering-the-communities-buried-under-center-field.

Long, Richard. *Richard Long: Many Rivers to Cross*. London: Thames and Hudson, 2022.

Low, Setha M. "Embodied Space(s): Anthropological Theories of Body, Space, and Culture." *Space and Culture* 6 (2003): 9–18.

Low, Setha M. *On the Plaza*. Austin: University of Texas Press, 2000.

Low, Setha M. "Symbolic Ties That Bind: Place Attachment on the Plaza." In *Place Attachment*, edited by Irwin Altman and Setha M. Low, 165–185. Vol. 12 of Human Behavior and Environment. New York: Plenum, 1992.

Low, Setha M., Gabrielle Bendiner-Viani, and Yvonne Hung. *Attachments to Liberty: An Ethnographic Assessment for the Statue of Liberty National Monument*. Washington, DC: National Park Service, 2005.

Low, Setha M., and Denise Lawrence-Zúñiga. *The Anthropology of Space and Place: Locating Culture*. Oxford: Blackwell, 2003.

Low, Setha M., Dana Taplin, and Suzanne Scheld. *Rethinking Urban Parks: Public Space and Cultural Diversity*. Austin: University of Texas Press, 2005.

Lynch, Kevin. *The Image of the City*. Cambridge, MA: MIT Press, 1960.

Lynch, Kevin, and Malcolm Rivkin. "A Walk around the Block." In *Environmental Psychology: People and Their Physical Settings*, edited by Harold Proshansky, William Ittelson, and Leanne G. Rivlin, 363–376. 2nd ed. New York: Holt, Rinehart & Winston, 1976.

Macedo, Donaldo. "Introduction." In *Pedagogy of the Oppressed*, by Paulo Freire. Translated by Myra Bergman Ramos, 11–27. 30th anniversary ed. New York: Continuum, 2005.

Madanipour, A. "Social Exclusion and Space." In *Social Exclusion in European Cities: Processes, Experiences and Responses*, edited by A. Madanipour, G. Cars, and J. Allen, 75–90. London, 1998.

Manzo, Lynne C. "Beyond House and Haven: Toward a Revisioning of Emotional Relationships with Places." *Journal of Environmental Psychology* 23, no. 1 (2003): 47–61. https://doi.org/10.1016/S0272-4944(02)00074-9.

Manzo, Lynne C. "For Better or Worse: Exploring Multiple Dimensions of Place Meaning." *Journal of Environmental Psychology* 25, no. 1 (2005): 67–86. https://doi.org/10.1016/j.jenvp.2005.01.002.

Manzo, Lynne Catherine, and Patrick Devine-Wright. *Place Attachment*. London: Routledge, 2014.

Manzo, Lynne, and Douglas Perkins. "Finding Common Ground: The Importance of Place Attachment to Community Participation and Planning." *Journal of Planning Literature* 20, no. 4 (2006): 335–350.

Margolin, Malcolm. *The Ohlone Way: Indian Life in the San Francisco-Monterey Bay Area*. 2nd ed. Berkeley, CA: Heyday, 1978.

Marías, Javier. *Venice, An Interior*. London: Hamish Hamilton, 2016.

Marston, S. A., J. P. Jones III, and K. Woodward. "Human Geography without Scale." *Transactions of the Institute of British Geographers*, n.s., 30 (2005): 416–432.

Massey, Doreen. "A Global Sense of Place." In *Space, Place and Gender*, 146–156. Minneapolis: University of Minnesota Press, 1994.

Matthews, Richard. "Fighting the Red Line Blues in Prospect Heights: Community Group Says City Seeks to Divide Neighbors." *The Phoenix*, April 17, 1986, 23. Robin Ketchum Prospect Heights Community Organizing Collection, BCMS.0079; Brooklyn Public Library, Center for Brooklyn History.

Mazumdar, Shampa, and Sanjoy Mazumdar. "Religion and Place Attachment: A Study of Sacred Places." *Journal of Environmental Psychology* 24, no. 3 (2004): 385–397.

Mazumdar, Shampa, and Sanjoy Mazumdar. "Sacred Space and Place Attachment." *Journal of Environmental Psychology* 13, no. 3 (1993): 231–242.

McDonogh, Gary, and Cindy Hing-Yuk Wong. "The Mediated Metropolis: Anthropological Issues in Cities and Mass Communication." *American Anthropologist* 103, no. 1 (2001): 96–111.

Merleau-Ponty, Maurice. *The World of Perception*. Abingdon, UK: Routledge, 2004.

Milliken, Randall. *A Time of Little Choice: The Disintegration of Tribal Culture in the San Francisco Bay Area, 1769–1810*. Menlo Park, CA: Malki-Ballena Press, 1995.

Milliken, Randall, Laurence H. Shoup, and Beverly R. Ortiz. *Ohlone/Costanoan Indians of the San Francisco Peninsula and Their Neighbors, Yesterday and Today*. San Francisco: National Park Service, June 2009. http://npshistory.com/publications/goga/ohlone-indians.pdf.

Morris, Scott. "City Council Approves 260-Foot Tower for MacArthur Transit Village." Hoodline, March 9, 2017. https://hoodline.com/2017/03/city-council-approves-260-foot-tower-for-macarthur-transit-village/.

Morris, Wright. *The Inhabitants*. New York: Charles Scribner's Sons, 1946.

Munn, Nancy. "Excluded Spaces: The Figure in the Australian Aboriginal Landscape." *Critical Inquiry* 22 (1996): 446–465.

Murray, Barbra. "Fifteen Years in the Making, Oakland's MacArthur Transit Village Breaks Ground—Multifamily Real Estate News." Multi-Housing News, June 1, 2011. https://www.multihousingnews.com/fifteen-years-in-the-making-oaklands-macarthur-transit-village-breaks-ground-3/.

Myers, Fred. *Pintupi Country, Pintupi Self*. Washington, DC: Smithsonian Institution Press, 1986.

Narayan-Parker, Deepa. "Bonds and Bridges: Social Capital and Poverty." Policy Research Working Paper, Report #WPS2167. World Bank, Washington, DC, 1999.

National Association of Real Estate Boards. *Code of Ethics, 1924*. Chicago: National Association of Real Estate Boards, June 6, 1924. https://www.nar.realtor/about-nar/history/1924-code-of-ethics.

National Park Service. "The Mountain View Cemetery: Frederick Law Olmsted National Historic Site." Accessed September 27, 2022. https://www.nps.gov/places/the-mountain-view-cemetery.htm.

National Park Service. "World War II Shipbuilding in the San Francisco Bay Area." Accessed September 21, 2022. https://www.nps.gov/articles/000/world-war-ii-shipbuilding-in-the-san-francisco-bay-area.htm.

Neil, Earl. "Black Panther Party and Father Neil." It's About Time: Black Panther Legacy and Alumni. Accessed May 4, 2023. http://www.itsabouttimebpp.com/our_stories/chapter1/bpp_and_father_neil.html.

Nelson, Alicia Underlee. "Cities with the Highest Rent in the U.S.: August 2022." Rent., September 19, 2022. https://www.rent.com/research/highest-rent-in-the-us/.

Nelson, N. C. *Shellmounds of the San Francisco Bay Region*. University of California Publications in American Archaeology and Ethnology 7, no. 4. Berkeley: The University Press, 1909. https://digitalassets.lib.berkeley.edu/anthpubs/ucb/text/ucp007-006.pdf.

Nelson, Robert K., LaDale Winling, Richard Marciano, Nathan Connolly, et al. "Mapping Inequality." In *American Panorama*, edited by Robert K. Nelson and Edward L. Ayers. Accessed October 30, 2023. https://dsl.richmond.edu/panorama/redlining/#loc=14/40.672/-73.967&mapview=graded&city=brooklyn-ny&area=C6&adview=full.

Nelson, Robert K., LaDale Winling, Richard Marciano, Nathan Connolly, et al. "Mapping Inequality." In *American Panorama*, edited by Robert K. Nelson and Edward L. Ayers. Accessed October 30, 2023. https://dsl.richmond.edu/panorama/redlining/#loc=14/37.825/-122.282&mapview=graded&city=oakland-ca&adview=full.

New York City Department of Parks & Recreation. "Eastern Parkway." Accessed May 2, 2023. https://www.nycgovparks.org/parks/B029/history.

New York City Department of Parks & Recreation. "James Forten Playground." Accessed May 2, 2023. https://www.nycgovparks.org/parks/underhill-playground/history.

New York Daily News. "Ford to City: Drop Dead." October 30, 1975.

New York Planning Commission. *Plan for New York City, Vol. 3: Brooklyn.* Cambridge, MA: MIT Press, 1969.

Newman, Andy. "How a Once-Loathed Brooklyn Arena Became a Protest Epicenter." *New York Times*, June 16, 2020. https://www.nytimes.com/2020/06/16/nyregion/barclays-center-protests.html.

Nora, Pierre. *Realms of Memory.* Edited by L. D. Kritzman. New York: Columbia University Press, 1998.

Nora, Pierre. *Rethinking France: Les Lieux de Memoire, Volume 2: Space.* Edited by D. P. Jordan. Chicago: University of Chicago Press, 2006.

Norman, Jeff. *Temescal Album: History of a Neighborhood.* Oakland, CA: Temescal Neighborhood History Project, 1998.

Norman, Jeff. *Temescal Legacies: Narratives of Change from a North Oakland Neighborhood.* Oakland, CA: Shared Ground, 2006.

NYC Housing Preservation & Development. "HDFC Cooperatives." Accessed September 27, 2022. https://www1.nyc.gov/site/hpd/services-and-information/hdfc.page.

NYC311. "In Rem Foreclosure." Accessed May 2, 2023. https://portal.311.nyc.gov/article/?kanumber =KA-02817.

NYU Furman Center. "State of Renters and Their Homes." In *The State of New York City's Housing and Neighborhoods Report.* New York: NYU Furman Center. Accessed October 10, 2022. https://furmancenter.org/stateofthecity/view/state-of-renters-and-their-homes.

Oakland Tribune. "Mosswood Club Would Have City Buy Tract: Improvement Organizers May Get Park Through Bond Issue." *Oakland Tribune*, February 6, 1908.

Oakland's Displacement Crisis: As Told by the Numbers. Policy Link. Accessed May 2, 2023. https://www.policylink.org/find-resources/library/oakland-displacement-crisis.

Oder, Norman. "Art or Advertising? The Contradictions of 'You/We Belong Here' Neon Signage at Barclays Center." *The Indypendent*, December 6, 2021. https://indypendent.org/2021/12/art -or-advertising-the-contradictions-of-you-we-belong-here-neon-signage-at-barclays-center/.

Oder, Norman. "Atlantic Yards/Pacific Park Infographics: What's Built/What's Coming/What's Missing, Who's Responsible, + Project FAQ/Timeline." *Atlantic Yards/Pacific Park Report* (blog), November 11, 2020. https://atlanticyardsreport.blogspot.com/2017/08/atlantic-yardspacific-park -graphic.html.

Oder, Norman. *Atlantic Yards / Pacific Park Report* (blog). Accessed September 28, 2022. https://atlanticyardsreport.blogspot.com.

Oder, Norman. "Brooklyn's Accidental New Town Square." *Bklyner*, June 10, 2020. https://bklyner .com/brooklyns-accidental-new-town-square/.

Oder, Norman. "Housing Displacement? The Map Points to Prospect Heights/Crown Heights." *Atlantic Yards/Pacific Park Report* (blog), November 1, 2006. https://atlanticyardsreport.blogspot .com/2006/11/housing-displacement-map-points-to.html.

Oder, Norman. "Why the Prokhorov Deal for the Barclays Center Was Likely Premised on the Brooklyn Behemoth." *Atlantic Yards/Pacific Park Report* (blog), February 18, 2016. https://atlantic yardsreport.blogspot.com/2016/02/why-prokhorov-deal-for-barclays-center.html.

Offenhartz, Jake. "In both the level of rage from demonstrators and total lack of restraint from NYPD, last night's protest was unlike anything I've seen in NYC. Here's our report" Twitter, May 30, 2020. https://twitter.com/jangelooff/status/1266731790968008705.

O'Hara, Morgan, and Susan Hewitt. "Formal Records of the Use of Time and Movement through Space: A Conceptual and Visual Series of Artworks." *Leonardo* 16, no. 4 (1983): 265–272.

Oldenburg, Ray. *The Great Good Place*. New York: Paragon House, 1991.

Oliver-Didier, Oscar, Gabriel Hernández Solano, and John Xavier Acosta. "You're Not Going to Tell Me When to Go Home." *Urban Omnibus*, September 10, 2020. https://urbanomnibus.net/2020/09 /youre-not-going-to-tell-me-when-to-go-home/.

Orange, Tommy. *There There*. New York: Knopf, 2018.

Orenstein, Natalie. "After a Pandemic Pause, Oakland Ramped up Homeless Camp Closures Again. Why?" The Oaklandside, January 12, 2022. https://oaklandside.org/2022/01/12/after-a-pandemic -pause-oakland-ramped-up-homeless-camp-closures-again-why/.

Orenstein, Natalie. "The City Wants to Close 2 Prominent Oakland Homeless Camps. Not So Fast, Some Residents Say." The Oaklandside, August 10, 2021. https://oaklandside.org/2021/08/10 /the-city-wants-to-close-2-prominent-oakland-homeless-camps-not-so-fast-some-residents-say/.

Osman, Suleiman. *The Invention of Brownstone Brooklyn: Gentrification and the Search for Authenticity in Postwar New York*. Reprint edition. Oxford: Oxford University Press, 2012.

"Part II, Section 9, Rating of Location." In *Underwriting Manual: Underwriting and Valuation Procedure Under Title II of the National Housing Act*. Washington, DC: Federal Housing Administration, 1938. https://www.huduser.gov/portal/sites/default/files/pdf/Federal-Housing-Administration-Under writing-Manual.pdf.

Paul, Stan. "If You Build It, Will They Have to Leave?" UCLA Newsroom, news release, August 29, 2016. https://newsroom.ucla.edu/releases/if-you-build-it-will-they-have-to-leave.

Paulas, Rick. "Sports Stadiums Are a Bad Deal for Cities." *The Atlantic*, November 21, 2018. https:// www.theatlantic.com/technology/archive/2018/11/sports-stadiums-can-be-bad-cities/576334/.

Peterson, Iver. "Prospect Heights Beginning Climb to Gentrification." *New York Times*, November 27, 1988. https://www.nytimes.com/1988/11/27/realestate/prospect-heights-beginning-climb-to -gentrification.html.

Pink, Sarah. *Doing Visual Ethnography: Images, Media and Representation in Research*. London: Sage, 2001.

Pink, Sarah. "An Urban Tour: The Sensory Sociality of Ethnographic Place-Making." *Ethnography* 9, no. 2 (2008): 175–196. https://doi.org/10.1177/1466138108089467.

Pink, Sarah. "Walking with Video." *Visual Studies* 22, no. 3 (December 1, 2007): 240–252. https://doi.org/10.1080/14725860701657142.

Pink, Sarah. *Working Images: Visual Research and Representation in Ethnography*. London: Routledge, 2004.

Pinto, Nick, and Jake Offenhartz. "Thousands of New Yorkers Protest Police Killing of George Floyd as NYPD Responds with Batons and Pepper Spray." Gothamist, May 30, 2020. https://gothamist.com/news/thousands-new-yorkers-protest-police-killing-george-floyd-nypd-responds-batons-and-pepper-spray.

Poblete, Gabriel. "Auction of Atlantic Yards Sites Endangers Hard-Fought Housing Promises." *The City*, February 2, 2024. https://www.thecity.nyc/2024/02/02/auction-atlantic-yards-endangers-hard-affordable-housing/.

Podair, Jerald. *City of Dreams: Dodger Stadium and the Birth of Modern Los Angeles*. Princeton, NJ: Princeton University Press, 2017.

Powell, Mark, and Clare Rishbeth. "Flexibility in Place and Meanings of Place by First Generation Migrants." *Tijdschrift Voor Economische En Sociale Geografie* 103, no. 1 (2012): 69–84. https://doi.org/10.1111/j.1467-9663.2011.00675.x.

Pred, Allan. "Place as Historically Contingent Process: Structuration and the Time-Geography of Becoming Places." *Annals of the Association of American Geographers* 74, no. 2 (1984): 279–297.

Pred, Allan. "Structuration and Place: On the Becoming of Sense of Place and Structure of Feeling." *Journal for the Theory of Social Behaviour* 13, no. 1 (March 1983): 45–68. https://doi.org/10.1111/j.1468-5914.1983.tb00461.x.

Price, Marty. "Mosswood Neighbor Responds." *East Bay Times*, April 29, 2004. https://www.eastbaytimes.com/2004/04/29/mosswood-neighbor-responds/.

Pritchard, Evan T. *Native New Yorkers: The Legacy of the Algonquin People of New York*. Rev. ed. Chicago Council Oak Books, 2007.

Promotion Committee of the Mexico City Charter for the Right to the City. *Mexico City Charter for the Right to the City*. Mexico City: Promotion Committee of Mexico City, 2010. https://www.right2city.org/wp-content/uploads/2021/04/Mexico_Charter_R2C_2010.pdf.

Proshansky, Harold. "The City and Self-Identity." *Journal of Environment and Behavior* 10, no. 2 (1978): 147–169.

Proshansky, Harold M., Abbe K. Fabian, and Robert Kaminoff. "Place-Identity: Physical World Socialization of the Self." *Journal of Environmental Psychology* 3, no. 1 (1983): 57–83.

Prosser, Jon, ed. *Image-Based Research: A Sourcebook for Qualitative Researchers*. London: Falmer Press, 1998.

Putnam, Robert D. "Bowling Alone: America's Declining Social Capital." *Journal of Democracy* 6 (1995): 64–78.

Putnam, Robert D. *Bowling Alone: The Collapse and Revival of American Community*. New York: Simon & Schuster, 2001.

Rashbaum, William K. "Woman's Arrest Led to Brother as Suspect in '99 Murder." *New York Times*, August 4, 2000. https://www.nytimes.com/2000/08/04/nyregion/woman-s-arrest-led-to-brother-as-suspect-in-99-murder.html.

Reed, Ishmael. *Blues City: A Walk in Oakland*. New York: Crown, 2007.

Relph, Ted, Yi-Fu Tuan, and Anne Buttimer. "Humanism, Phenomenology, and Geography." *Annals of the Association of American Geographers* 67, no. 1 (1977): 177–183.

Relph, Edward. *Place and Placelessness. Research in Planning and Design*. London: Pion, 1976.

Residents of Prospect Hill. "Slope, Heights or Hill? (Letter to the Editor)." *Brooklyn Daily Eagle*, March 17, 1889.

Rhodes, Jon. *Whichaway? Photographs from Kiwirrkura, 1974–1996*. Jon Rhodes, 1998.

Richardson, Miles. "Being-in-the-Market versus Being-in-the-Plaza: Material Culture and the Construction of Social Reality in Spanish America." In *The Anthropology of Space and Place: Locating Culture*, edited by Setha Low and Denise Lawrence-Zúñiga, 74–91. Oxford: Wiley-Blackwell, 2003.

Riger, Stephanie, and Paul J. Lavrakas. "Community Ties: Patterns of Attachment and Social Interactions in Urban Neighborhoods." *American Journal of Community Psychology* 9, no. 1 (1981): 55–66.

Riley, Robert B. "The Visible, the Visual, and the Vicarious: Questions about Vision, Landscape, and Experience." In *Understanding Ordinary Landscapes*, edited by Paul Groth and Todd Bressi, 200–210. London: Yale University Press, 1997.

Rishbeth, Clare. "Everyday Places That Connect Disparate Homelands: Remembering through the City." In *Transcultural Cities*, edited by Jeffrey Hou, 118–132. New York: Routledge, 2013.

Rishbeth, Clare, Farnaz Ganji, and Goran Vodicka. "Ethnographic Understandings of Ethnically Diverse Neighbourhoods to Inform Urban Design Practice." *Local Environment* 23, no. 1 (January 2, 2018): 36–53. https://doi.org/10.1080/13549839.2017.1385000.

Rivlin, Leanne G. "Group Membership and Place Meanings in an Urban Neighborhood." *Journal of Social Issues* 38 (1982): 75–93.

Rivlin, Leanne G. "The Neighborhood, Personal Identity and Group Affiliation." In *Neighborhood and Community Environments*, edited by Irwin Altman and Abraham Wandersman, 1–34. New York: Plenum Press, 1987.

Roane, Kit R., and Jim Yardley. "Graduate Student Stabbed to Death Near Her Brooklyn Home." *New York Times*, March 10, 1999. https://www.nytimes.com/1999/03/10/nyregion/graduate-student-stabbed-to-death-near-her-brooklyn-home.html.

Roberts, Allen, and Matthew Booker. "Shellmounds in San Francisco Bay Area, 1909." From an original 1909 map by N.C. Nelson. Stanford Spatial History Project, Stanford University. Accessed December 5, 2023. https://web.stanford.edu/group/spatialhistory/static/visualizations/viz23.html.

Rodas, Ashley McBride, Ricky. "'We Will Rise Again': A Devastating Fire Won't Stop the East Bay's Oldest Black Church." The Oaklandside, March 6, 2023. https://oaklandside.org/2023/03/06/oakland-first-african-methodist-episcopal-church-rebuilding-after-fire/.

Rogovin, Milton, Dave Isay, David Miller, and Harvey Wang. *Milton Rogovin: The Forgotten Ones.* New York: Quantuck Lane Press, 2003.

Rojas, James, and John Kamp. *Dream Play Build: Hands-On Community Engagement for Enduring Spaces and Places.* Washington, DC: Island Press, 2022.

Rose, Gillian. *Visual Methodologies: An Introduction to the Interpretation of Visual Materials.* London: SAGE, 2011.

Rose, Kalima, and Margaretta Lin. *A Roadmap toward Equity: Housing Solutions for Oakland, California.* Oakland, CA: Policy Link, 2015. https://www.policylink.org/sites/default/files/pl-report-oak -housing-070715.pdf.

Rosenbaum, Mark S. "Exploring the Social Supportive Role of Third Places in Consumers' Lives." *Journal of Service Research* 9, no. 1 (August 1, 2006): 59–72. https://doi.org/10.1177/1094670506289530.

Rosenbaum, Mark S., James Ward, Beth Walker, and Amy Ostrom. "A Cup of Coffee with a Dash of Love: An Investigation of Commercial Social Support and Third-Place Attachment." *Journal of Service* 10, no. 1 (2007): 43–59.

Rosler, Martha. *If You Lived Here: The City in Art, Theory and Social Activism.* Edited by Brian Wallis. Seattle: Bay Press & Dia Art Foundation, 1991.

Rothstein, Richard. *The Color of Law: A Forgotten History of How Our Government Segregated America.* New York: Liveright Publishing, 2017.

Rudofsky, Bernard. *Streets for People: A Primer for Americans.* Garden City, NY: Doubleday & Company, 1969.

Saegert, Susan. "Charged Contexts: Difference, Emotion, and Power in Environmental Design Research." *Architecture et Comportment/Architecture and Behavior* 9, no. 1 (1993): 69–84.

Saegert, Susan. "The Role of Housing in the Experience of Dwelling." In *Home Environments,* edited by Irwin Altman and Carol Werner, 287–309. New York: Plenum, 1985.

Saegert, Susan, and Gary Winkel. "Crime, Social Capital and Community Participation." *American Journal of Community Psychology* 34, no. 3/4 (2004): 219–133.

Saegert, Susan, and Gary Winkel. "Social Capital and the Revitalization of New York City's Distressed Inner-City Housing." *Housing Policy Debate* 9, no. 1 (1998): 17–60.

Saegert, Susan, and Gary Winkel. *Social Capital Formation in Low Income Housing.* New York: Housing Environments Research Group of the Center for Human Environments, City University of New York, 1997.

Saint Augustine's Episcopal Church. "History of Our Church." Accessed April 3, 2023. https://www.staugepiscopal.org/about.

Schwartzenberg, Susan. *Becoming Citizens: Life and the Politics of Disability.* Seattle: University of Washington Press, 2005.

Schwartzenberg, Susan. "The Personal Archive as Historical Record." *Visual Studies* 20, no. 1 (2005): 70–82.

Schwarzer, Mitchell. *Hella Town: Oakland's History of Development and Disruption*. Berkeley: University of California Press, 2022.

Seamon, David. "Awareness and Reunion: A Phenomenology of the Person-World Relationship as Portrayed in the New York Photographs of Andre Kertész." In *Place Images in Media: Portrayal, Experience, and Meaning*, edited by Leo Zonn, 31–61. Lanham, MD: Rowman & Littlefield, 1990.

Seamon, David. *Dwelling, Seeing, and Designing: Toward a Phenomenological Ecology*. Albany: State University of New York Press, 1993.

Seamon, David. *A Geography of the Lifeworld: Movement, Rest and Encounter*. New York: Palgrave Macmillan, 1979.

Seamon, David. "A Way of Seeing People and Place: Phenomenology in Environment-Behavior Research." In *Theoretical Perspectives in Environment-Behavior Research*, edited by Seymour Wapner, Jack Demick, Takiji Yamamoto, and Hirofumi Minami, 157–178. New York: Kluwer Academic, 2000.

Seamon, David, and Robert Mugerauer, eds. *Dwelling, Place & Environment: Towards a Phenomenology of Person and World*. New York: Columbia University Press, 1989.

Self, Robert O. *American Babylon: Race and the Struggle for Postwar Oakland*. Princeton, NJ: Princeton University Press, 2003.

Sennett, Richard. *The Uses of Disorder: Personal Identity & City Life*. New York: Knopf, 1970.

Shehadeh, Raja. *Palestinian Walks: Forays into a Vanishing Landscape*. New York: Scribner, 2008.

Shields, Rob. *Lefebvre, Love and Struggle: Spatial Dialectics*. London: Routledge, 1999.

Silvers, Emma, and Annelise Finney. "'We Have a Vision': East Bay Ohlone Tribe Looks to Future as Oakland Announces Landback Plan." KQED, September 9, 2022. https://www.kqed.org/news /11925121/we-have-a-vision-east-bay-ohlone-tribe-looks-to-future-as-oakland-announces-landback-plan.

Simone, AbdouMaliq. "People as Infrastructure: Intersecting Fragments in Johannesburg." *Public Culture* 16, no. 3 (Fall 2004): 407–29.

Smith, Mark. "Dialogue and Conversation for Learning, Education and Change." *The Encyclopedia of Pedagogy and Informal Education*, last updated June 20, 2013. https://infed.org/mobi /dialogue-and-conversation/.

Smith, Neil. *The New Urban Frontier: Gentrification and the Revanchist City*. London: Routledge, 1996.

Sogorea Te' Land Trust. "Lisjan (Ohlone) History & Territory." Accessed May 4, 2023. https:// sogoreate-landtrust.org/lisjan-history-and-territory/.

Solnit, Rebecca. *Wanderlust: A History of Walking*. New York: Penguin Books, 2001.

Solnit, Rebecca, and Susan Schwartzenberg. *Hollow City: The Siege of San Francisco and the Crisis of American Urbanism*. London: Verso, 2002.

Sorkin, Michael, ed. *Variations on a Theme Park: The New American City and the End of Public Space*. New York: Hill and Wang, 1992.

Soursourian, Matthew. *Suburbanization of Poverty in the Bay Area: Community Development Research Brief*. San Francisco: Federal Reserve Bank of San Francisco, January 2012. https://www.frbsf.org/wp-content/uploads/sites/3/Suburbanization-of-Poverty-in-the-Bay-Area2.pdf.

Steinhauer, Jillian. "The Real Story Behind the Gentrification of Brooklyn." Hyperallergic, February 1, 2013. http://hyperallergic.com/64500/the-real-story-behind-the-gentrification-of-brooklyn/.

Strayhorn, Terrell L. *College Students' Sense of Belonging: A Key to Educational Success for All Students*. 2nd ed. London: Routledge, 2018.

Sturken, Marita. *Tangled Memories: The Vietnam War, the AIDS Epidemic, and the Politics of Remembering*. Berkeley: University of California Press, 1997.

Sundiata, Sekou, and Kym Ragusa. *The America Project: A Teaching Method for Collaboration, Creativity, and Citizenship*, edited by Gabrielle Bendiner-Viani. New York: dance & be still arts and MAPP International, 2009.

Szarkowski, John, and William Eggleston. *William Eggleston's Guide*. New York: Museum of Modern Art, 2002.

Tagg, John. *The Burden of Representation: Essays on Photographies and Histories*. London: Macmillan, 1987.

Temescal Neighborhood History Project and Oakland Heritage Alliance. *A Walk through Temescal, a Joint Project of the Temescal Neighborhood History Project and the Oakland Heritage Alliance*. Oakland, CA: Oakland Heritage Alliance, 1997.

Terkel, Studs. *Working: People Talk about What They Do All Day and How They Feel about What They Do*. New York: Ballantine Books, 1990.

Thrasher, Steven W. "An Uprising Comes from the Viral Underclass." *Slate*, June 12, 2020. https://slate.com/news-and-politics/2020/06/black-lives-matter-viral-underclass.html.

Times Union. "Predicts Delay for Subway Extension." April 5, 1907.

Times Union / Brooklyn Daily Times. "Urges Subway Speed-Up." December 8, 1918.

Tolman, Edward C. "Cognitive Maps in Rats and Men." *Psychological Review* 55, no. 4 (1948): 189–208.

Torrez, James, and Henry Lee. "Oakland's First African Methodist Episcopal Church Damaged by Fire." KTVU FOX 2, February 20, 2023. https://www.ktvu.com/news/oaklands-first-african-methodist-episcopal-church-damaged-by-fire.

Tuan, Y. F. "Language and the Making of Place: A Narrative-Descriptive Approach." *Annals of the Association of American Geographers* 81, no. 4 (1991): 684–696.

Tuan, Yi-Fu. *Topophilia: A Study of Environmental Perceptions, Attitudes, and Values*. New York: Columbia University Press, 1990.

Tyska, Jane. "Photos: City of Oakland Clears Large Homeless Encampment at Mosswood Park." *East Bay Times*, February 4, 2020. https://www.eastbaytimes.com/2020/02/04/photos-city-of-oakland-clears-large-homeless-encampment-at-mosswood-park.

Underhill, John, and Paul Royster. "Newes from America; or, A New and Experimentall Discoverie of New England; Containing, a True Relation of Their War-Like Proceedings These Two Yeares

Last Past, with a Figure of the Indian Fort, or Palizado." *Newes from America*, January 1, 1638. Available from Libraries at University of Nebraska-Lincoln. https://digitalcommons.unl.edu/etas/37.

Urban Ecology. *Walkable Streets: A Toolkit for Oakland*. Oakland, CA: Urban Ecology, 2004.

Vandam, Jeff. "Living in Prospect Heights, Brooklyn: A Neighborhood Comes into Its Own." *New York Times*, December 18, 2005. https://www.nytimes.com/2005/12/18/realestate/a-neighborhood-comes-into-its-own.html.

Vergara, Camilo Jose. *The New American Ghetto*. Camden, NJ: Rutgers University Press, 1997.

Vergunst, Jo Lee, and Tim Ingold. "Fieldwork on Foot: Perceiving, Routing, Socializing." In *Locating the Field: Space, Place and Context in Anthropology*, edited by Simon Coleman and Peter Collins, 67–86. Oxford: Berg, 2006.

Vergunst, Jo Lee, and Tim Ingold. *Ways of Walking: Ethnography and Practice on Foot*. London: Routledge, 2016.

Vigdor, Jacob L. "Does Gentrification Harm the Poor?" *Brookings-Wharton Papers on Urban Affairs*, 2002: 133–182.

Wade, Meredith. "Breakfast of Unsung Heroes: Black Women's Forgotten Crusade for Survival in the Free Breakfast for Children." Honors thesis, Wellesley College, April 2017. https://repository.wellesley.edu/object/ir776.

Warner, Sam Bass. *The Urban Wilderness: A History of the American City*. Berkeley: University of California Press, 1995.

Wellman, Judith. *Brooklyn's Promised Land: The Free Black Community of Weeksville, New York*. New York: NYU Press, 2014.

Whang, Vanessa. *Belonging in Oakland: A Cultural Development Plan*. Oakland, CA: City of Oakland Cultural Affairs Division, Economic & Workforce Development Department, Spring 2018. https://www.oaklandca.gov/resources/cultural-plan.

Whitford, Emma. "This Is What Affordable Housing Means If You Want to Live Above Barclays Center." Gothamist, April 28, 2016. https://gothamist.com/news/this-is-what-affordable-housing-means-if-you-want-to-live-above-barclays-center.

Whyte, William H. *The Social Life of Small Urban Spaces*. Washington, DC: Conservation Foundation, 1980.

Wigle, Jill, and Lorena Zárate. "Mexico City Creates Charter for the Right to the City." PN: Planners Network, July 14, 2010. https://www.plannersnetwork.org/2010/07/mexico-city-creates-charter-for-the-right-to-the-city/.

Wigoder, Meir. "History Begins at Home: Photography and Memory in the Writings of Siegfried Kracauer and Roland Barthes." *History & Memory* 13, no. 1 (2001): 19–59.

Wilder, Craig Steven. *A Covenant with Color: Race and Social Power in Brooklyn 1636–1990*. New York: Columbia University Press, 2000.

Wilkerson, Isabel. *The Warmth of Other Suns: The Epic Story of America's Great Migration*. New York: Random House, 2011.

Willensky, Elliot. *When Brooklyn Was the World, 1920–1957.* New York: Harmony, 1986.

Williams, Raymond. *Keywords: A Vocabulary of Culture and Society.* New ed. Oxford: Oxford University Press, 2014.

Wood, Stephanie, ed. "Temazcalli." In *Nahuatl Dictionary.* Eugene: Wired Humanities Projects, College of Education, University of Oregon, 2000. https://nahuatl.wired-humanities.org/content /temazcalli.

Woodall, Angela. "Neldam's Closes Its Doors after Eight Decades." *East Bay Times*, July 23, 2010. https://www.eastbaytimes.com/2010/07/23/neldams-closes-its-doors-after-eight-decades/.

Woodrow, Melanie. "Neighbors Call for Rebuilding of Oakland Rec Center." ABC7 San Francisco, November 26, 2016. https://abc7news.com/fire-in-oakland-california-at-rec-center-mosswood -performing-arts/1626815/.

Woolf, Virginia. *Street Haunting.* San Francisco: Westgate Press, 1930.

Yates, Frances. *The Art of Memory.* Chicago: University of Chicago Press, 1974.

Ybarra-Frausto, Tomás. "Rasquachismo: A Chicano Sensibility." In *Chicano Aesthetics: Rasquachismo*, 5–8. Phoenix, AZ: MARS, Movimiento Artístico del Rio Salado, 1989. Exhibition catalog.

Young, Iris Marion. *Justice and the Politics of Difference.* Princeton, NJ: Princeton University Press, 1990. https://doi.org/10.2307/j.ctvcm4g4q.

Young, Michael, and Peter Willmott. *Family and Kinship in East London.* Rev. ed. Reprint. Harmondsworth, UK: Penguin Books, 1966.

Zárate, Lorena. "Right to the City for All: A Manifesto for Social Justice in an Urban Century." In *The Just City Essays: 26 Visions for Urban Equity, Inclusion and Opportunity*, edited by Toni Griffin, Ariella Cohen, and David Maddox. New York: J. Max Bond Center on Design for the Just City at the Spitzer School of Architecture, City College of New York, Next City and the Nature of Cities, 2015. https://www.designforthejustcity.org/read/essays/zarate.

Zeltzer-Zubida, Aviva. "Housing Displacement in Brooklyn—Preliminary Findings." Presented at the Housing Displacement in Brooklyn: A Discussion. Center for the Study of Brooklyn, June 9, 2006. https://web.archive.org/web/20060909181150/http://depthome.brooklyn.cuny.edu/csb /reports/housingdiscussion1.html.

Zuk, Miriam, and Karen Chapple. *Case Studies on Gentrification and Displacement in the San Francisco Bay Area.* Berkeley: Center for Community Innovation, University of California, July 2015. https://communityinnovation.berkeley.edu/sites/default/files/case_studies_on_gentrification _and_displacement_in_the_san_francisco_bay_area.pdf.